ICONS

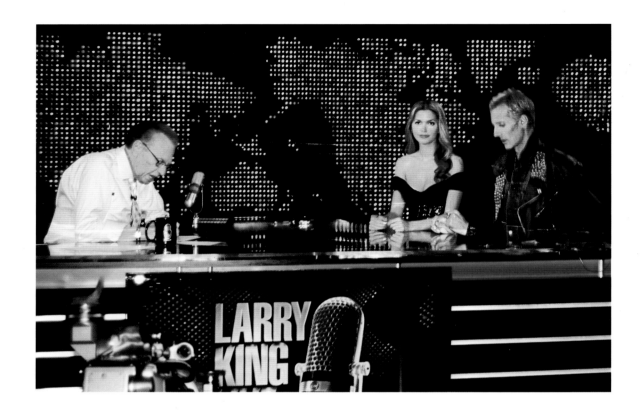

"Two of photography's biggest talents . . ."

—AMERICAN PHOTO

"At the forefront of contemporary photography . . ."

—NOWNESS

"Photography duo Markus Klinko and Indrani have become notorious for producing iconic images . . ."

—ARENA

"It's a powerful dream vision—seamless, erotic, unforgettable . . . the work of two contemporary masters."

—THE MASTERS

ICONS

MARKUS KLINKO

&

INDRANI PAL-CHAUDHURI

WITH CINDY DE LA HOZ

FOREWORDS BY

IMAN & FERN MALLIS

RUNNING PRESS
PHILADELPHIA · LONDON

Books published by Running Press are available at special discounts for bulk purchases in the United States by corporations, institutions, and other organizations. For more information, please contact the Special Markets Department at the Perseus Books Group, 2300 Chestnut Street, Suite 200, Philadelphia, PA 19103, or call (800) 810-4145, ext. 5000, or e-mail special.markets@perseusbooks.com.

ISBN 978-0-7624-4676-6
Library of Congress Control Number: 2012945805

9 8 7 6 5 4 3 2 1
Digit on the right indicates the number of this printing

Designed by Joshua McDonnell
Typography: Lato and Avenir

Running Press Book Publishers
2300 Chestnut Street
Philadelphia, PA 19103-4371

Visit us on the web!
www.runningpress.com

Behind the scenes photography credits:
Page 13, top left; page 16: Mark Sebastian
Page 14: Kaitlyn Barlow
Page 19, bottom right; page 20, center: Alex Bauzon

DEDICATION

To our greatest inspirations and supporters: Hedwig and Albert Klinko; Ajay Pal-Chaudhuri and Greta Thompson; GK Reid and Sora Akizuki Reid; David Bowie, Beyoncé Knowles, Daphne Guinness, and Lady Gaga; and to the memory of Isabella Blow.

CONTENTS

IMAN

For the cover of my first book, *I Am Iman*, I wanted a photographer who could bring something new to the table, something different from the many thousands of images that had been taken of me since I began modeling in the late '70s. I found the answer was not one photographer but two artists working in perfect tandem—Markus and Indrani. Though it was early in their career, I had seen enough of their work to know that they could produce the transformative image I wanted to strip away all artifice and take me from the "supermodel" Iman that the world knew back into the girl from Somalia that I still was inside. Markus and Indrani succeeded in creating the beautifully raw image I wanted to evoke memories of the past that had taken me to my present.

There are very few photographers in our industry who work as a team, and Markus and Indrani are truly a dynamite duo. As a model, the closest comparison I can draw to their process is how a fashion designer works with their muse to bring a work of art to life. Feeling that synergy of collaboration between photographer and subject is a rare commodity. Markus and Indrani do their research ahead of time and come to each shoot with a vision, one in which they allow their subjects to move freely. From the fashions, to the hair and makeup, to the pose, while working with Markus and Indrani you can almost imagine what will take form. As a muse before their lens you become totally engaged in the artistry of bringing a fantasy to life.

Markus and Indrani elevate the art of photography by producing elevated versions of life. If it's a fashion shot, you can see how every stitch of a garment becomes important. If it's a celebrity shoot they reveal a personal side of those whom the public adores without ever truly knowing them. That's the power of photography.

I have worked with Markus and Indrani many times and have always been excited to see where immersion in their artistic fantasy will lead next. They have proven to have a gift for producing iconic, ever-lasting photos. I am proud to open this glorious assemblage of Markus and Indrani's photography.

FERN MALLIS

Markus and Indrani are a remarkable team, personally and professionally.

Together they have produced some of the most enduring, beautiful, and iconic images of the celebrities of our time. With masterful lighting and imaginative sets and props—and sometimes without any background at all—they manage to bring out something in these people that actually explains who they are. With their images we can visually understand their passion, feel their soul, know what makes them tick, and ultimately what makes them interesting to us. Markus and Indrani provide a peek inside a celebrity's personality. Ultimately, these images sell a celebrity to the public—the person, perhaps even more than the product they are endorsing.

Markus and Indrani have a clear and focused aesthetic which comes from a uniquely collaborative process. When two talented, special people who lived together, loved together, and now work together, come together in a studio or on an exotic location for a few hours or a full day's shoot, they challenge each other to bring on their best shot. They create images that last a lifetime, and that can launch a new scent or sell millions of albums.

Markus and Indrani's body of work over the past eighteen years tells a story of our time, of our culture. This is a worthy "time capsule" for future generations to see what was happening on planet Earth these past couple decades.

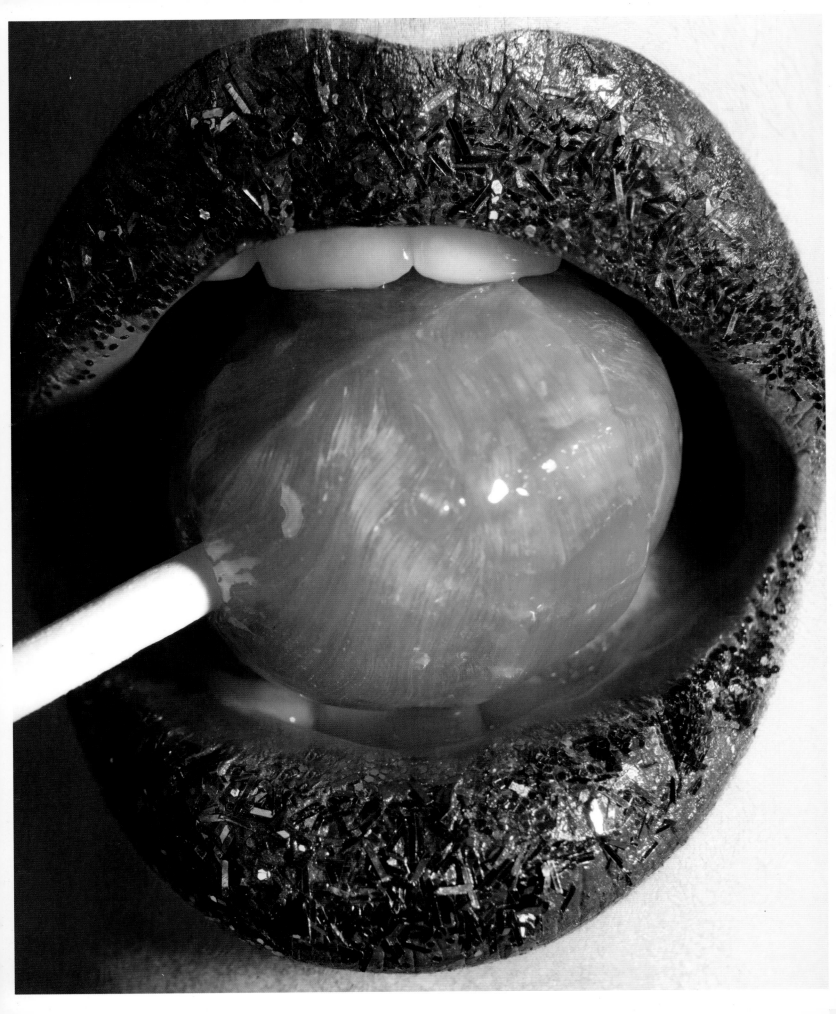

INTRODUCTION

Indrani: "In a world where authenticity is an autograph and reality a genre of TV, our images provide society a mirror to reflect upon its ideals and devotions. We seek to reveal those qualities that make our subjects extraordinary: their personality, aura, beauty, and power. As multi-media artists who embrace collaboration with creative partners' opposing viewpoints, our work embodies a multiplicity of perspectives. We come together through love and communication, collaborating closely with our subjects, to understand them and be inspired by their reality, their fantasies, and artistry. We empower them to move freely through our multiple exposures, which we combine for their truest expression, movement, and being."

As a photography duo Markus and Indrani have a very unique relationship. They often have opposing perspectives and come to shoots with completely different ideas; yet through their creative process, and in collaboration with all of the artists involved, on each shoot they find harmony not only with the images they're creating but with each other. Markus: "It's all about collaboration for us. We find that when we have created an image that we both love from our opposite points of view, that image appeals to the widest audience of viewers. No one is higher than anyone else in terms of the ability to have ideas. We encourage our subjects to experiment and explore their own ideas as well, to reveal their real personalities."

Indrani: "The lens captures a slice of reality in a way that can be symbolic of the whole. I seek to convey reality in a way that is iconic and unforgettable. It's not beauty that really captivates the viewer but connection and communication. I believe that everything in the universe is connected. You can define that connectedness in many different ways depending on your background and your belief system. There are moments when you feel that you connect with the subject of a photograph or film, when you feel you really understand that person. Take, for example, our photo of Beyoncé that was used on the cover of her album *Dangerously in Love*. What struck us immediately about Beyoncé was her amazing charisma and energy that transcends her beauty. Of course it helps to have good physical qualities. This image strongly defined those deeper qualities of Beyoncé, and communicates a sense of her true persona to the viewer, even if they never meet her. We thrive on that familiarity as human beings because we're social creatures. In all of our images we look for that moment of connectedness—the 'divine spark.'"

MARKUS KLINKO

"No matter what, as long as I can walk and have my health, I will be a photographer, and I will put all my heart, soul, and energy into that."

—MARKUS

Winterthur is a small city in Switzerland with a rich cultural history and known for its commitment to the arts. It was there that a young Markus Klinko fell in love with the music of the city's symphony orchestra as well as the French Impressionist collection housed in the local Reinhart museum. Yet Markus never felt that he fit in. "There were two things I realized practically from the minute I was born: One—I didn't belong in Switzerland, and two—I really loved girls." Markus would bring the latter realization to blossom by glorifying women in his photography with Indrani, but the former issue was resolved by launching an international career as a musician from a very young age.

Markus's mother Hedwig, part Swiss and part French-Italian, was the daughter of a successful businessman who made billions in real estate and construction. His father, Albert, was Hungarian and a world-class French horn player whose talent earned him principal seats with the Budapest Philharmonic Orchestra, Toscanini's legendary NBC Symphony of the Air, and later with Zurich's Tonhalle Orchestra. Starting from age three, Markus followed in his father's footsteps as a musician by training to play piano.

Soon Markus became more inspired by Elvis than the symphony scene, so he dropped piano to study the classical guitar, eventually followed by the harp. "By chance I went to a harp concert and found myself thinking, 'That is so much bigger and better than the guitar!' I was completely obsessed with it. My grandfather fully supported my new interest and bought

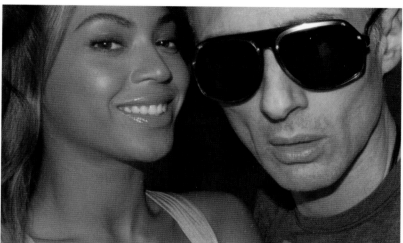

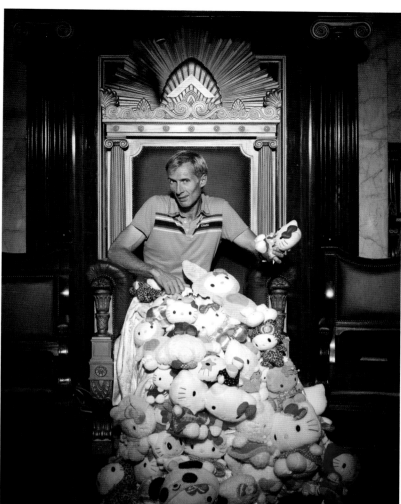

On set with Beyoncé (bottom left), and wearing the dress for Lady Gaga by GK Reid (right)

me my first harp. As a young teen, I already practiced six to eight hours a day—literally until my fingers bled." During his childhood, Markus's musical talents earned him opportunities to play guitar concertos with local symphony orchestras, small solo recitals, and to participate in chamber music concerts. It was the harp that proved to be Markus's ticket out of Switzerland when he was accepted as a student at the prestigious Paris National Conservatory. "There were only two harp classes," remembers Markus. "Each had fourteen students and I was the only guy. It was perfect!"

After living in Paris for almost ten years and completing his training at the Conservatory, Markus took an opportunity to record as a soloist with a chamber orchestra in Dallas, Texas with a French-Scandinavian

conductor he had met during his years in France. That is when things started to happen quickly. "I moved to the U.S. and signed recording contracts, first with Audiofon and soon thereafter with EMI Classics. That was the beginning of my relatively short but intense career as a classical concert harpist."

Managed by Columbia Artists, between the years 1987 and 1994 Markus toured the world as a harp soloist with great success and recorded albums for EMI Classics, often playing the French Impressionist works of such composers as Debussy and Ravel. Noting his chiseled good looks and flair for fashion, the press began calling Markus "the sex symbol of classical music." "In those years I was regularly featured in fashion magazines like *Harper's Bazaar* and Italian *Vogue* sporting suits and

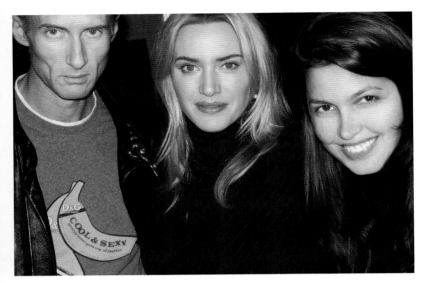

On set with Kate Winslet

ties—a dress code totally at odds with the leather jackets and jeans that are my look now as a photographer."

In the spring of 1994 Markus's career was going strong. He had recently given a recital at the prestigious Paris Opera Bastille and also was just awarded the Grand Prix de Disque for his latest recording for EMI Classics. He was practicing non-stop, preparing for his next tour when the unthinkable happened—he suddenly couldn't play anymore. "I got up one morning, set up the harp, and started my normal practice routine. Suddenly my thumb simply wouldn't move properly. It was a powerful sensation though not painful. It just didn't move right. I was very scared and I didn't know what to think except, 'Let's not think about it. Maybe I just need a break.' So that's what I did, but the next day it was even worse. My thumb would not work properly when playing, yet there was no injury. I got myself to a hand specialist and a neural brain specialist. I saw a few other experts and they all said, 'There's nothing wrong with you.' And yet, I couldn't play. It was really traumatizing.

"For about two weeks I was completely disoriented and didn't know what to do. One day as I was just sitting there, all of the sudden a message popped into my head: 'I want to be a photographer. I've been a musician for so many years and actually achieved my childhood dreams in that career. It's just not meant to be anymore.' Literally from one moment to the next I made up my mind to become a photographer. I knew nothing about photography; it wasn't even a hobby of mine. I bought a copy of Ansel Adams's *The Camera* and devoured every bit of information. I read this tome ten hours a day and wrote down everything in a notebook. After this traumatic experience with my hand I suddenly was buzzing with excitement again. I was literally like a kid with a new toy because I had never even owned a camera up to that time."

Markus's father gave him his first camera, a small 35mm with Polaroid film. In the fall of 1994 Markus bought a store-window mannequin and began playing with a lamp for lighting effects and started taking pictures of the mannequin. "Within a couple of days of using my dad's camera I said, 'That's it. I know I can do this.' I sold my harps and bought over $100,000 worth of photography equipment—and had no clue what to do with it. I just experimented endlessly."

He convinced model agents that he knew from his former career as a harpist, to let him do test shots of models for their portfolios. Markus was in heaven with his new passion for photography and the succession of beautiful models that were being sent up to his Gramercy Park apartment to be photographed.

A week after Markus began photographing models, a model from the Wilhelmina agency was sent to Markus. "The doorbell rang and I opened it and there, wearing a bright green cape, was the most beautiful woman I ever met—Indrani. She came in, we hit it off right away, and essentially she never left."

INDRANI PAL-CHAUDHURI

"To me, being an artist is about capturing the 'divine spark,' that moment of connectedness and inspiration that can transform the viewer. I want to inspire people to be their highest selves."

—INDRANI

The Pal-Chaudhuri family were Zamindars, the rulers of a large area of Bengal, India. "Three hundred years ago, my ancestor Krishna Panti was a merchant who lived in a mud hut. He became legendary for rising to become one of the most powerful and wealthiest men of Bengal, through hard work and honesty, winning the trust of all."

The Pal-Chaudhuri family built themselves several palaces, and gave back to the community by building many temples, hospitals, and schools. "With their vast wealth, some of my ancestors lived decadent lives of ease. Others, like my grandfather, devoted their lives to charity and meditation. My father, Ajay Pal-Chaudhuri, went to monastic school and moved by the poverty he saw around him, he became the first in the family to pursue a profession, as a Chartered Accountant in England."

There he met Indrani's mother, Greta, and together they returned to India, where they lived glamorous lives. Greta dedicated twelve years to working with charities in Calcutta, and it was there that their only child, Indrani, was born. Indrani's parents forbid her to watch films or TV, and sent her to a Catholic convent school, but taught

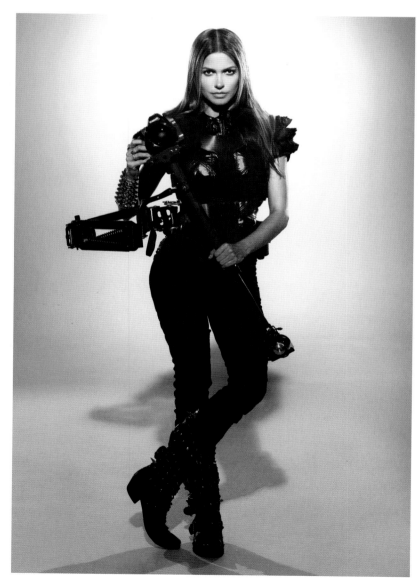

her about all religions and art. "They wanted me to understand the value of spirituality and creativity from all approaches, and to value those differences.

When Indrani was seven years old the family moved to England, then Canada, so Indrani would have more opportunities. "I had a hard time there. It was total culture shock, far from the beautiful world I knew. I never felt I 'fit

was four inches too short to fit the standards and her Indian background made her too exotic for most clients, but she studied lighting and motion and excelled in front of the camera. "It was amazing because I got to be in the center of photo shoots and commercials and see everything that went into each. I'm very grateful for all the talented people I got to work with who shared their

On-set for *Flaunt* magazine with agent Jorge Perez (left)

Clockwise from left: GK Reid, Armie Hammer, Jessica Stroup, Luis Barajas, and Indrani

in' in Toronto any more than I did in England so I dreamed of traveling the world. I took refuge in my studies—but my biggest passion was photography. I was fascinated by the glamour of fashion magazines that reminded me of my previous life in India, and I was determined to learn about photography and filmmaking."

Indrani went to a photography studio in Toronto and asked if she could assist. The photographer looked at her skinny fourteen-year-old frame and laughed at the thought of her carrying heavy lights around; he suggested that she become a model instead. Indrani thought that it could be a great way to learn about photography so she took a course and learned how to be photogenic enough to land a modeling agency. She

knowledge with me. With money from my first modeling job I bought a camera and started taking pictures everywhere. I didn't have the confidence then to spend time looking through them or printing them. I just took pictures obsessively."

Indrani used modeling opportunities to travel around the world, including to Athens, Tokyo, Münich, Milan, Paris, Barcelona, and Thailand. With boundless energy and a fearless spirit, Indrani didn't mind being on her own as a teenager. Most significant of these travels, Indrani returned to India. "I grew up with an idealized memory of my childhood there. I finally made it back when I was eighteen and I saw just how desperate many people's lives are, and it really shocked me. I decided to start a school

called Shakti Empowerment Education (SEEschool.org) with my father. I put all my modeling earnings into it, and then that became the backbone of everything I was doing. My father moved back to India to co-direct the school while I continued working to support it."

In the early 1990s Indrani modeled, did photography, and spent a lot of time in ashrams, conflicted about her path in life. "I was inspired by Vedanta and Swami Vivekananda in England, then went back to India and spent two weeks with a great spiritual teacher, Swami Bhuteshananda, the ninety-eight-year-old president of the Ramakrishna Vedanta Mission, who gave me my mantra. From a very low point I came into what I still look back on as the best time of my life. I had been wandering the world and absorbing as much as I could. My spiritual experiences helped me to realize that I was absorbing and learning on a very superficial level, and what I really wanted to do was find deeper truths and start to create. I realized that art is one of the most powerful forces to help people connect to their higher selves and be inspired to create, whether they're artists or not. We're all creators in some way. We create life and the world we live in. We create meaning for others. We create happiness. I believe great art helps people to be more positive and bring beauty into the world themselves."

Shortly after this revelatory experience in India, Indrani went to work in New York for the Wilhelmina Agency. She also applied to Princeton University and in this process she looked at her own pictures for the first time. She submitted a portfolio of her photography along with the application and continued modeling. Then one fall day in 1994 she was sent for test shots with a new photographer named Markus Klinko.

Indrani with her father Ajay Pal-Chaudhuri and some of their students at SEEschool.org in Bengal, India (photo by Markus Klinko)

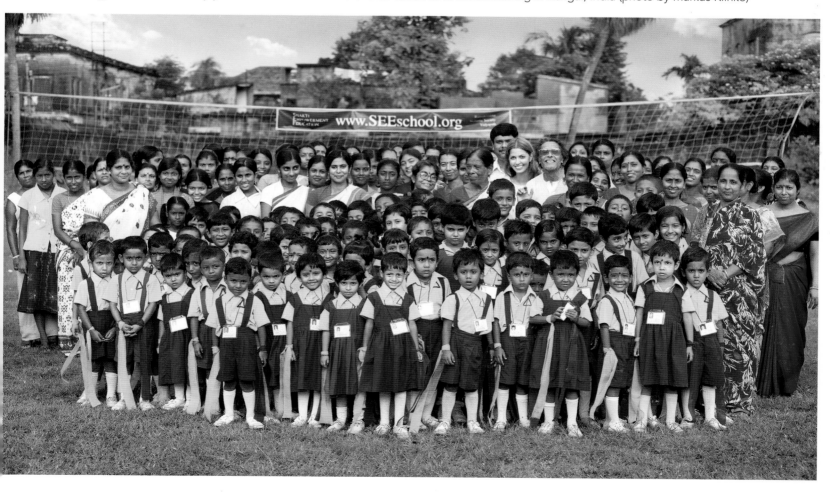

MARKUS + INDRANI

Markus + Indrani the day they met

Markus and Indrani came together at critical times in their lives from very different worlds and experiences. Indrani had been passionate about photography since childhood but was too shy to share with anyone the countless images she took over the years. Making peace with the mysterious, never fully diagnosed hand issues that forced him to abandon his successful concert and recording career, Markus had now become driven to become a professional photographer only two weeks before they met and was brimming with both ambition and confidence.

That "divine spark" of connectedness was immediate between Markus and Indrani the day they met. "He started showing me his portfolio. I was super-shy at the time. I don't know how I had the confidence but right away I started telling him what he could've done differently. Markus didn't mind; he was so eager to experiment. That night I went home and told my roommate that I'd just met this guy, and that it was really strange but I felt like we'd

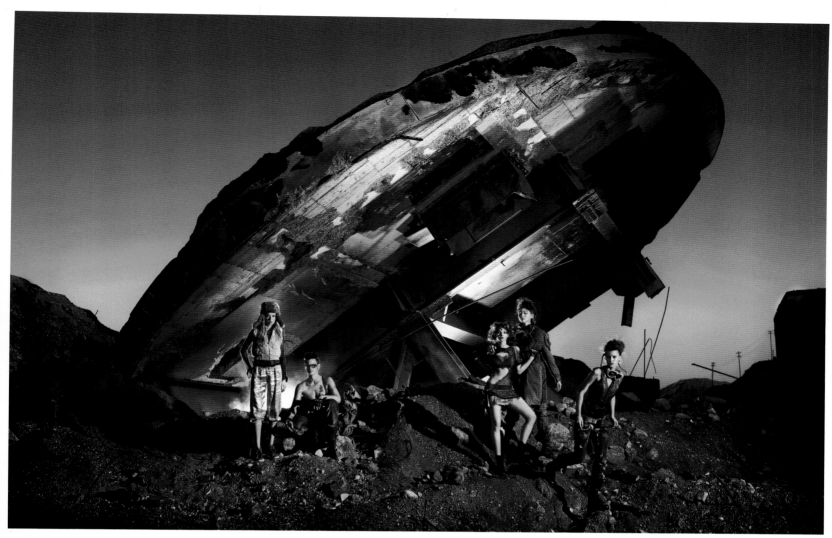

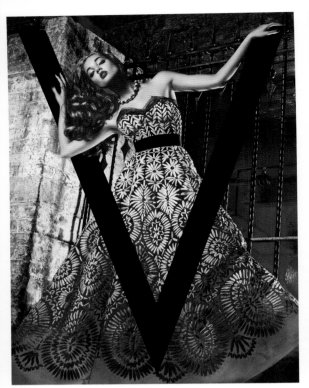
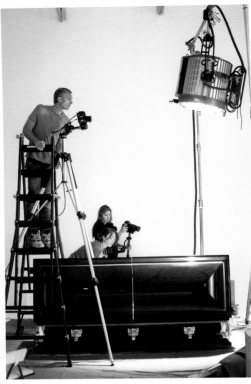

always be best friends. There was an instant connection even though we were completely opposites. I never really had a focused goal. I wanted to go to college and figure it out there. Meanwhile, Markus was so goal-oriented. I wanted to be a photographer too, but I was afraid that I'd never make enough money to support myself and my school in India. I was fearless in other ways—I had traveled around India with a little dagger around my waist and $100 in my pocket—but pursuing the arts as a career seemed very impractical. I thought I should go to college and become a scientist or writer." Indrani's perspective changed after she met Markus. She was accepted into Princeton but deferred for a year to pursue photography and Indrani and Markus became a couple both romantically and professionally.

The two intensely experimented with their photography and began landing small jobs. They lived and worked in Miami and Paris for a year and a half. On early photo shoots they developed an understanding that two heads are better than one. Markus: "At that time I learned a lot about photography and Indrani was my creative partner. But we weren't officially called 'Markus and Indrani' for

some time. She was still modeling and we were very much in love and she just worked with me on that basis with all her passion and dedication.

"In Paris we met with technicians at a digital retouching company called Media Cryptage to discuss a colorful, hyper-real look we wanted to achieve. At that time there were, of course, existing forms of retouching on traditional prints and some limited possible manipulations in the dark room, but these were the days before methods of computerized retouching were widely used. That meeting set in motion the course of what would become our signature photographic style. Media Cryptage became our post-production partner and we created cutting-edge, futuristic editorials that got people talking. We learned so much from the experience. Indrani, who is gifted with an incredible eye for detail, soon became an expert retoucher herself." After a successful time in Paris the couple moved back to New York, where they could continue their work and Indrani could begin her studies at Princeton University.

Between the years 1995 and 2000, Markus and Indrani primarily photographed models for advertisements and

magazine editorials. They also shot pin-ups for British *GQ*, some early ad campaigns, and gained the attention of top magazine editors such as Ingrid Sischy of *Interview* and Isabella Blow of the *London Sunday Times*.

Isabella Blow was a great champion of Markus and Indrani's work and influential in steering them into a course of high-end fashion photography. Soon stylist GK Reid became an integral part of their work. Indrani: "GK was the first stylist we ever worked with to really bring a dynamic energy about what people are doing in fashion, and he always finds a way to make the fashion work within the context of our image." Markus: "We loved working with GK instantly. He became our closest friend and still works with us not just as a stylist but as a true artistic collaborator."

With essential elements of Markus and Indrani's process coming together, they were ready for their first major iconic photo shoot. Supermodel Iman had seen their portfolio and wanted them to shoot the cover of *I am Iman*, a collection of the greatest photographs of her career. Iman's husband, rock-and-roll legend David Bowie, witnessed their work on set and asked Markus and Indrani to shoot the cover of his upcoming album, *Heathen*. Indrani: "We were thrilled to work with Bowie. He was very unpretentious, very friendly, and very hands-on—such a dream to work with." These breakthrough collaborations instantly put the duo among the upper echelons of celebrity and fashion photographers.

In the midst of this activity Indrani commuted two hours to Princeton three days a week. In her time at the prestigious university she re-established classes in Sanskrit, spearheaded the student initiative for a program in South Asian Studies, and graduated with a Magna Cum Laude (High Honors) AB degree in Cultural Anthropology.

Markus and Indrani's relationship shifted from romantic to best friends. Indrani: "It's very hard to be in a relationship when you're working twenty hours a day together and living in the place where you work—our studio in Soho. The best way to preserve our relationship was to create some distance. I feel that our relationship only grew stronger. We became better at expressing our different perspectives and came to understand and love each other as people on a deeper level. We can say anything to each other and don't have to edit. It makes for a dramatic, explosive conversation style sometimes, which of course is what the TV cameras later captured on our show *Double Exposure*." Markus: "Our romantic split was an organic development. There wasn't a great feeling of sadness or sudden breakup. We never stopped working together and continued to spend so much time together."

The momentum of Markus and Indrani's career continued. They met one of their favorites muses, Beyoncé Knowles, on a shoot for Destiny's Child. Markus: "After that everyone called us to shoot all-girl singing groups for both album covers and editorial shoots. Between many other album covers, editorials, and some other major commercial ad campaigns in this period, our work gained greater worldwide visibility.

"Another milestone in our photography was our transition from film to digital photography that started in 2002. Up to that point, not only did we only shoot with film that needed to be processed first and then scanned into a digital format, our overall style up to then was very statuesque. One day in early 2002 I was given a revolutionary new digital camera. We had just shot a huge campaign for Skyy Vodka in Los Angeles at the time. I stayed in a cottage at the Chateau Marmont for a couple weeks and had agencies send over models to shoot a personal series of 'nudes' with this new digital camera. It was basically a repeat of my mannequin experience when I first decided to become a photographer. I was determined to experiment again.

Back in New York I showed Indrani and she agreed this was a breakthrough. The images were fluid and full of movement. They didn't look anything like what we had ever done before."

personalized and "tricked out" custom version of this famous workhorse camera. His camera became known as the "Mammoth Cam" due to the special hand-carved Mammoth ivory handgrips he developed. They also built

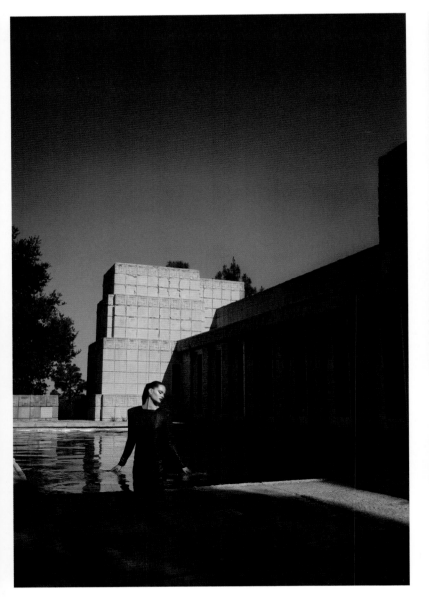

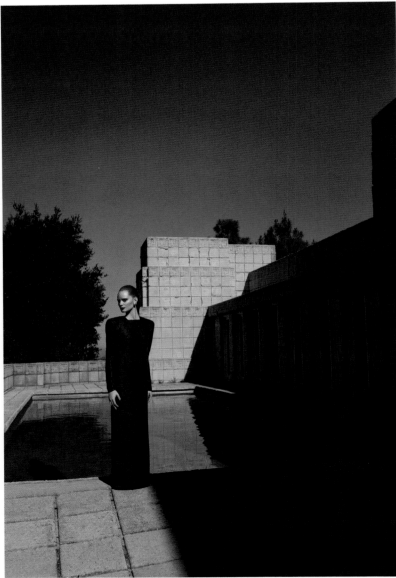

These early experimentations with digital photography eventually led Markus and Indrani to abandon film completely for all of their work. Markus also became obsessed with ideas of re-designing the classic Mamiya RZ camera. During 2004 and 2005 he developed a highly

many long-lasting relationships with industry-leading equipment manufacturers and photography magazines.

From Ziv Argov (Director of Marketing at Mamiya Leaf): *"We have been working with Markus Klinko and Indrani since they left film for digital with their first Leaf digital*

back, the 22 MP Valeo 22, back in 2003. Since then I've been watching in wonder as this dynamic duo have developed their unique image look to leverage each and every detail available. Over the years we've collaborated

iconic photographs of some of the most famous and glamorous people in the world. Markus and Indrani don't rely on a formula that uncomfortably molds their subjects into a look. Instead, they work with the person in front of

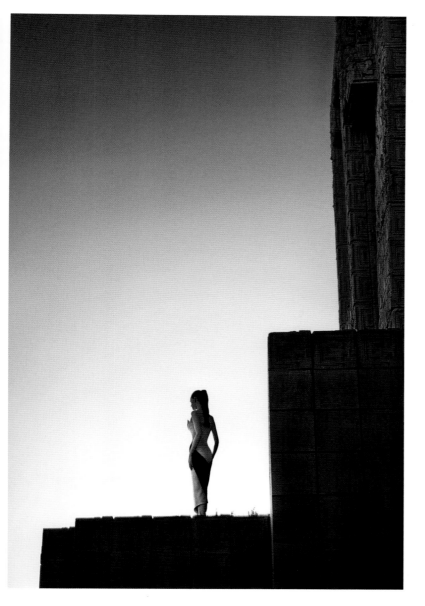

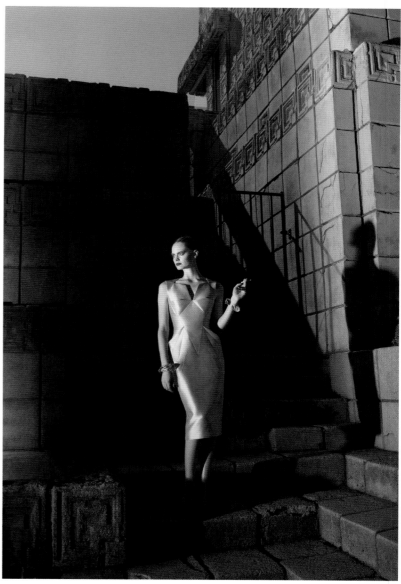

closely, as their powerful shots truly showcase the capabilities of our products."

From Christopher Robinson, Editor-in-Chief, *Digital Photo Pro*: Markus and Indrani's work is always crisp, sharp, and flawless. They are perfectionists who create

the lens to create the perfect photograph.

"Since I first came to the work of Markus and Indrani, the single word that comes to mind when I think of their approach to photography and their images is 'perfection.' Speaking with Markus about his custom camera, he

describes his need to have the sharpness and resolution with the sort of fervor one equates with a scientist looking at cellular structures more than a fashion photographer. That quest for perfection is ingrained in every image."

Markus and Indrani's famed cover shoot for Beyoncé's debut solo album, *Dangerously in Love*, followed. "That image literally changed our lives almost overnight. Clients began requesting shoots similar to Beyoncé's. That photo also opened the door to the cosmetics market for us in a major way because Beyoncé signed with L'Oréal Paris shortly after and requested us as her photographers." Many more record covers followed. Among them they shot Mariah Carey for the cover of 2005's best-selling album, *The Emancipation of Mimi*. Mariah then hired Markus and Indrani to shoot her tour promotions and her *Playboy* magazine cover. This lucrative and prolific period was also marked by memorable shoots with Mary J. Blige, Jennifer Lopez, Britney Spears, Kate Winslet, and dozens of other celebrities.

Over the course of their career people always noticed the unique and fascinating dynamic between Markus and Indrani and how they come together to create images as unique artists with strong and often divergent opinions. They often heard, "You two should be on TV." Markus: "When *America's Next Top Model* started we were asked to appear as photographers on the show. Then *Project Runway* came out in 2006 and all of the sudden fashion on television became kind of 'cool.' There was talk that Bravo wanted to do a photography-based reality show. Our agent called us and said 'This is perfect for you guys.' The time seemed right and we got excited. We filmed a sizzle reel and presented it to IMG's TV department and they immediately showed it to Bravo. However, that was followed by over eighteen months of painful back and forth negotiations before the show was finally green-lit by the beginning of 2009."

The TV series, titled *Double Exposure*, began filming in April 2009, when Markus and Indrani presented "Icons," their first major solo exhibit, at the Pacific Design Center in Los Angeles. More filming followed over the next few months, capturing shoots with the likes of Naomi Campbell, Lady Gaga, and Dita Von Teese. *Double Exposure* premiered in 2010 and aired for a single summer season. It was an experience the duo looks back on with mixed feelings.

Indrani: "The show missed the great support that Markus and I have for each other, GK, and everyone we work with. I thought Markus turned out to be a natural on camera. He doesn't edit himself and is very outgoing. It's possible to make that a disadvantage though because when you take all that enthusiasm and exuberance and cut it together you don't get a full understanding of who Markus is—that he was constantly joking around, playing with over-the-top self-parody, and generally having fun with it. Meanwhile, GK and I

came across as much more guarded. What I cherish about the experience is that it helped me to learn a lot as a director and to gain an understanding of the editing process."

Markus: "I wish the series had shown a lot more of our creative and work processes and far less of the silly, exaggerated drama that the reality producers pushed for so hard. I think we were made to come across as kind of out-of-control train-wrecks who got some good shots purely by accident. What's great though is that the show got a huge international pickup, in over one hundred countries like Russia, Australia, Canada, South Africa—the whole world. But I'm never going make the mistake of losing focus on our core business again. No matter what, as long as I can walk and have my health, I will be a photographer, and I will put all my heart, soul, and energy into that."

Indrani: "The rest of that year was very exciting because we did several big charity projects. In the forests of Congo I filmed a charity campaign for the UN's Nothing But Nets with Mandy Moore. And together Markus and I photographed and filmed dozens of celebrities for the 'Keep a Child Alive' campaign, which won two gold lions at Cannes. It was on that project that we became friends with Daphne Guinness, who became a wonderful muse for us."

While shooting still images of Guinness, Indrani began directing a film as well. The results of Markus and Indrani's shoots with Guinness were a series of high-fashion photos that were published around the world and Indrani's first short film, *The Legend of Lady White Snake*, which premiered as part of a private exhibition which also showcased a selection of Markus and Indrani's photographs of Guinness. The images and previews were featured in the celebrated Fashion Institute's Exhibition Daphne Guinness, and they became an ad for Barney's

famed window display of Daphne preparing for the Met Ball. Indrani's film met with great critical reception and earned many awards at the La Jolla Fashion Film Festival at the Museum of Contemporary Art San Diego in 2012, including Best Director, Best Cinematography, and Best Picture. Indrani is now represented by Aero Films as a commercial director, and often directs commercials alongside stills with Markus.

Markus: "From 2001 to 2012, a relatively short time in a photographer's career, I feel that Indrani and I achieved a great deal. We wanted to encapsulate that in this book and continue on the path of new career milestones that we see ahead. Our photography keeps evolving. We continually step out of our comfort zone and explore new techniques, new ideas, and ways of communicating a story though the camera. We're extremely excited about what's to come next."

ANNALYNNE

MCCORD

Markus and Indrani shot actress Annalynne McCord for *Cosmopolitan* magazine. Markus: "We thought Annalynne had an all-American look, so our concept was a tongue-in-cheek reference to American icons. We made the shoot an homage to Madonna in the early '80s, who of course in those days was a walking homage to Marilyn Monroe. Annalynne was very attractive and personable, and she clearly has impeccable taste, saying, "You guys are the most stylish photographers I've ever met!'" *Cosmopolitan* originally ran this photo in color, but Markus and Indrani prefer it in black and white.

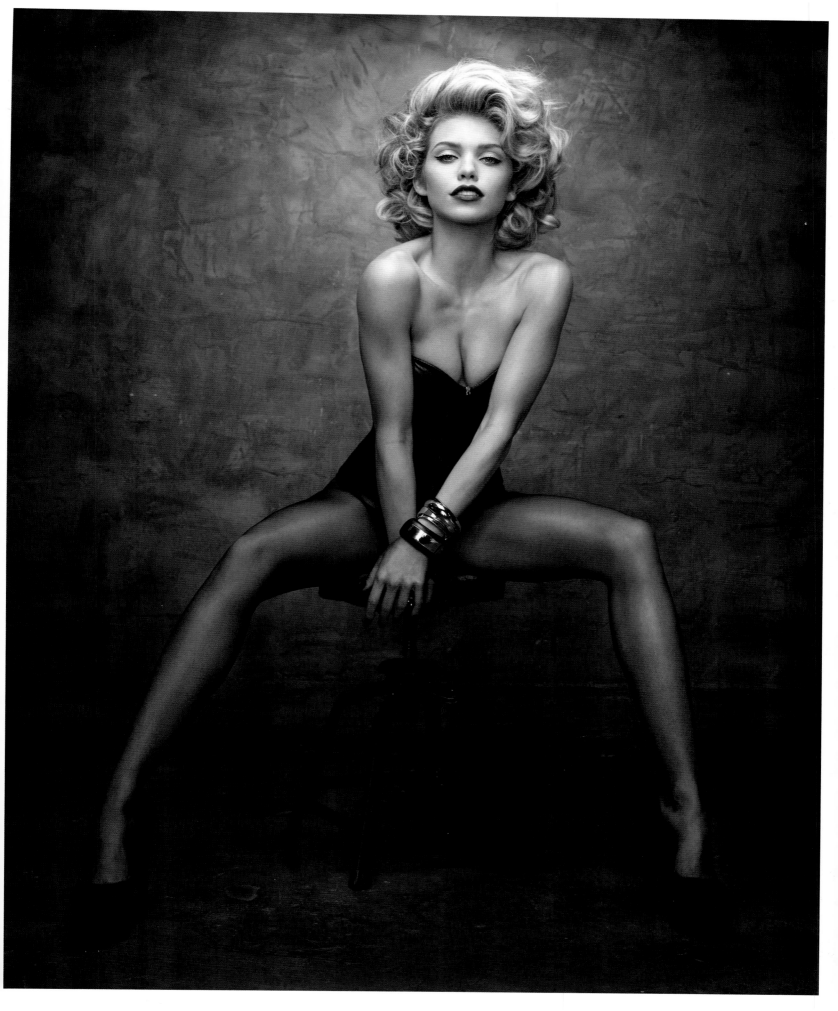

ANNE

HATHAWAY

"When Anne came to the studio we instantly felt her warmth and friendliness," recalls Markus. "But we recognized other qualities as well," adds Indrani: "Her complexity, inner strength, and flair for fashion hadn't yet been revealed to the world." This was the shoot that initiated Hathaway's transformation from cute teen star of the *Princess Diaries* into the sexy, fashion-forward icon that emerged with the *The Devil Wears Prada*, which premiered less than a month after this shoot took place.

Markus and Indrani were eager to explore different aspects of Anne, and in doing so, they also stretched themselves, inspired by some of their own history. This was the last photo shoot in their Soho studio, which also doubled as the duo's home for eight years. It was where they had built their careers, and transitioned from a couple to best friends. They shot in previously private areas of their home, trying different angles and lighting, seeing it with a fresh eye. Anne was open to it all, from shooting on a ladder to the kitchen and surrounded by the mirrors of the bathroom.

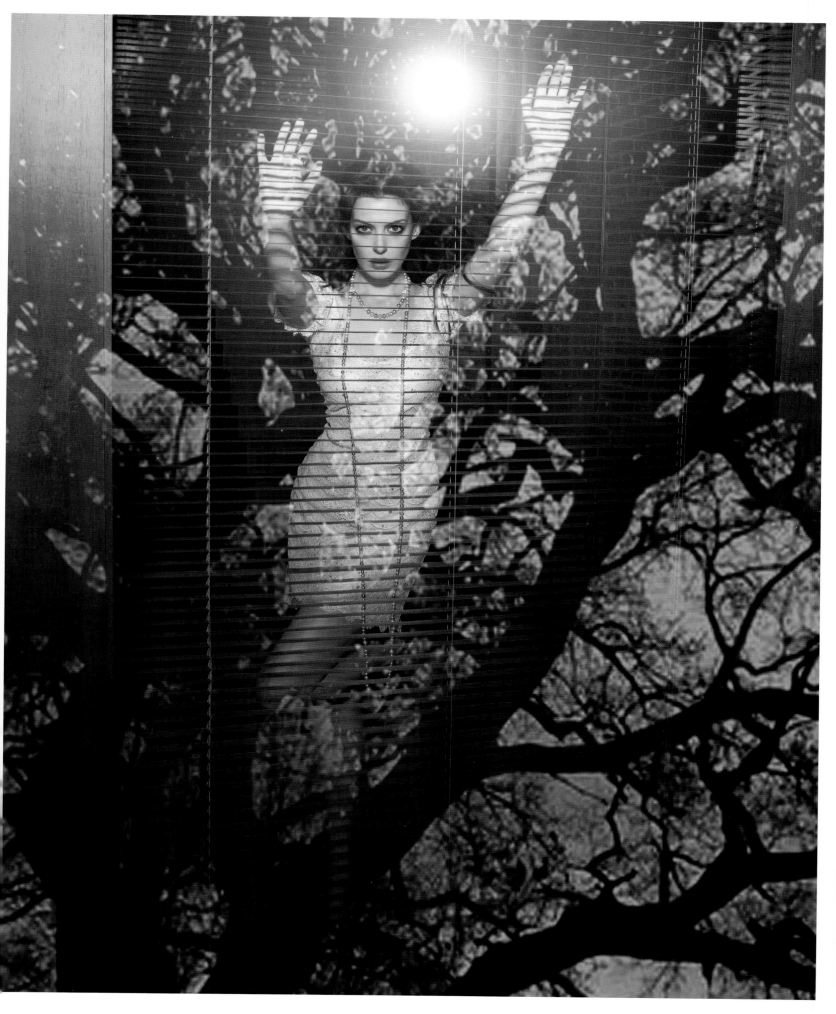

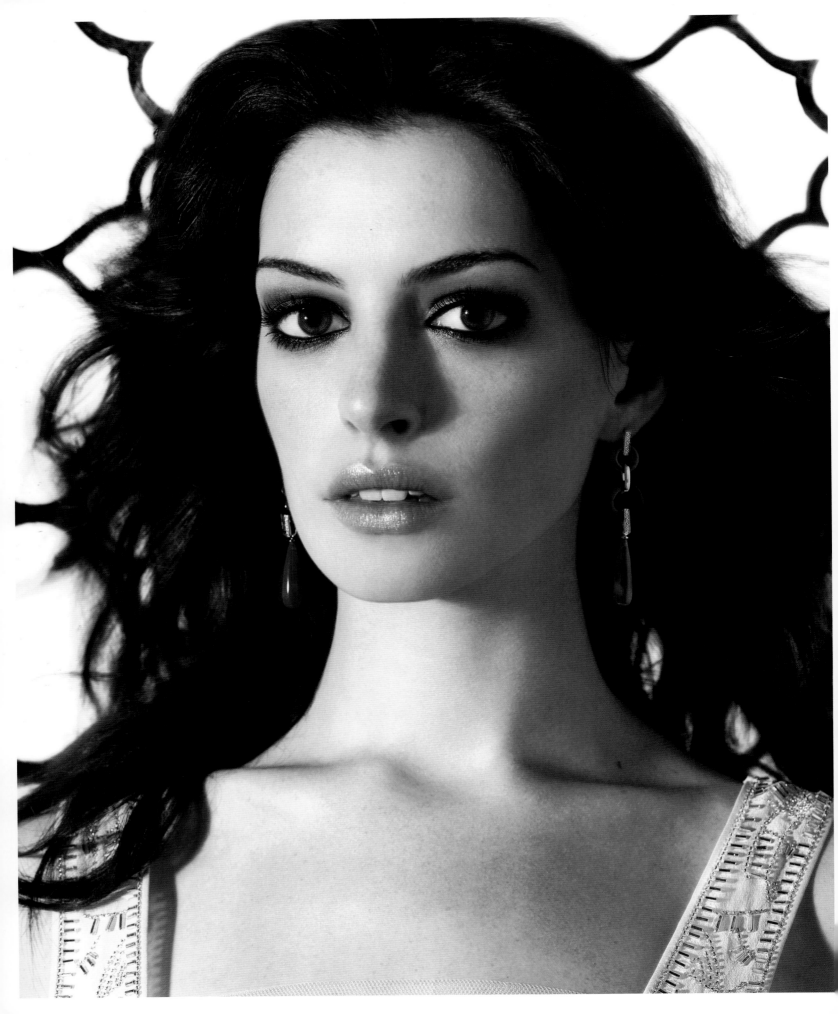

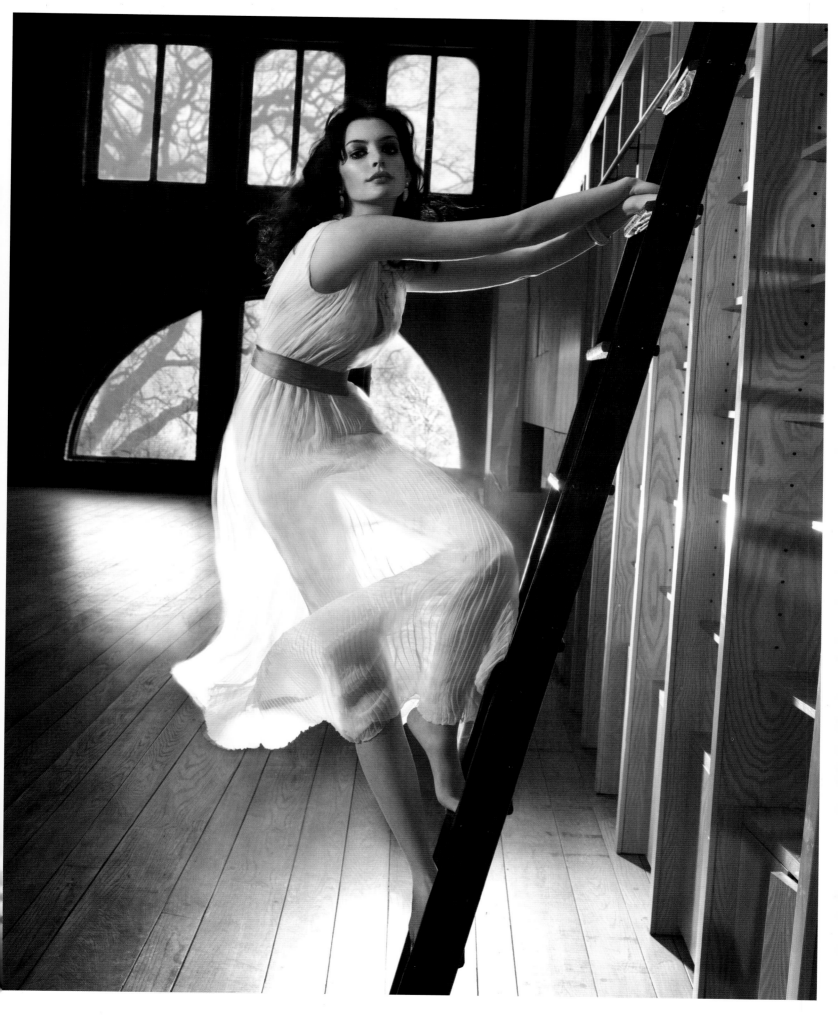

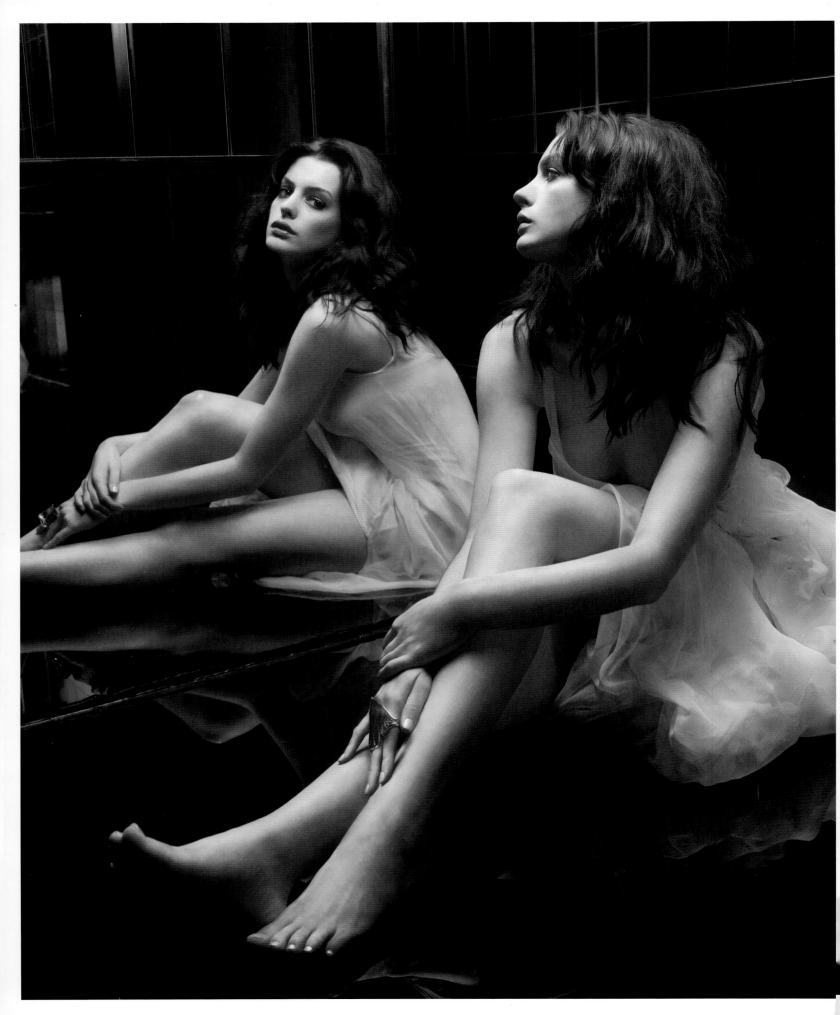

As is often the case, Markus and Indrani see the shoot from different perspectives, and their thoughts on why they love a certain image are equally valid and insightful. Perhaps influenced by the fact that it was the last shoot in the studio in which he and Indrani shared so much history, for Markus the photos of Anne Hathaway are "Ethereal and have a touch of melancholy." For Indrani they "show a strong woman coming into her own in a new and exciting way, reflecting on the process of her own transformation." However one looks at it, together they produced a truly intimate and unique look at one of Hollywood's most luminous and talented actresses.

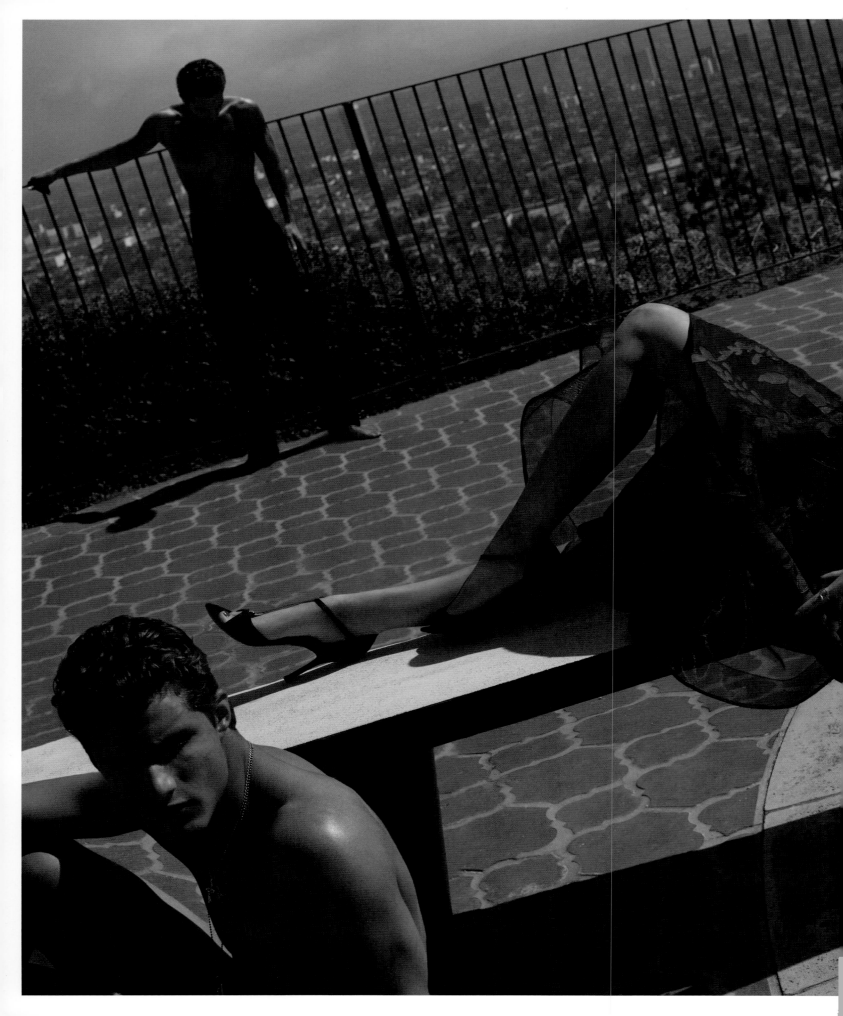

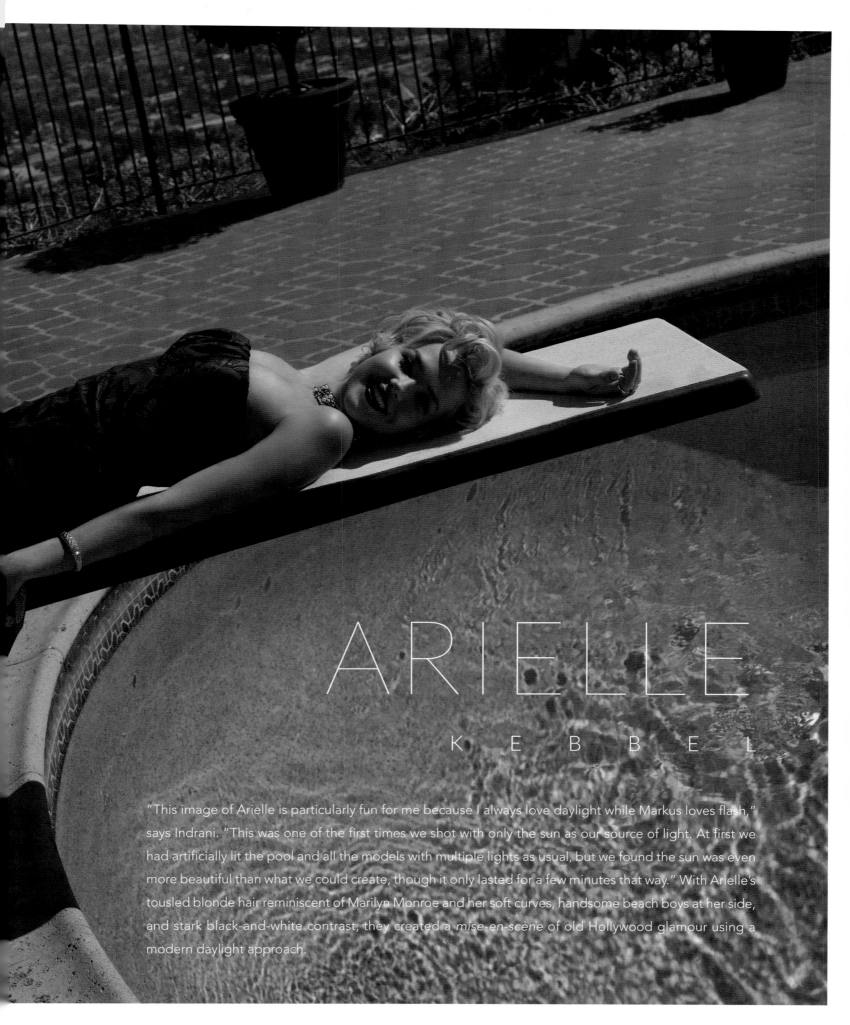

ARIELLE
KEBBEL

"This image of Arielle is particularly fun for me because I always love daylight while Markus loves flash," says Indrani. "This was one of the first times we shot with only the sun as our source of light. At first we had artificially lit the pool and all the models with multiple lights as usual, but we found the sun was even more beautiful than what we could create, though it only lasted for a few minutes that way." With Arielle's tousled blonde hair reminiscent of Marilyn Monroe and her soft curves, handsome beach boys at her side, and stark black-and-white contrast, they created a *mise-en-scène* of old Hollywood glamour using a modern daylight approach.

ARMIE & JESSICA
HAMMER STROUP

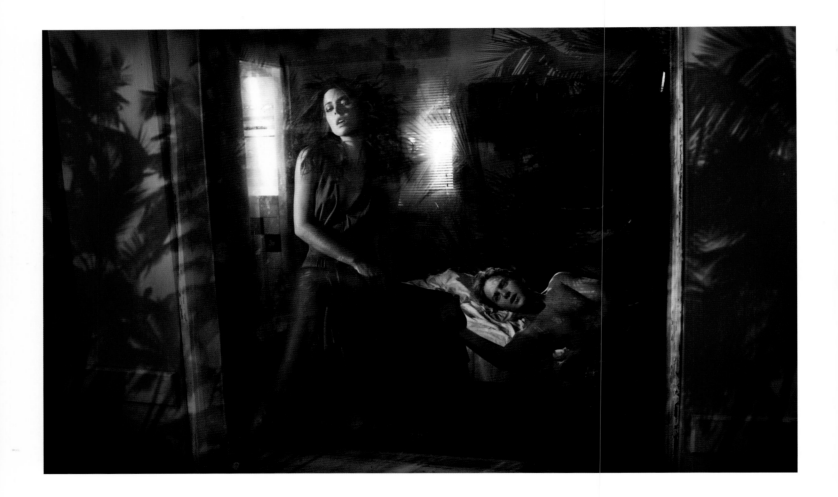

This fashion shoot with *90210* star Jessica Stroup and *The Social Network*'s Armie Hammer was prominently featured in episode two of *Double Exposure*. "*Flaunt* magazine wanted the shoot to be very sexy," says Markus. "So we came up with the theme of Bonnie and Clyde. Not the criminal element; the idea was to portray them as a sexy couple on the run, hunted by police." The main setting was a diner and things really got steamy when they set Jessica up on the counter, Armie's shirt came off, and the star subjects began simulating the passion of a pair of lovers with nothing to lose. They were able to conjure up the necessary emotional intensity in spite of the large crew and entourage that were present on set.

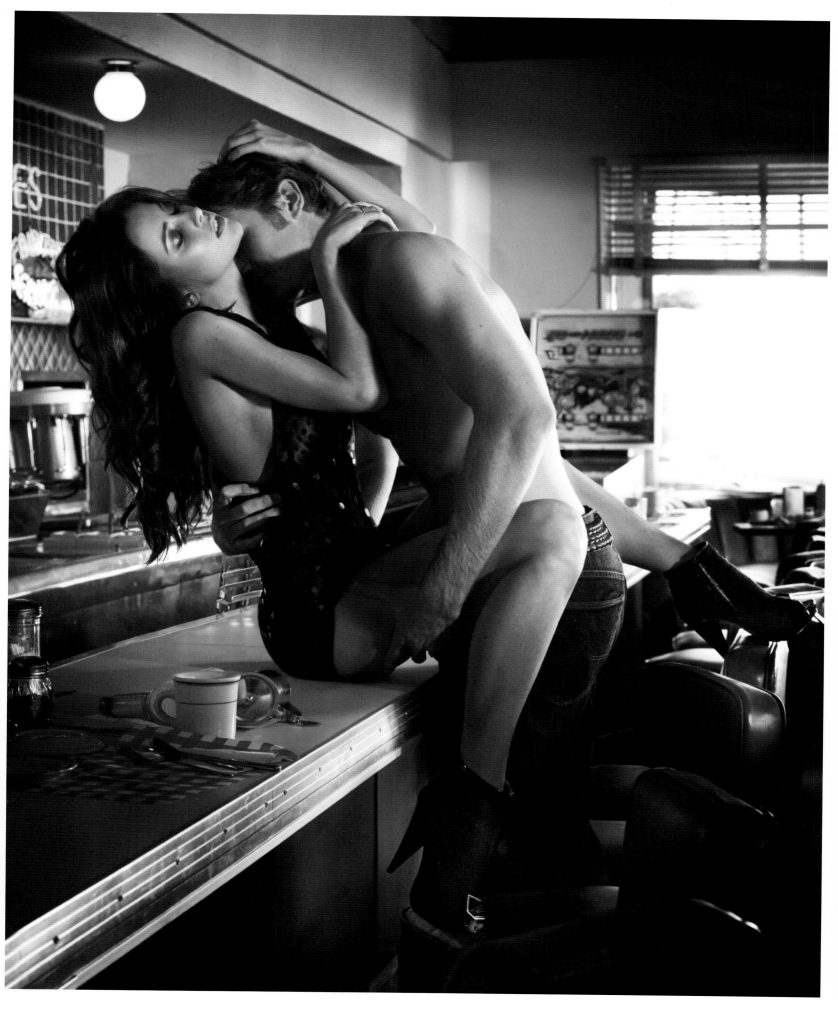

AURORA
S N O W

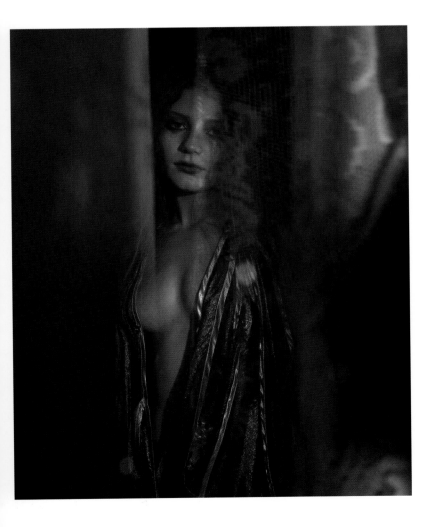

Markus: "I was fascinated by Aurora Snow's beauty and eager to photograph her." Indrani: "I was intrigued by her innocent energy, like a little wild deer. She's smart and quick, but there's also a very vulnerable quality to her and something ethereal—almost ghostlike." Always unconventional, the duo shot her fully clothed in high fashion, in direct contrast with the way she's usually seen, as an adult film star.

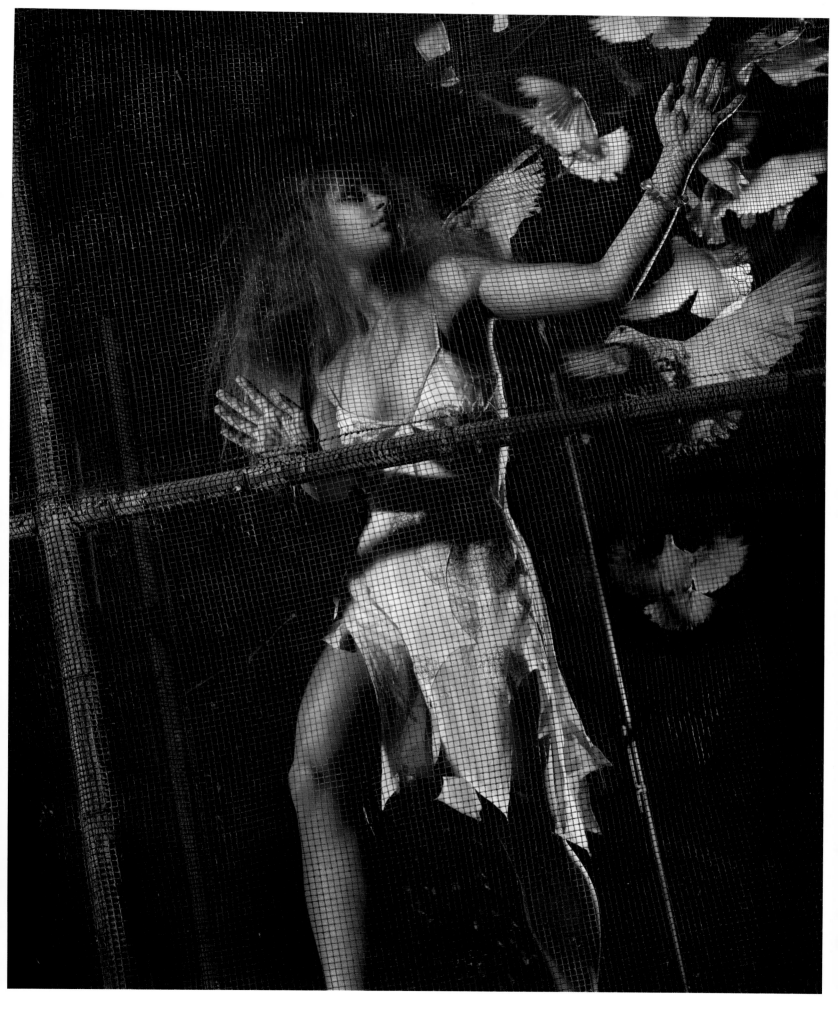

BEYONCÉ
K N O W L E S

Markus and Indrani have worked with Beyoncé many times throughout her career. They were enlisted to shoot the singer's debut solo album, *Dangerously in Love*. This was a defining moment in Beyoncé's career and she needed nothing short of an iconic image to establish her persona as a solo artist. It had to be authentic to Beyoncé but also a transformative shot to carry her into this new phase of her career. Markus and Indrani had photographed her years earlier, when she was starting out as a member of Destiny's Child, so she had established a trust with the duo. The photographers decided they wanted to give Beyoncé a celestial look to enhance her natural luminescence and emphasize her star quality.

Indrani recalls, "Among Beyoncé's wardrobe options was a bejeweled top that seemed challenging because the rocks weren't as sparkly as her personality, but we convinced the team that it could be enhanced with lighting and post-production." For the bottom half of the look, Markus thought jeans would be perfect—a shame she hadn't brought a pair. Beyoncé thought it was a great idea, and didn't hesitate to say yes when Markus came to the rescue by saying, "Just wear my jeans."

The result of the shoot was a glittering, unforgettable photograph of one of the world's leading musical sensations. *Dangerously in Love*, featuring catchy hits like "Crazy in Love" and "Baby Boy," debuted at number one on the *Billboard* charts when it released. It earned Beyoncé five Grammy Awards and has sold more than eleven million copies worldwide to date.

As for Markus's jeans, Beyoncé returned them the next time they met at a shoot almost a year later, clean, folded, wrapped in tissue paper, and with a thank-you note attached.

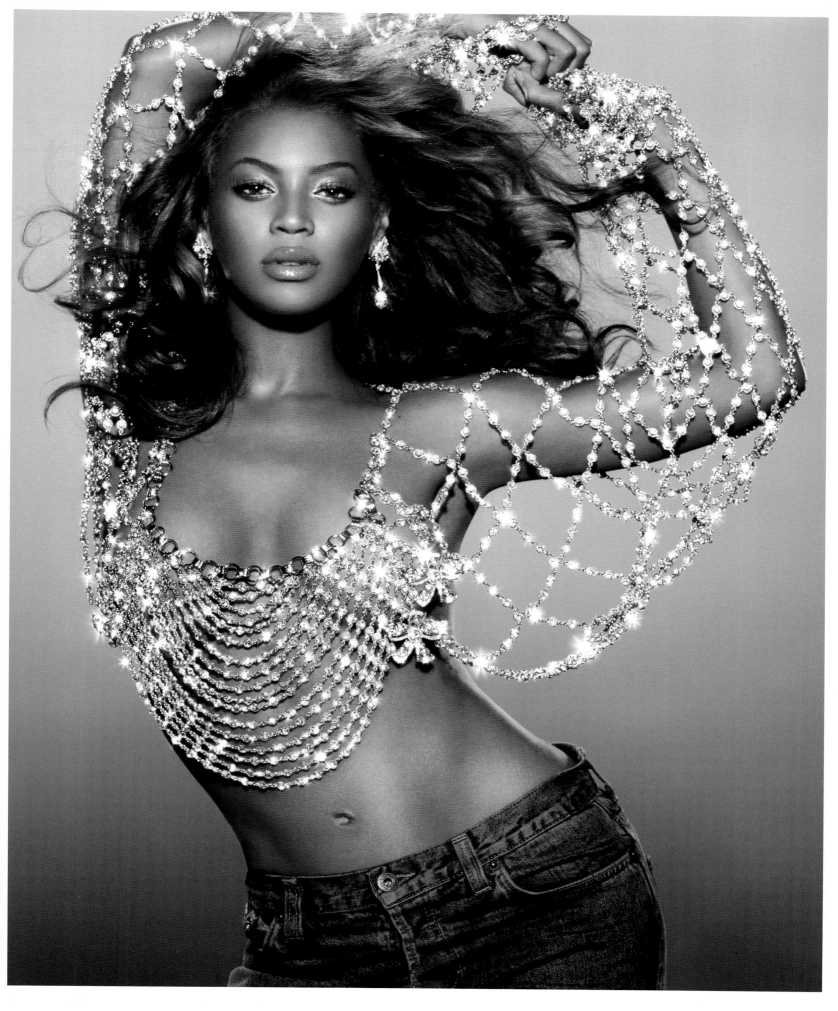

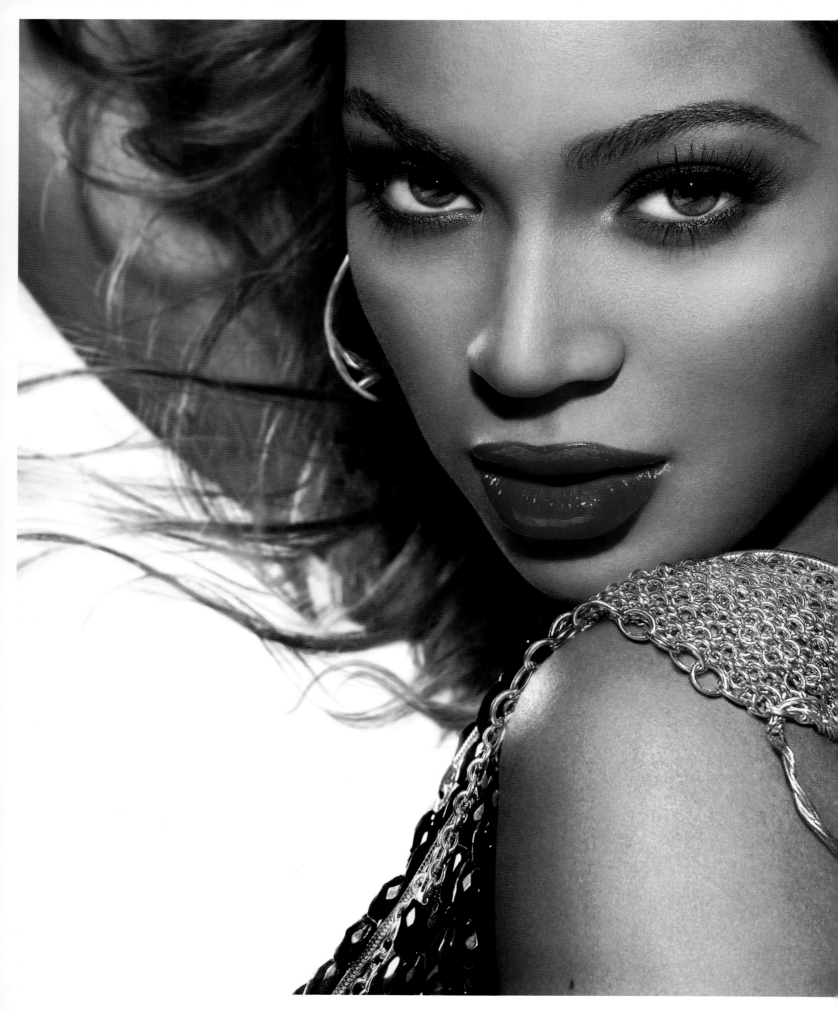

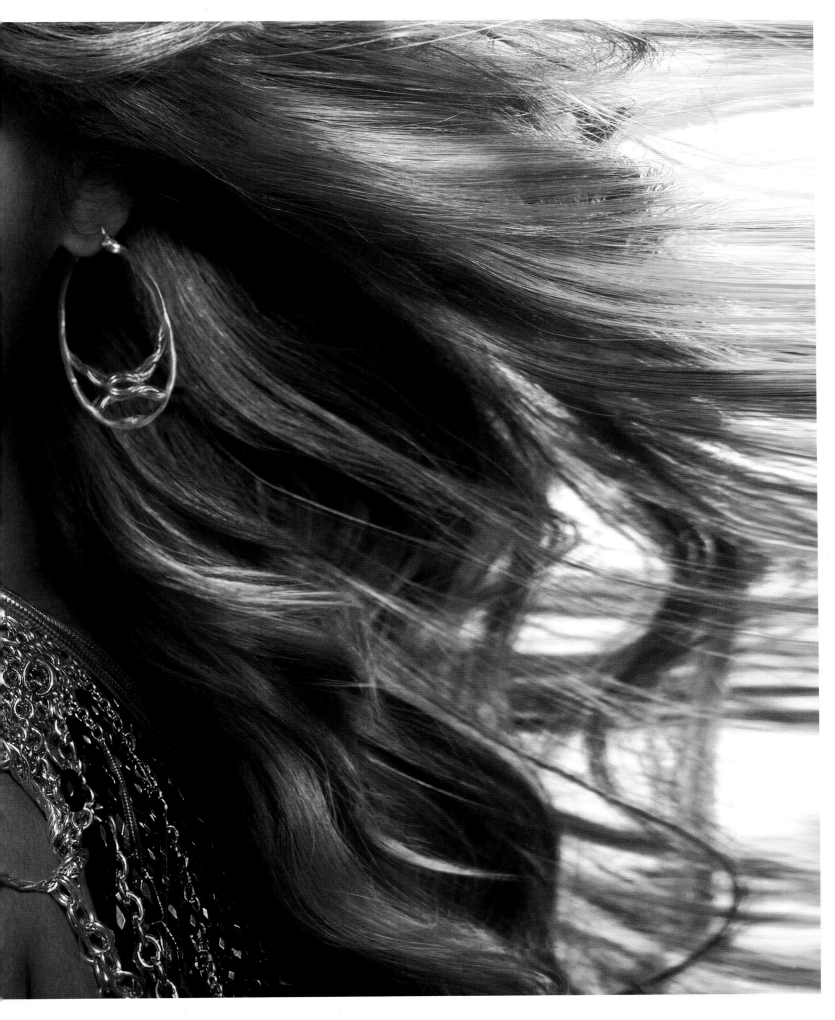

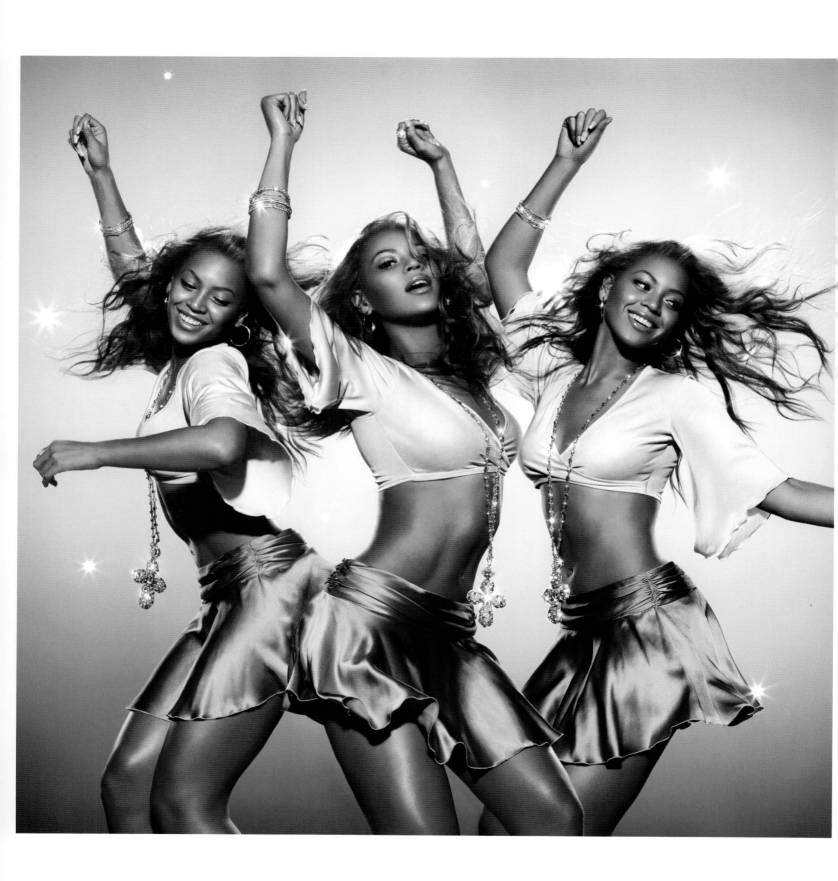

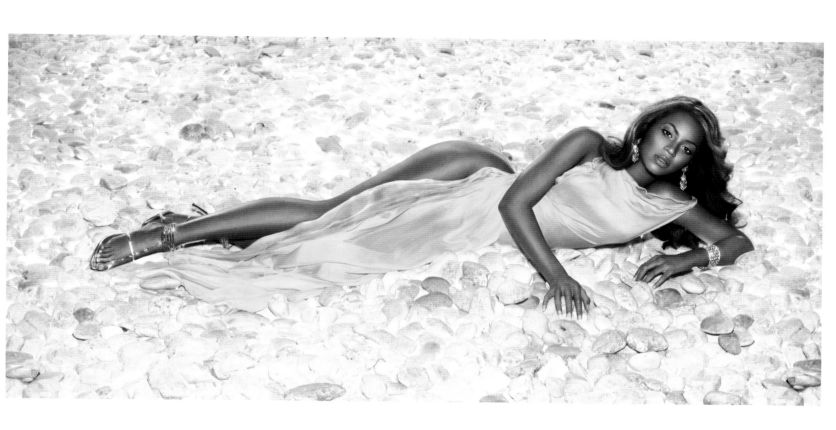

Markus and Indrani also shot Beyoncé for many L'Oréal Paris cosmetics and hair campaigns. After the cosmetics company signed Beyoncé, she asked them to work with Markus and Indrani. This was the start of a long and highly successful collaboration between L'Oréal Paris and the photography duo.

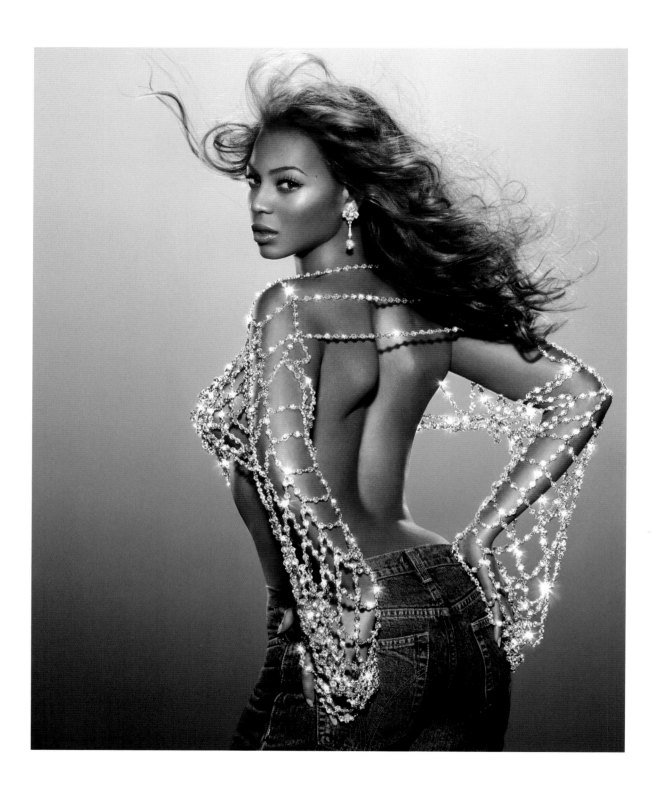

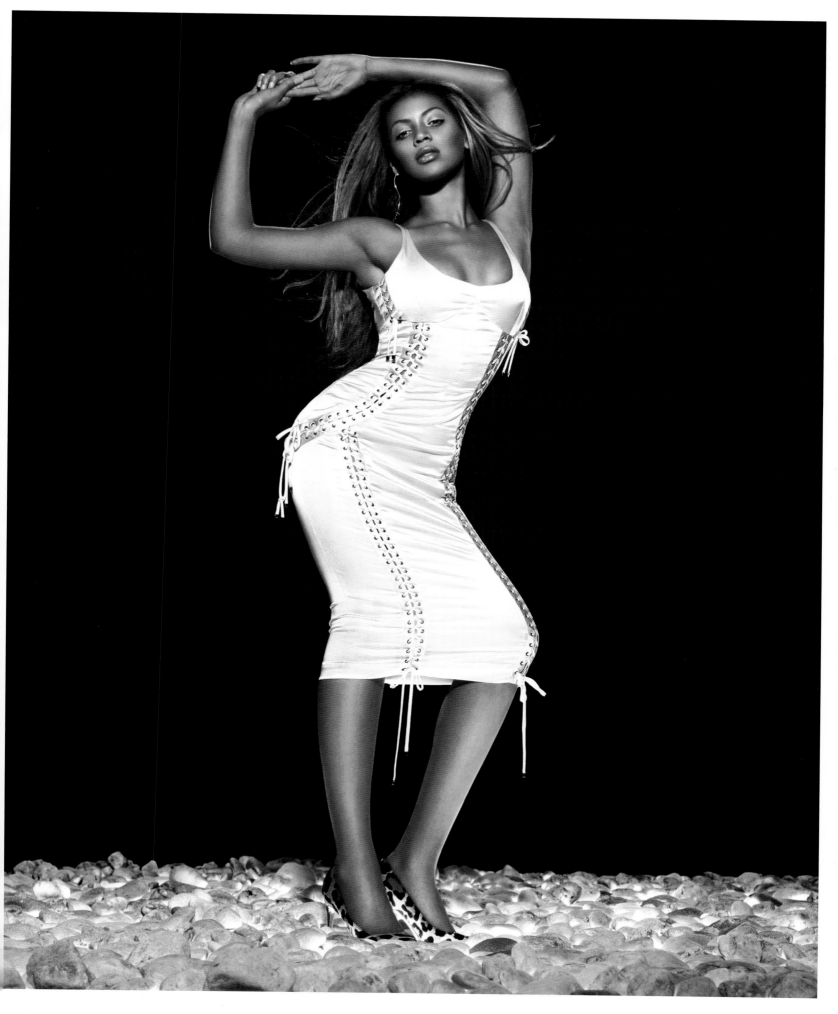

THE BLACK EYED PEAS

When Markus and Indrani were commissioned to shoot the cover of an album titled *Elephunk*, visions of an elaborate shoot involving a real-life elephant in the streets of New York danced in Indrani's head. However, this was soon after 9/11, and among the city's new ordinances were laws specifically requiring elephants to be accompanied by sharpshooters on the roofs of buildings all around, and blocking off city blocks, in case the elephant went wild. The set-up would have cost upwards of a million dollars in insurance and rental fees. Indrani was thwarted and Markus was relieved.

A much simpler portrait session with The Black Eyed Peas was planned instead. The four photos Markus and Indrani shot of the members were used as elements on the album cover of *Elephunk*. Female vocalist Fergie was brand new to the group and relatively unknown, but that would soon change. Featuring the hit tracks "Where is the Love" and "Let's Get It Started," *Elephunk* would reach platinum status and Fergie would become one of the most popular singers in the world, and it all started with this shoot. Markus recalls, "It was fascinating to see Fergie learning the trademark Black Eyed Peas moves along with the other amazing dancers, right there on the set of our photo shoot."

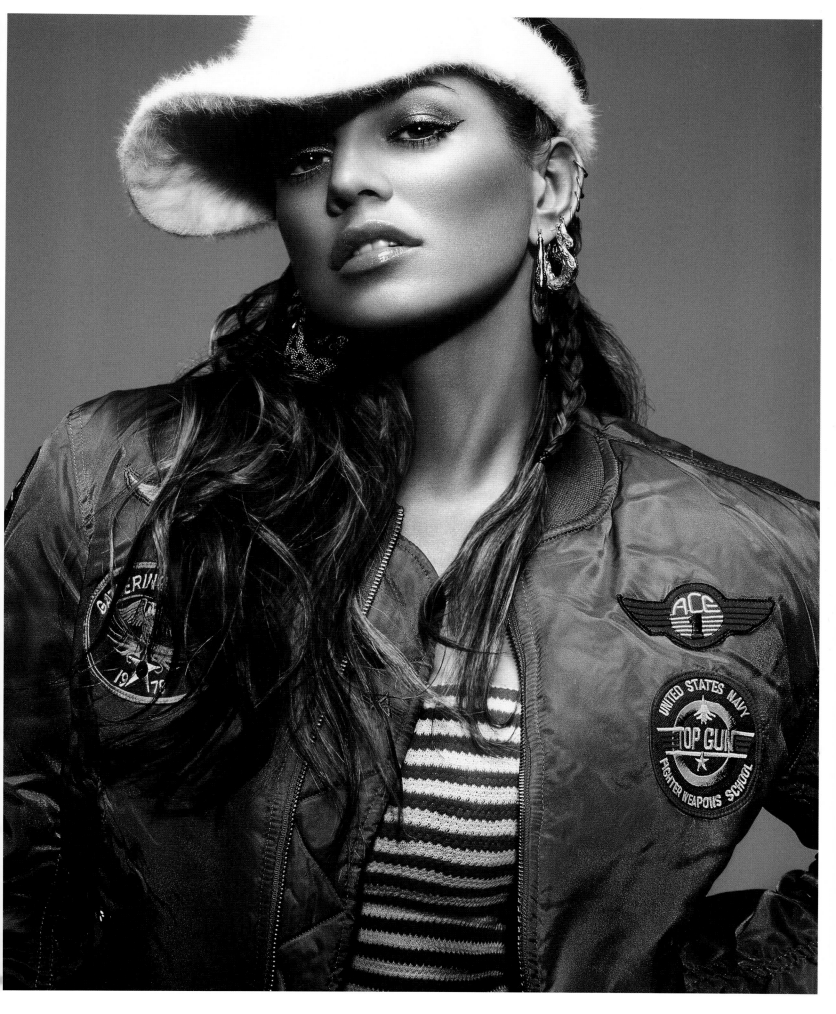

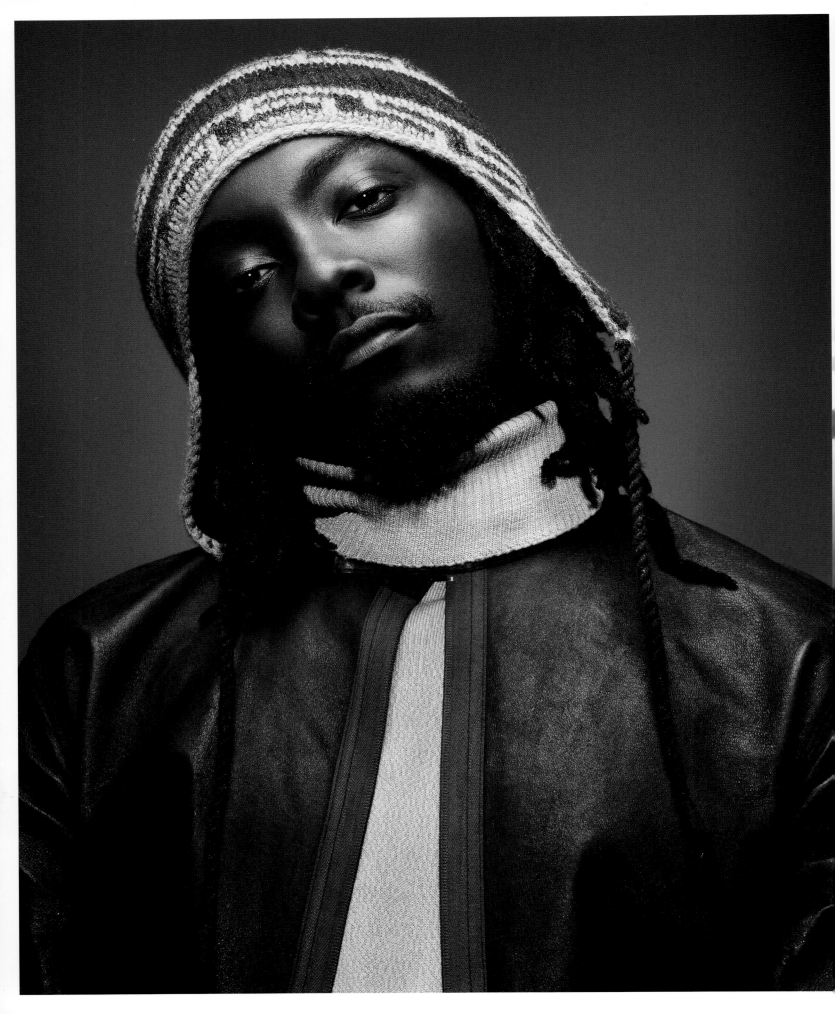

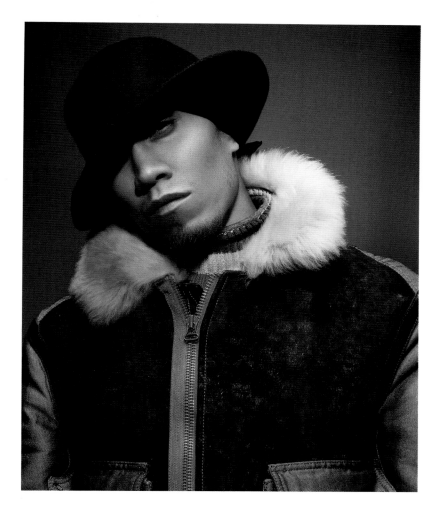

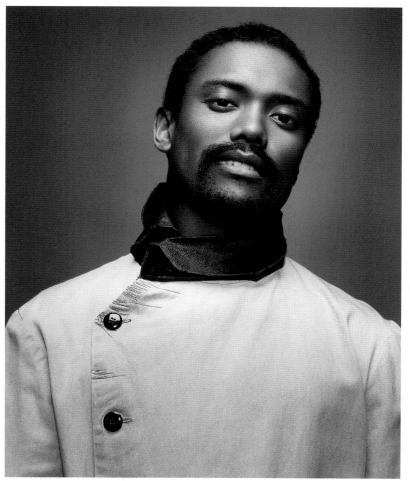

BRITNEY
SPEARS

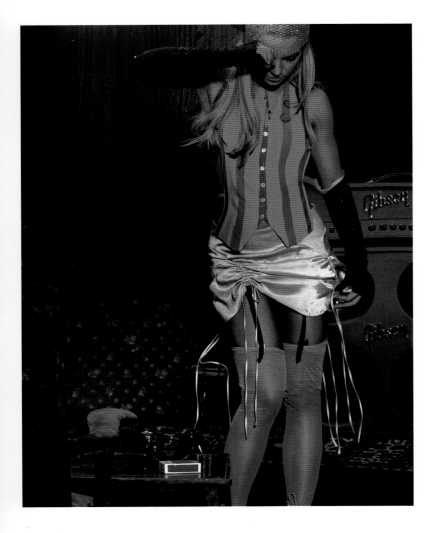

This photo session with Britney Spears was a campaign to promote her Onyx Hotel Tour, in conjunction with the release of the superstar's album *In the Zone*. "Britney had very precise ideas of what she wanted—a dark, magical world with inspirations including enchanted gardens, jazz clubs, ice castles, and haunted bedrooms. The shoot was incredibly successful, with images used everywhere from promotions for the Onyx Tour, to Britney's perfume ads, to the cover of *Vanity Fair*.

Shot at the height of Britney's fame, Indrani says "We found Britney Spears to be very cute, fun, hard working, and professional. She'd been filming a music video for twelve hours before she got to us, and kept up her enthusiasm through ten hours more on our shoot."

At the time Britney was seeking a break from the good-girl image of her youth. Markus and Indrani's photos of Britney immortalize her as the stunning force of nature that she had become, and the strong woman that would emerge again after her brush with the dark side a few years later. In these shots she is a goddess, a beautiful creature out of mythology.

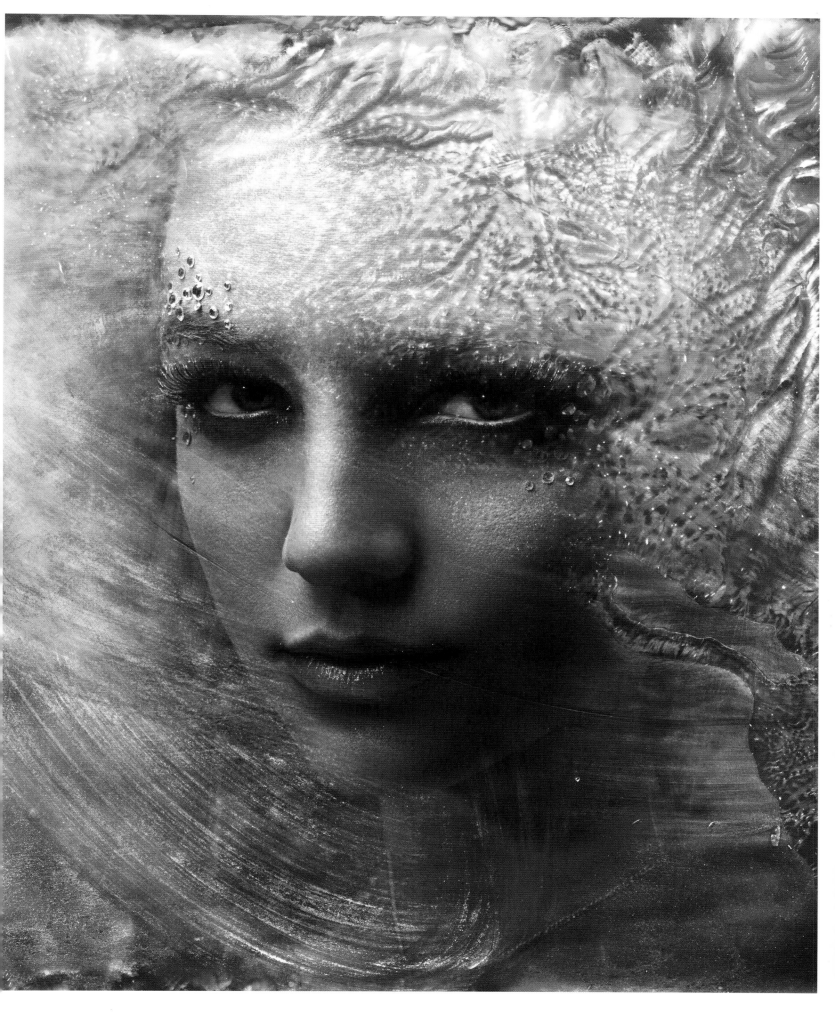

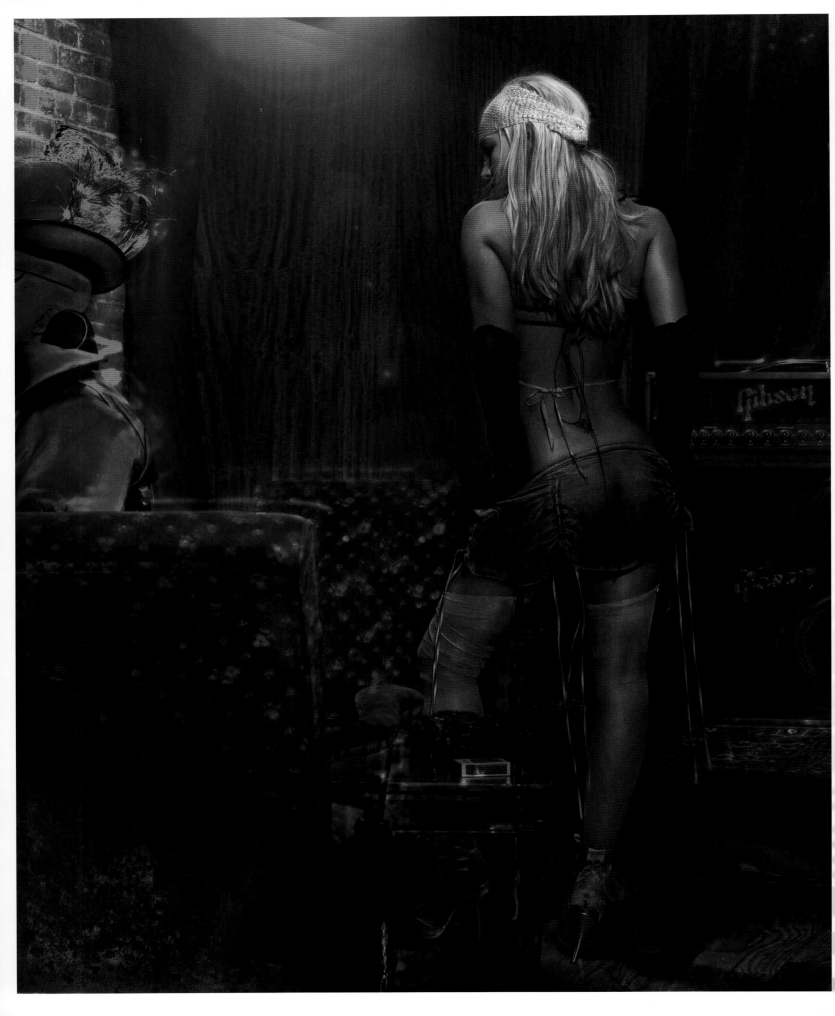

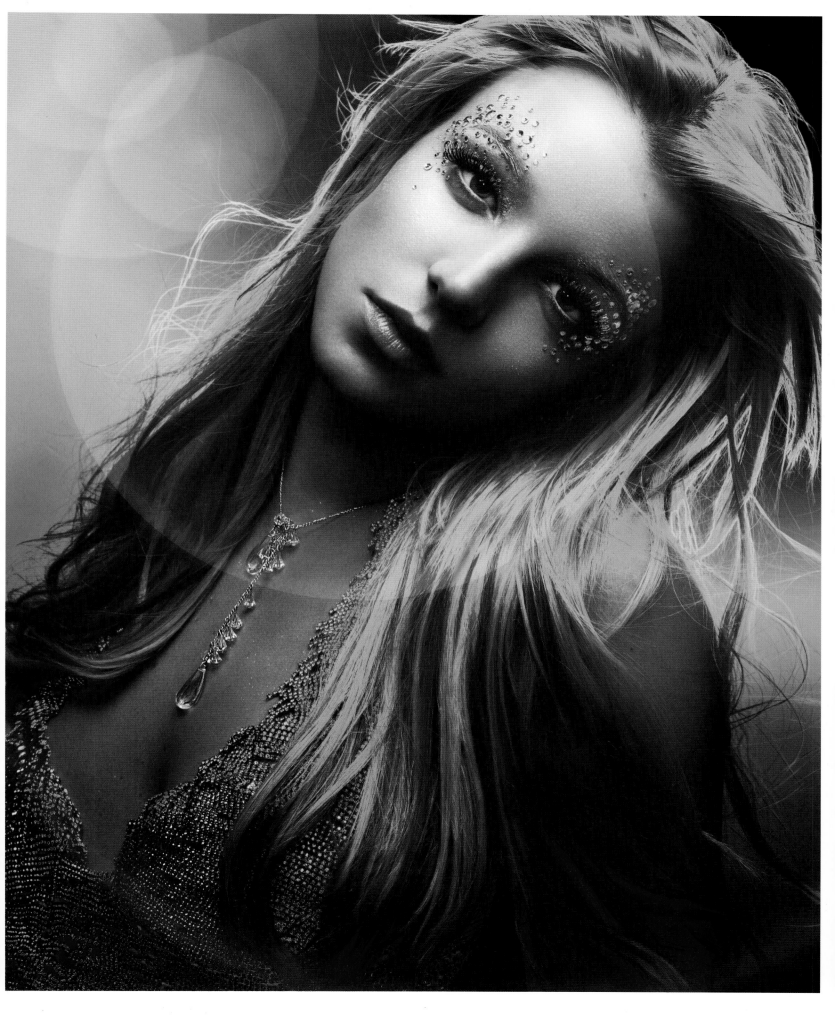

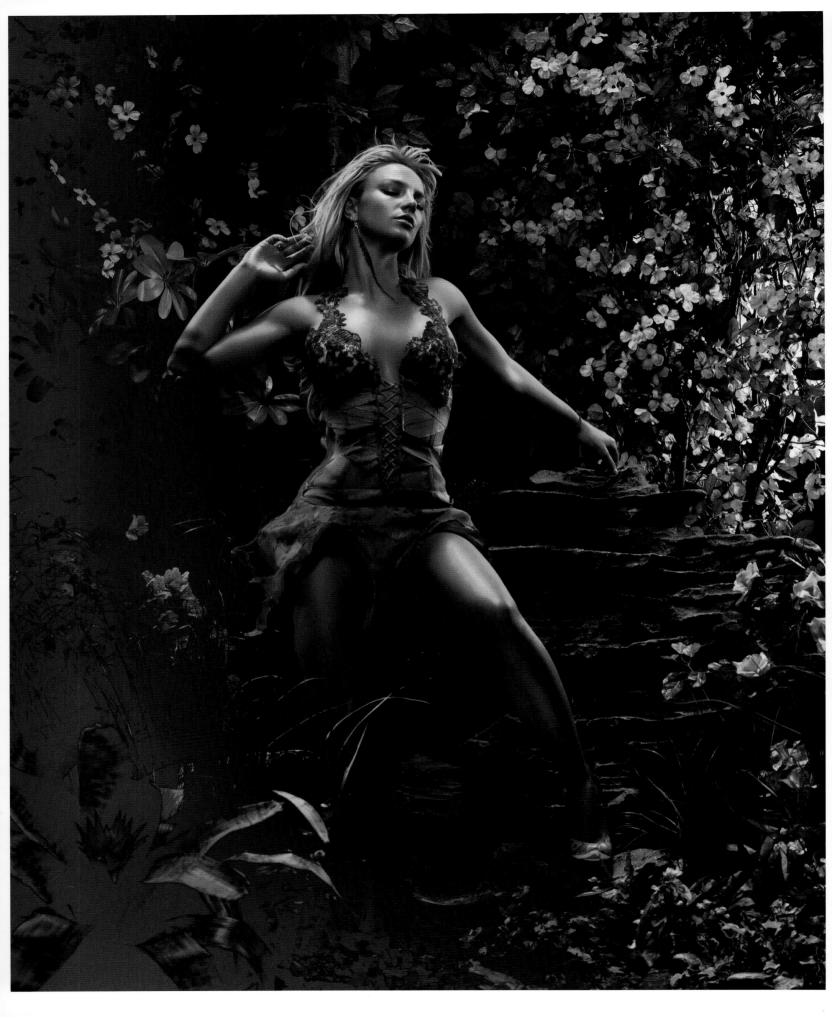

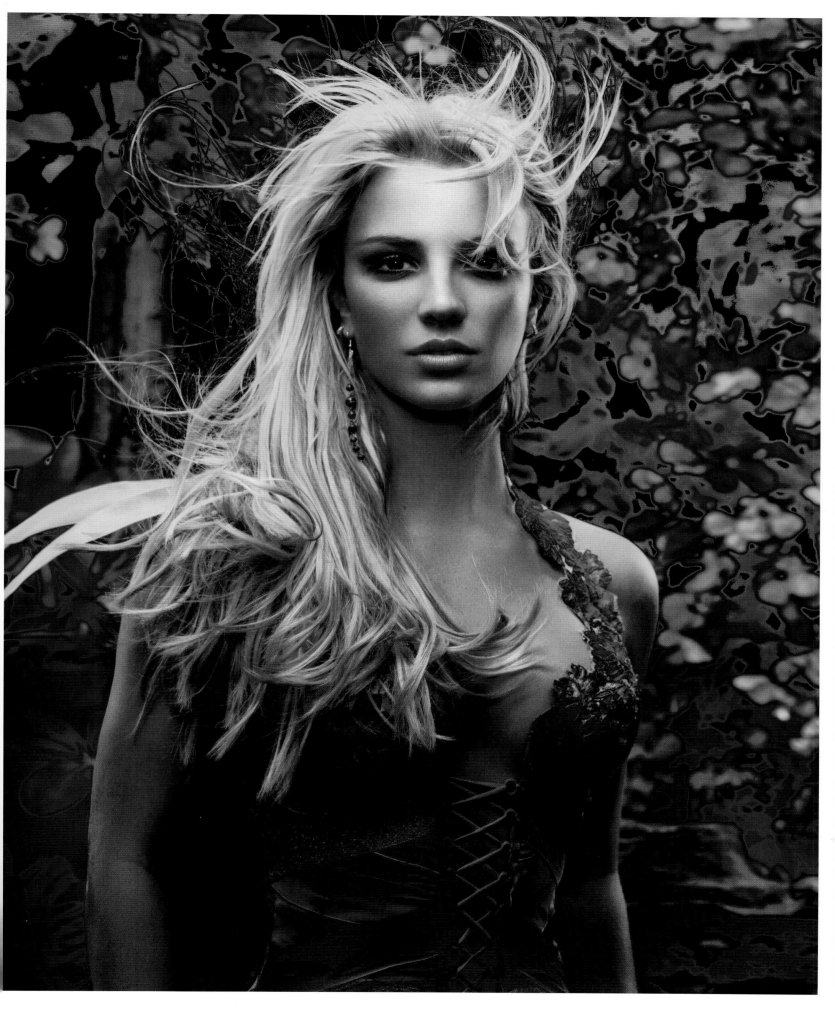

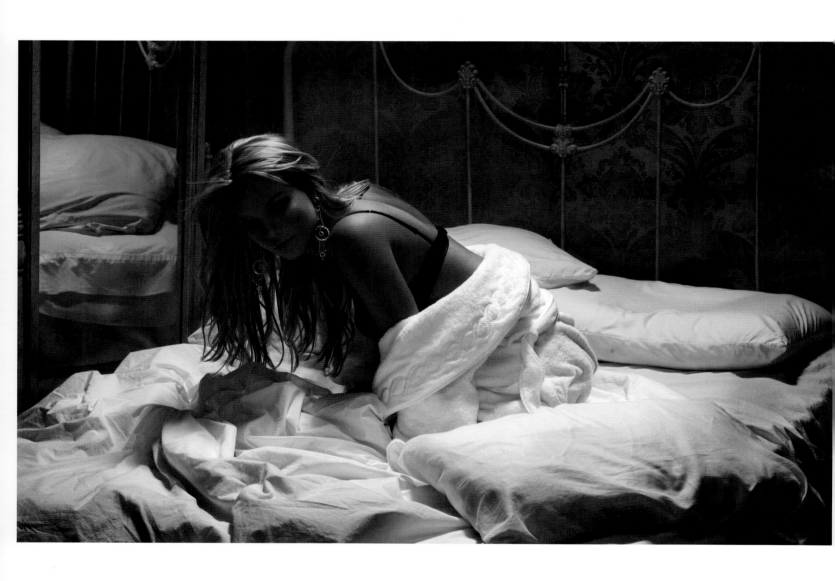

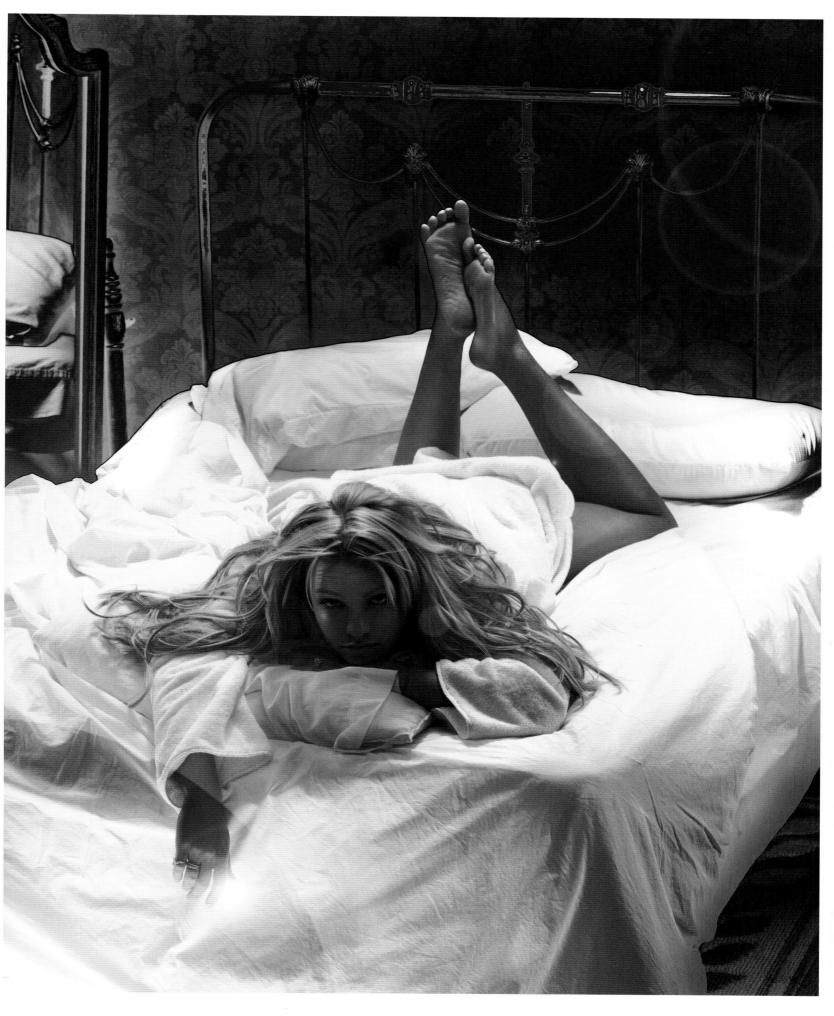

BROOKLYN
D E C K E R

Having recently graced the cover of the *Sports Illustrated* Swimsuit Edition, and become engaged to tennis star Andy Roddick, Brooklyn Decker was one of the hottest models in the world at the time of this shoot. Segments of the shoot were featured on *Double Exposure*, along with a humorous and exaggerated storyline involving a model Markus was dating at the time. Markus and Indrani saw Brooklyn as more than a beautiful face. She was shapelier than most models and had a dancer's grace of movement. Always looking for ways to bring out the best in their subjects, Indrani encouraged Brooklyn to move and pose mid-air before the camera. In post-production multiple shots were assembled into this composite image to showcase the best of Brooklyn.

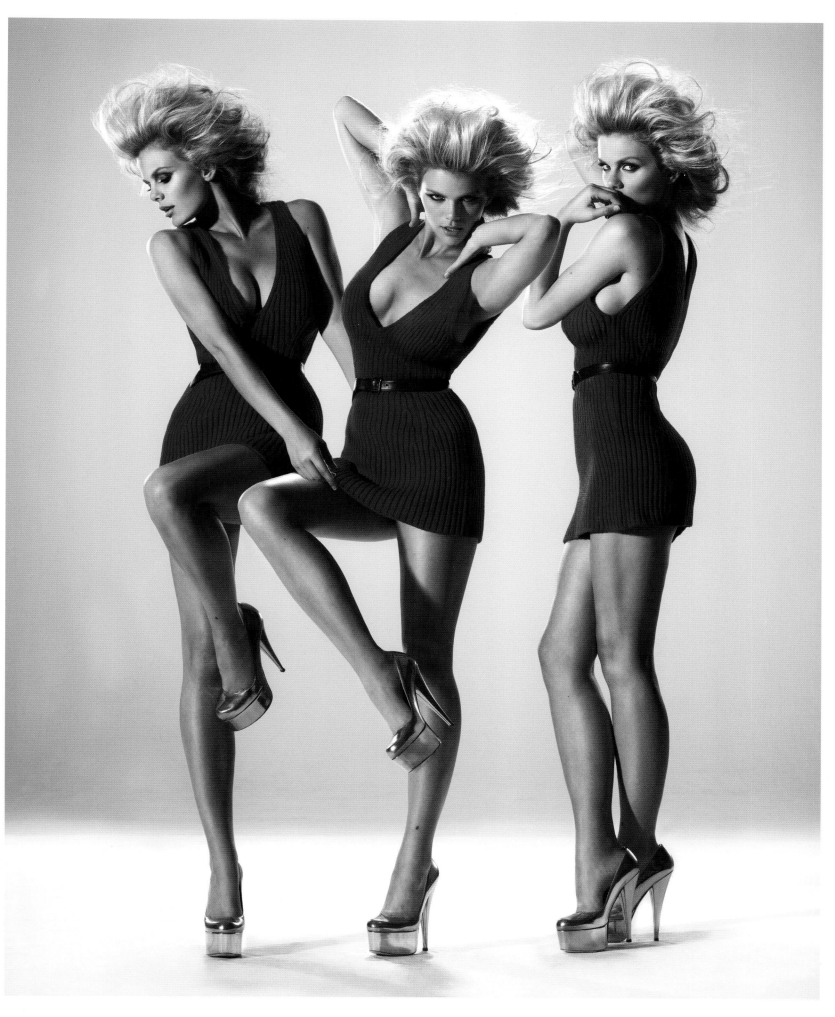

CARMEN
E L E C T R A

On their shoot with Carmen Electra Markus and Indrani went for a concept contrary to the model and television star's typically sexy bombshell image. They photographed her as a kohl-eyed goddess of the silent film era. Indrani recalls, "Carmen was completely into the transformative concept, and reveled in channeling the darker dimensions of her character. Stylist GK Reid created fashions for the shoot that included covering her from head to toe in lace, accessorized with tarot cards representing the webs of fate." In another shot Carmen is shown with artificial tears streaming down her face. She had just been through a highly publicized break-up and she embraced the cathartic symbolism of owning her emotions in a work of art.

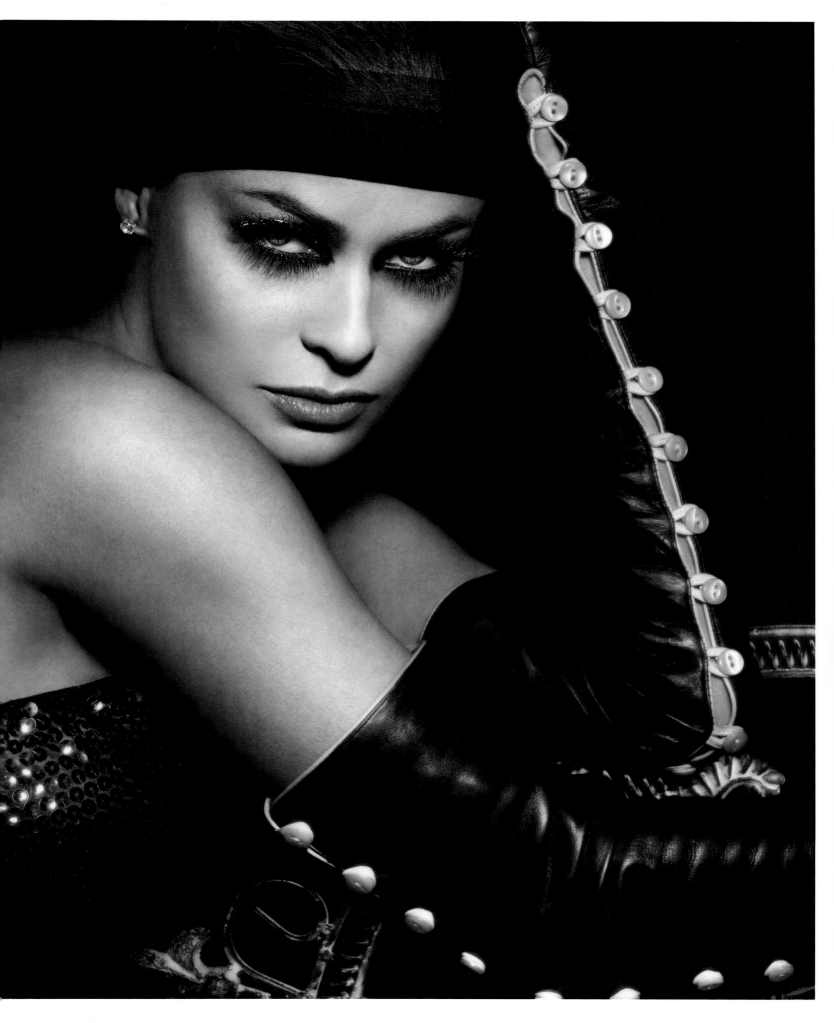

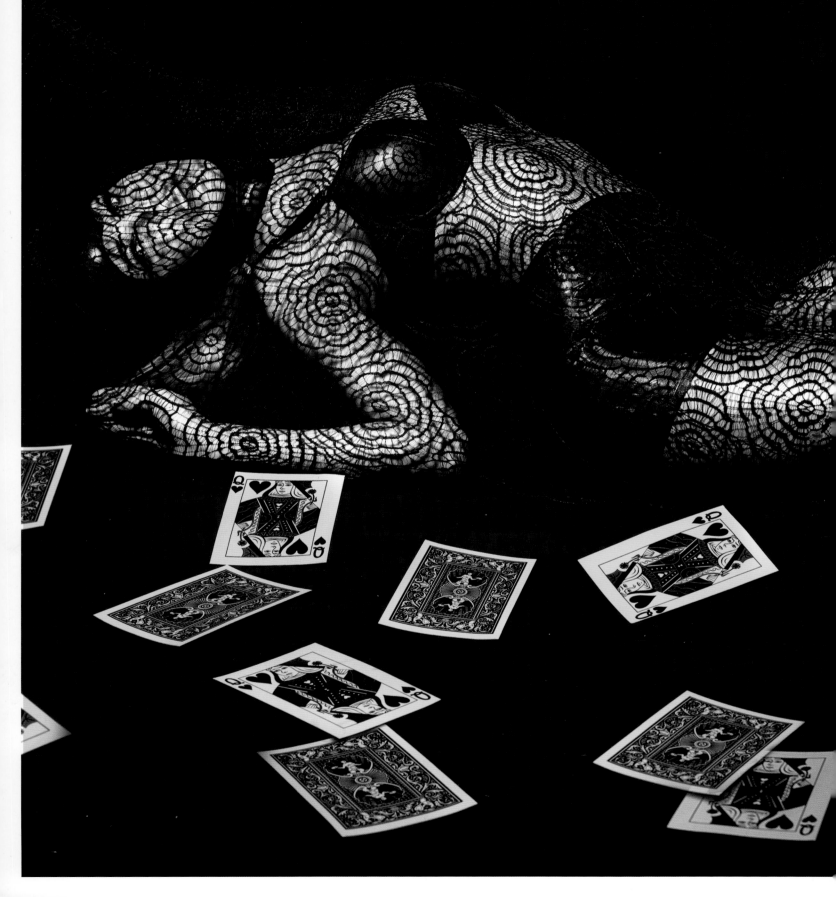

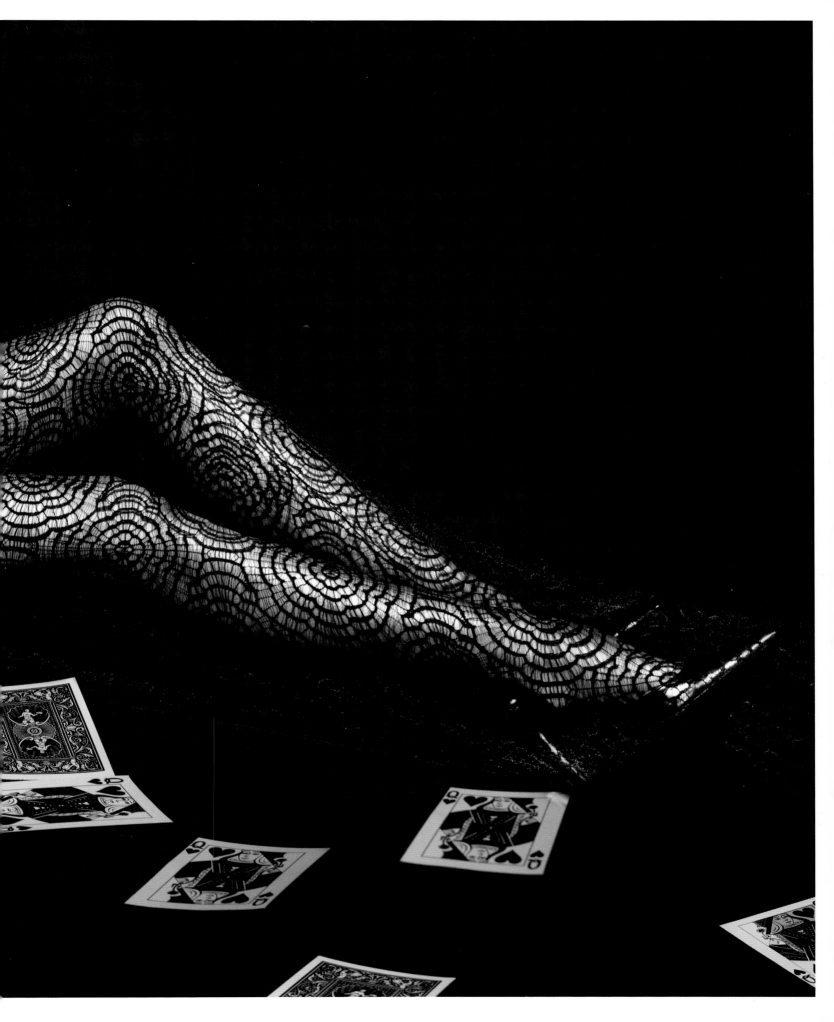

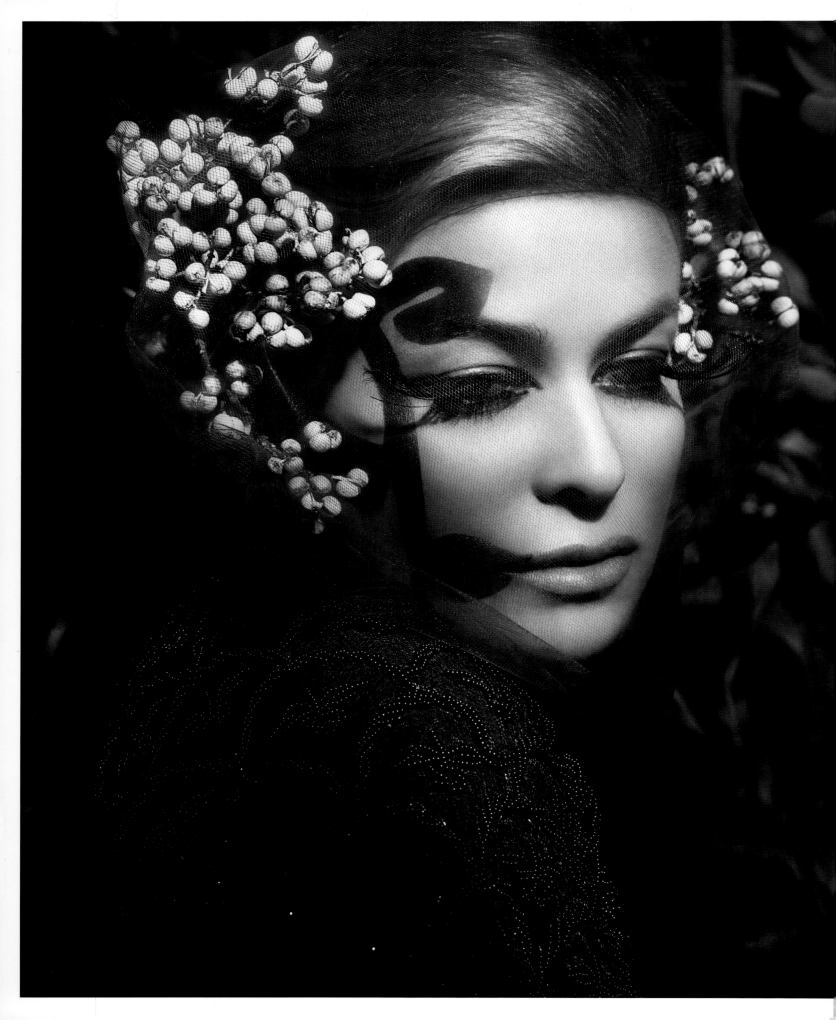

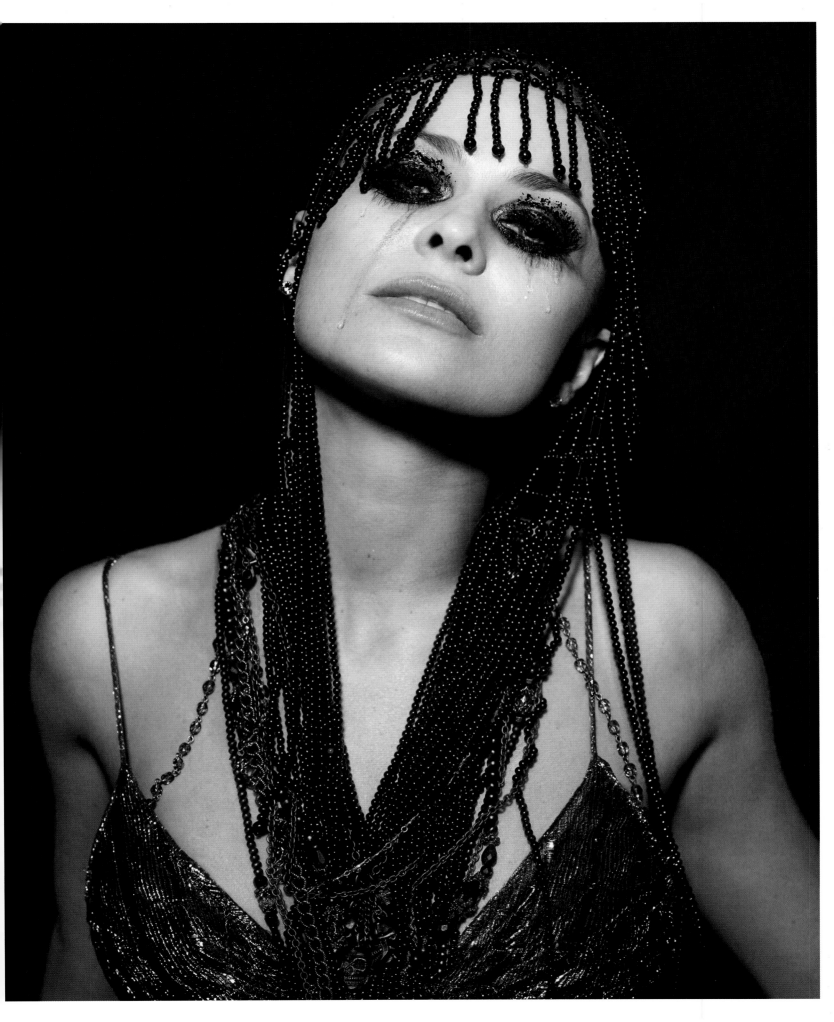

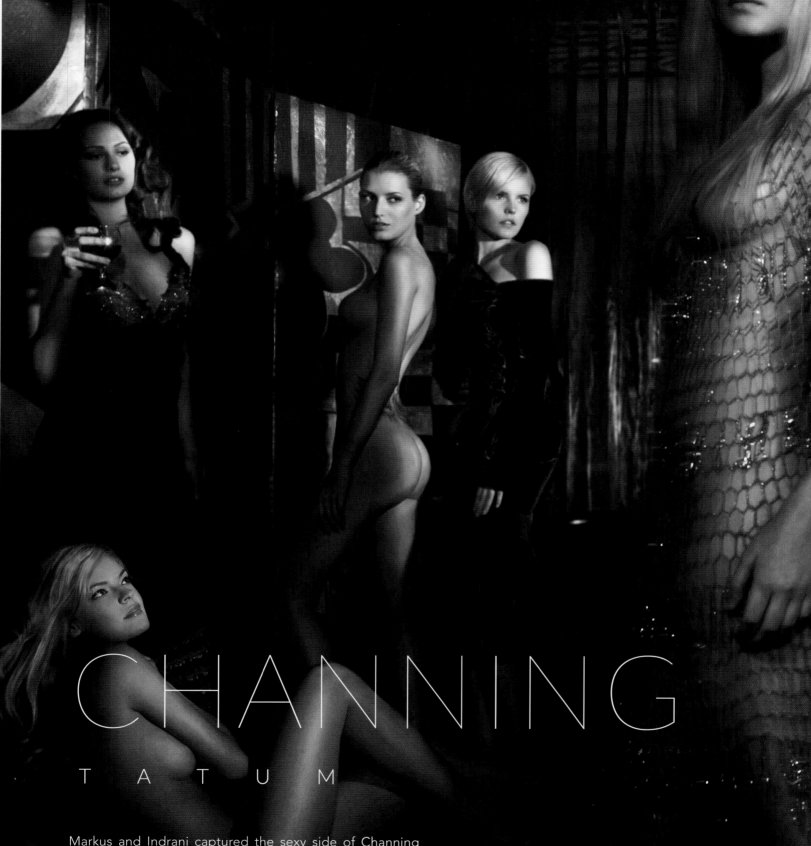

CHANNING
TATUM

Markus and Indrani captured the sexy side of Channing
Tatum for this editorial shoot. Surrounding the handsome
actor with beautiful models, they presented him as the
ultimate object of both woman's desire and a man's envy.

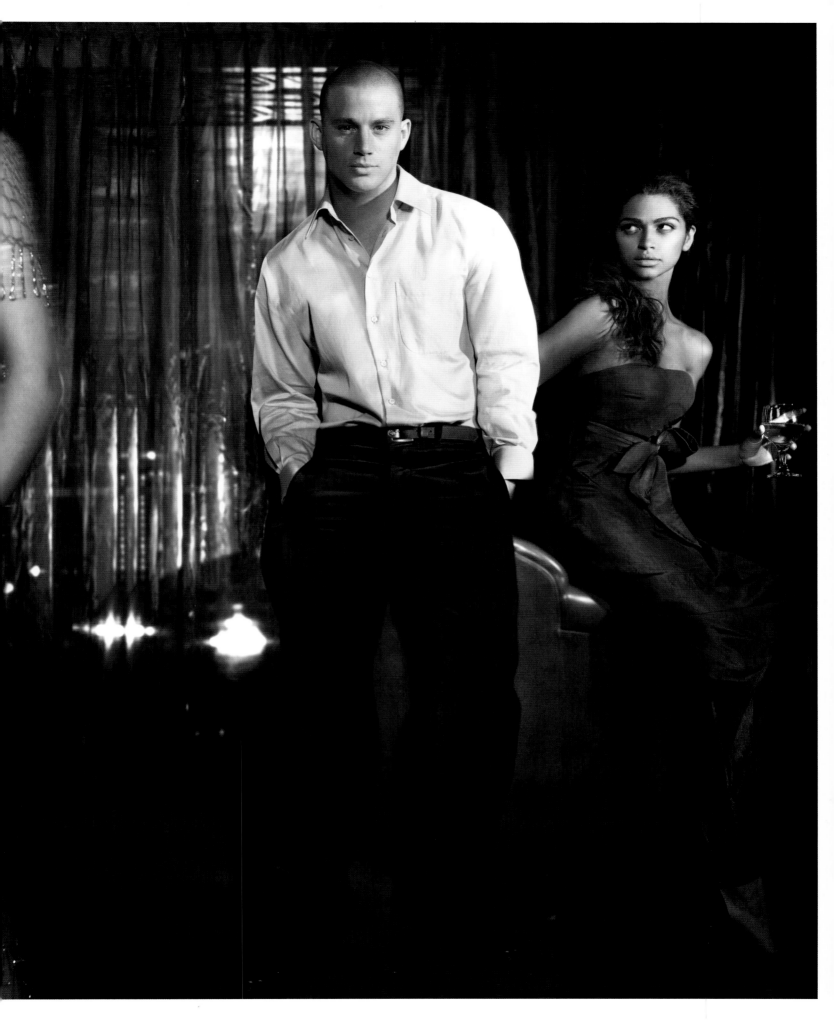

CHINA
CHOW

With artist China Chow hosting the Bravo reality show *Work of Art: The Next Great Artist*, it was no surprise that the three artists would meet. China asked Markus and Indrani to shoot her for her cover feature for *Vogue China*. China also asked art star Richard Phillips to collaborate on the project, and to paint her portrait at the same time. Markus and Indrani, embracing the collaborative aspect, suggested including Richard in their photos, painting China. As it turned out, Phillips based his painting entirely on Markus and Indrani's photograph, which he produced after the shoot. Nonetheless, the duo was asked to incorporate his rendering of their photo into the backdrop of their photos. Indrani says, "It was an extraordinarily post-modern collaborative approach. Though there was great potential for drama in such a complex situation, Markus and I fully embraced the multiplicity of perspectives involved, and for the most part, we all got along because we mutually respect each other."

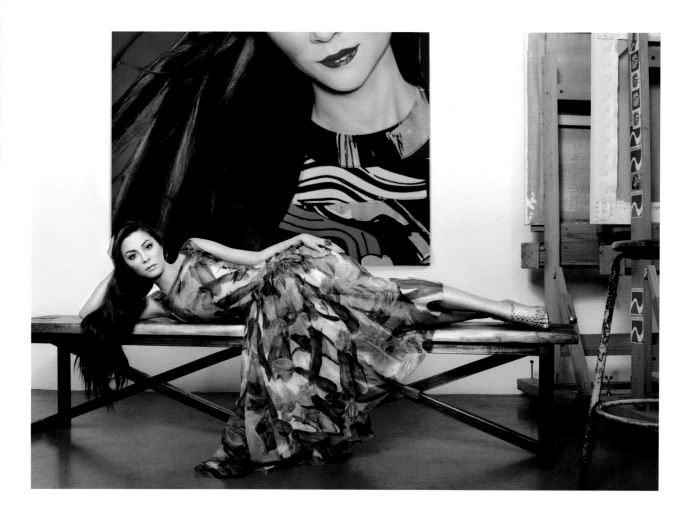

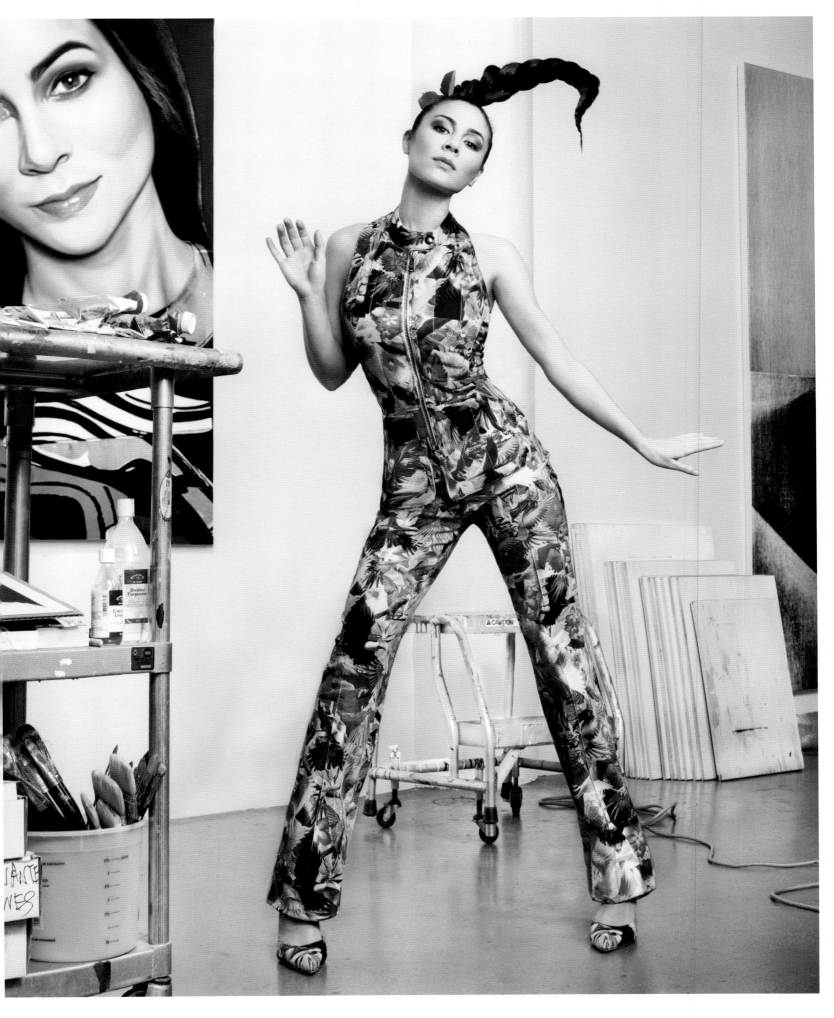

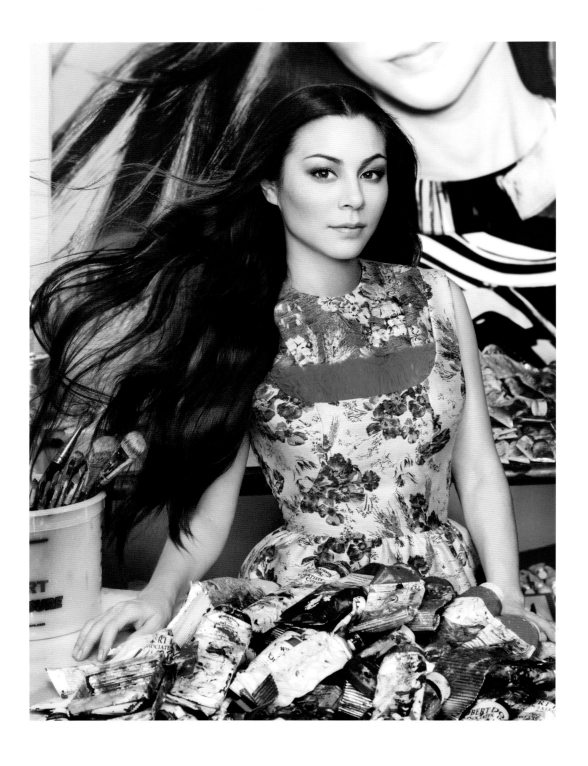

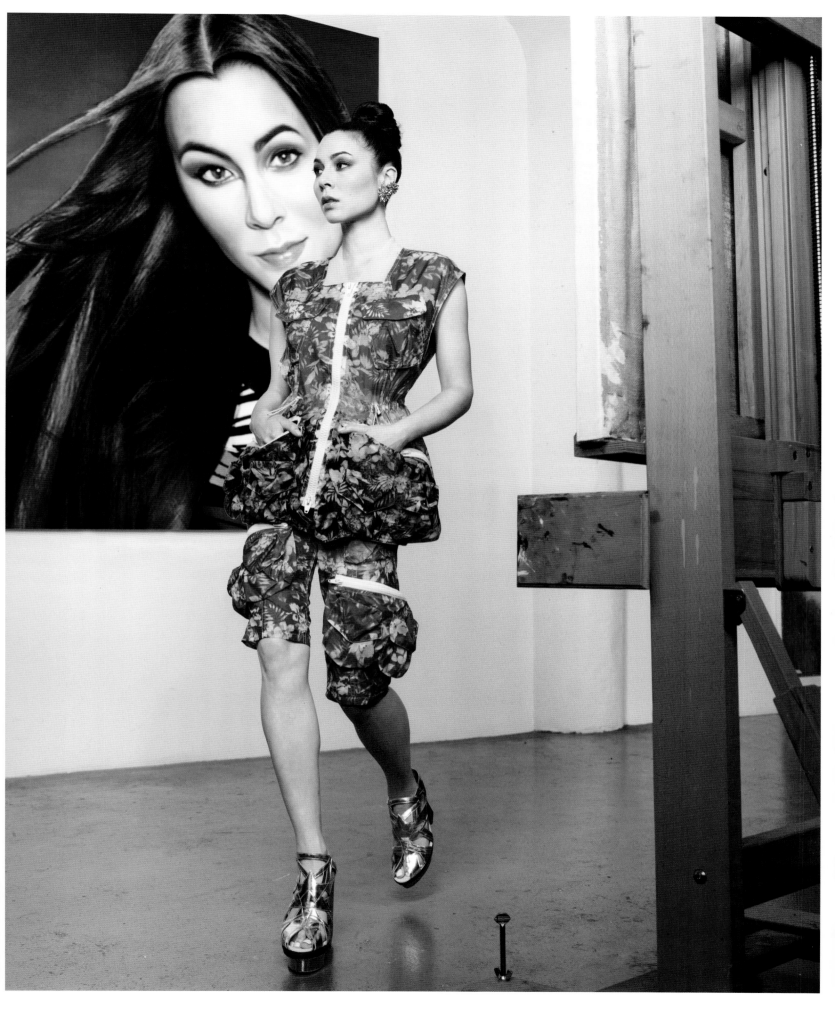

CHRIS
ROCK

"Although Chris Rock was a perfectly friendly subject," recalls Markus, "he gave me the impression that being photographed, standing still and posing, wasn't the most comfortable thing for him; that he prefers to be active or making jokes—which he did throughout the shoot. When it was over he seemed to relax and enjoy himself." The resulting powerful portraits of one of the nation's greatest comedian's belie any apprehension that may have been stirring within.

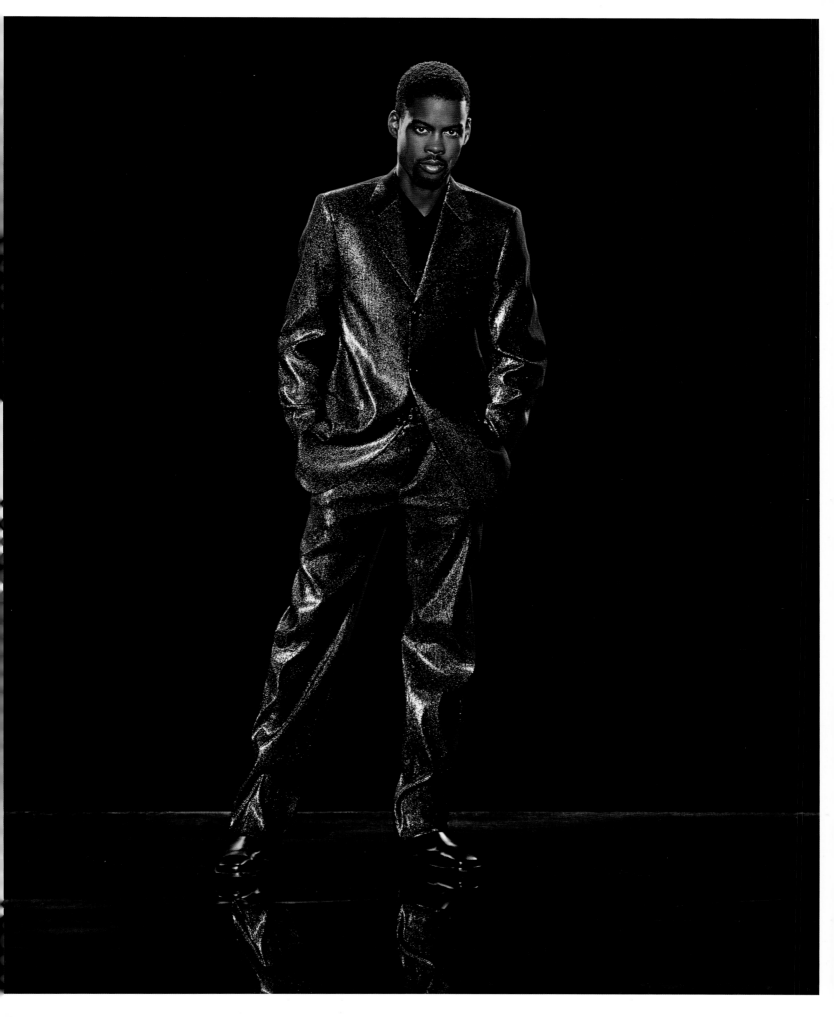

CHRISTINA
A G U I L E R A

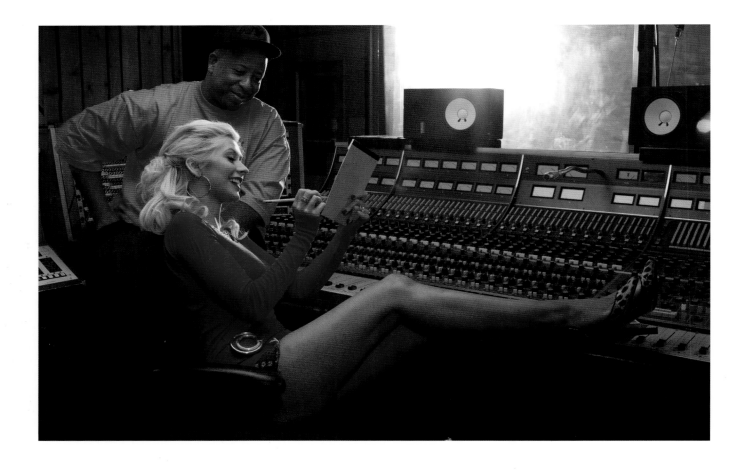

The Christina Aguilera shoot was a magazine editorial and Markus and Indrani wanted to showcase one of the great voices of modern times completely at ease in her element—in a recording studio, at work, doing what she loved best. However, in order to create those images, they had to stage a recording session, complete with all the necessary props and equipment to make it seem realistic. "The most natural-looking shoots often require the greatest artifice— and vice versa," explains Indrani.

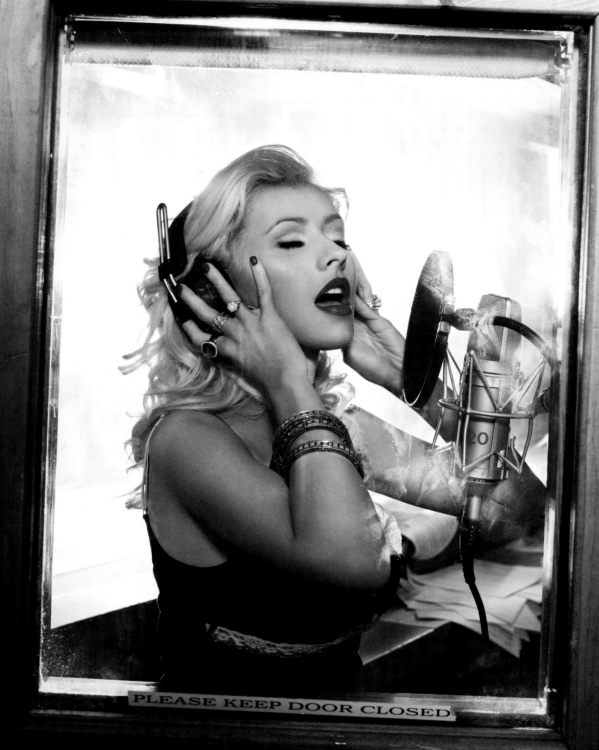

PLEASE KEEP DOOR CLOSED

PRE-SET

DAPHNE
G U I N N E S S

David LaChapelle suggested Markus and Indrani shoot Daphne Guinness for a campaign they did for the charitable organization Keep a Child Alive. Indrani and GK had met the heiress and fashion icon at a party in the Hamptons, so they were intrigued to photograph her. For Keep a Child Alive, stars were shot in coffins, with Markus snapping pictures from a ladder above. Indrani notes, "Daphne's great elegance coupled with her sensuality and vulnerability made her coffin shot stand out as particularly poignant among the other stars."

Fascinated by Daphne, they found a new opportunity to shoot her for the *London Sunday Times*, which they photographed at the stunning Gothic synagogue the Angel Orensanz Foundation for Contemporary Art. The team developed a great rapport with their new muse, who in turn showed them complete trust, not phased for a moment when they asked if she would be comfortable being photographed with a giant albino python—just as she hadn't flinched when asked to step into a casket for them for Keep a Child Alive.

Indrani discovered many commonalities between them, including shared passions for poetry and mythology, and she and Daphne talked about making a film together. With surprising foresight, Indrani had assembled a skilled film team and all the equipment needed in case this opportunity might work out, and Daphne was thrilled that they were able to begin shooting video alongside the stills. These shots became central to Indrani's exquisite first short film, based on an ancient Chinese tale, *The Legend of Lady White Snake*. Shoots with Daphne followed throughout 2011 and 2012 in New York and Paris, all of which similarly paired stills and video. The resulting images were published by magazines throughout the world, used in beauty and fashion ad campaigns, and a beautiful film took form, taking Markus and Indrani to a new heights in their career.

Indrani's perspective: "This film was a labor of love for all of us. We were very fortunate to work with Daphne, whose acting is extraordinary. Though known for her visual art, in this her first speaking role she imbues the complex character of Lady White Snake with a forceful ancient wisdom, a naïve vulnerability, otherworldly charm, and deadly intensity."

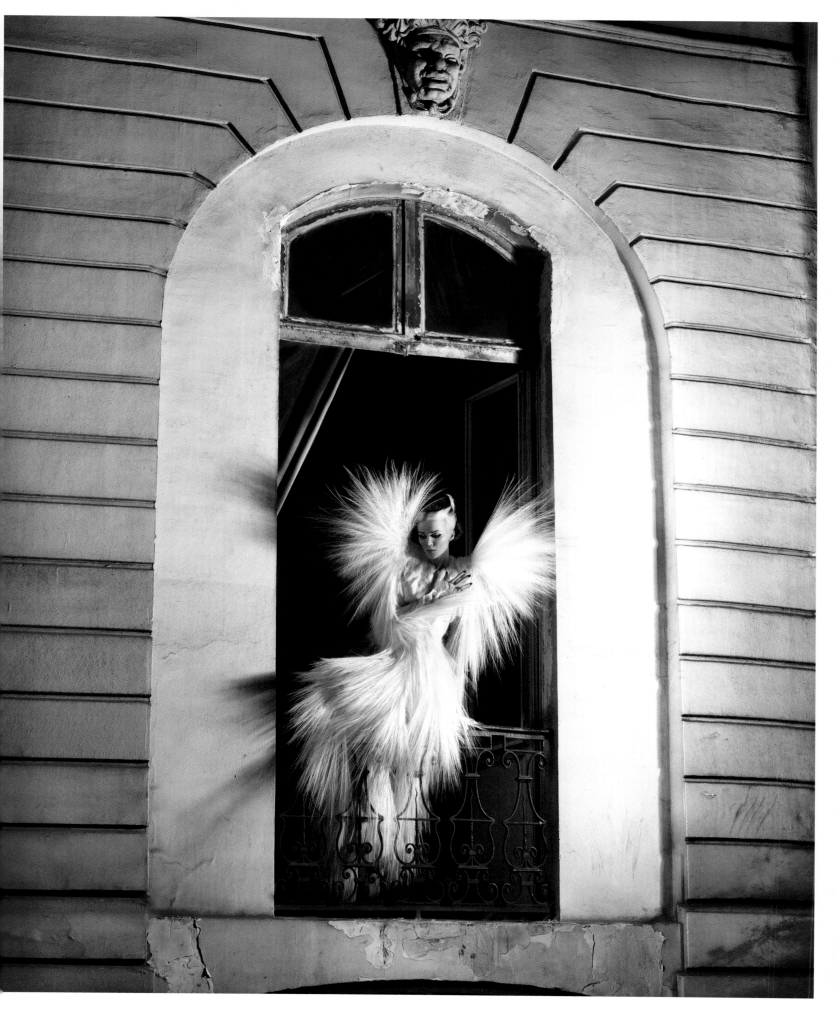

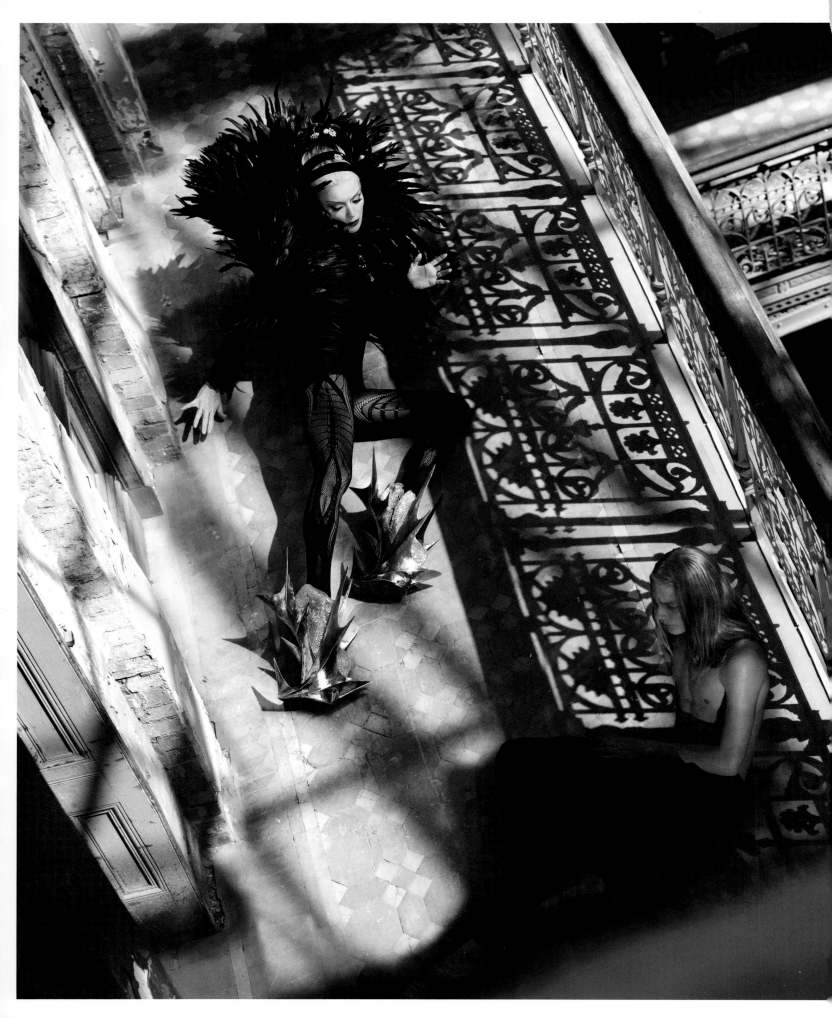

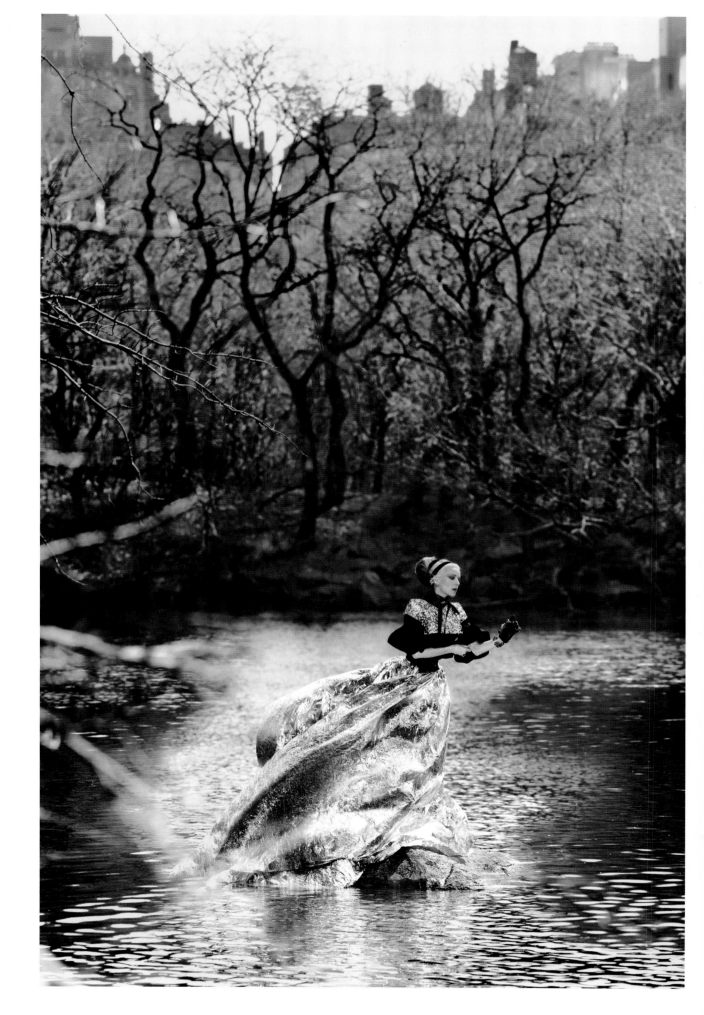

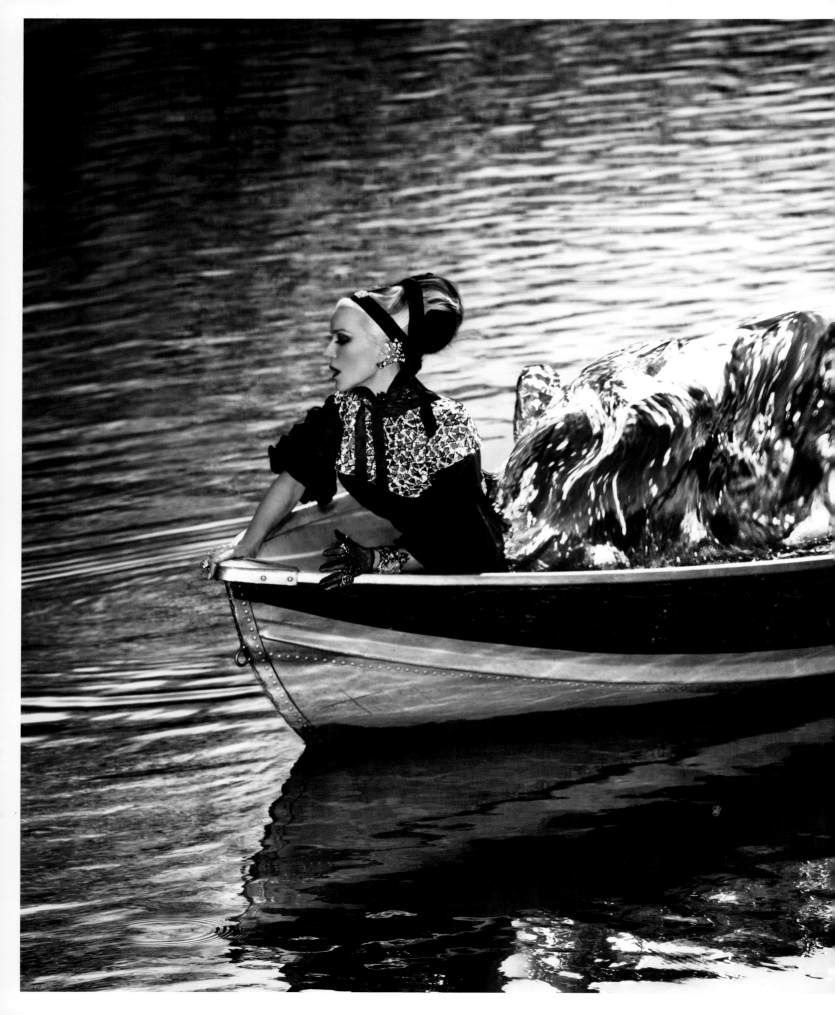

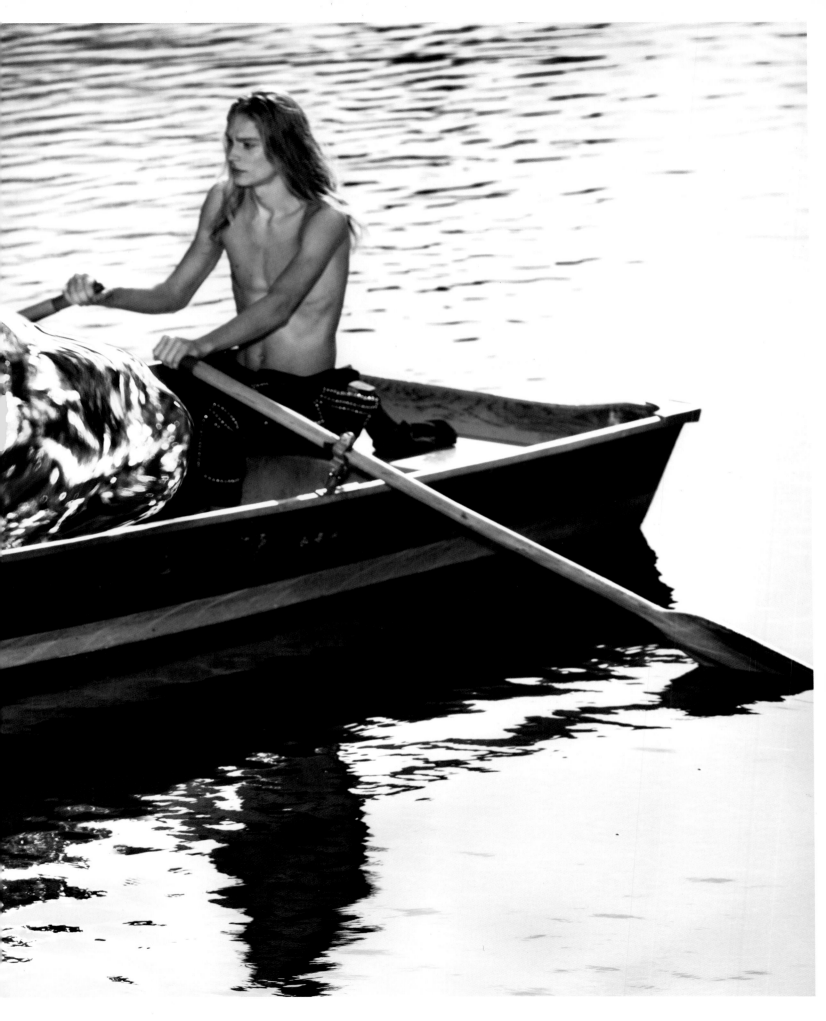

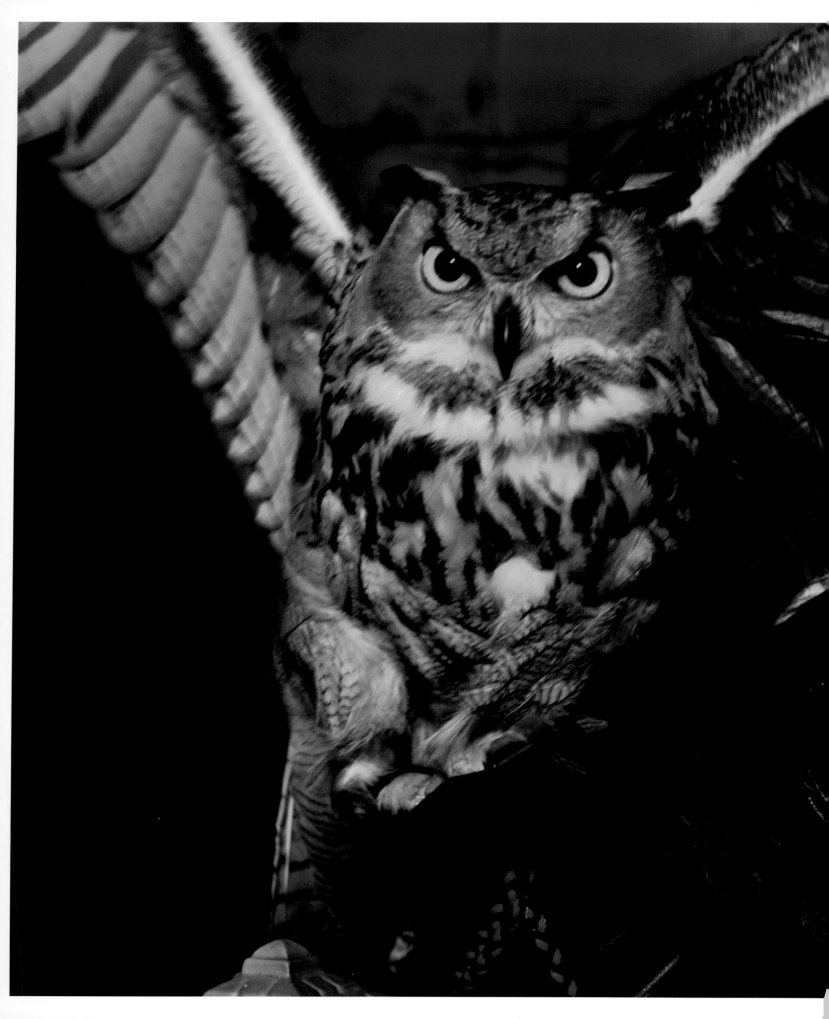

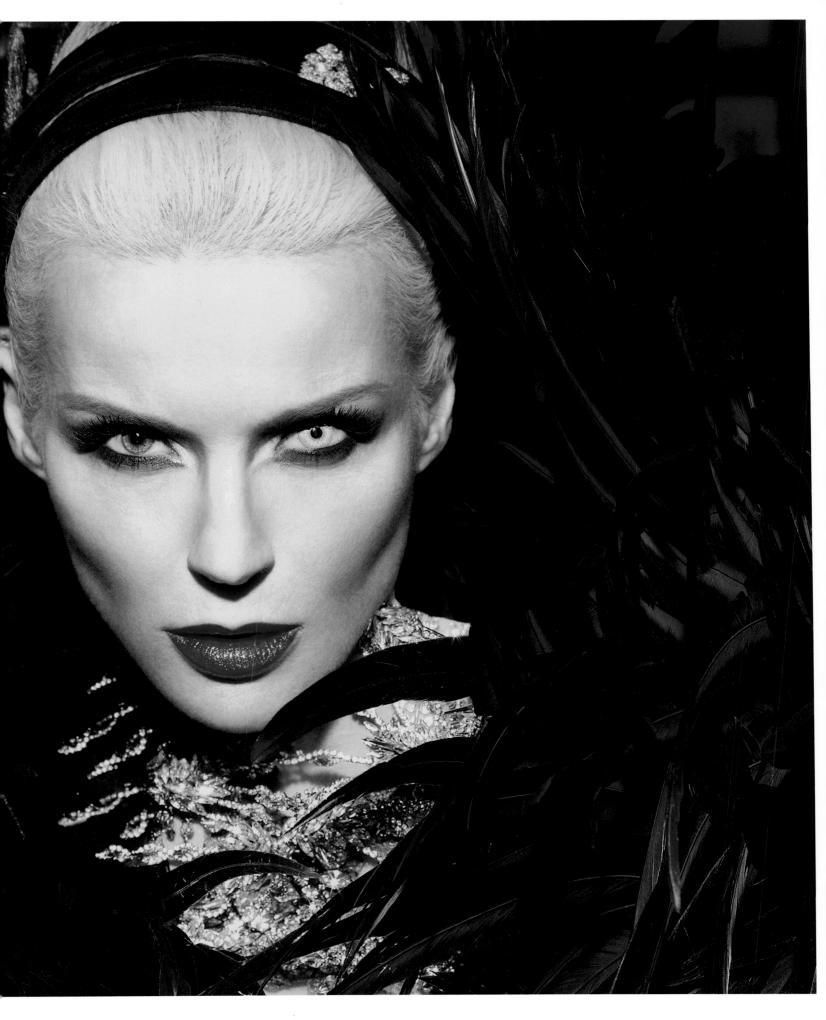

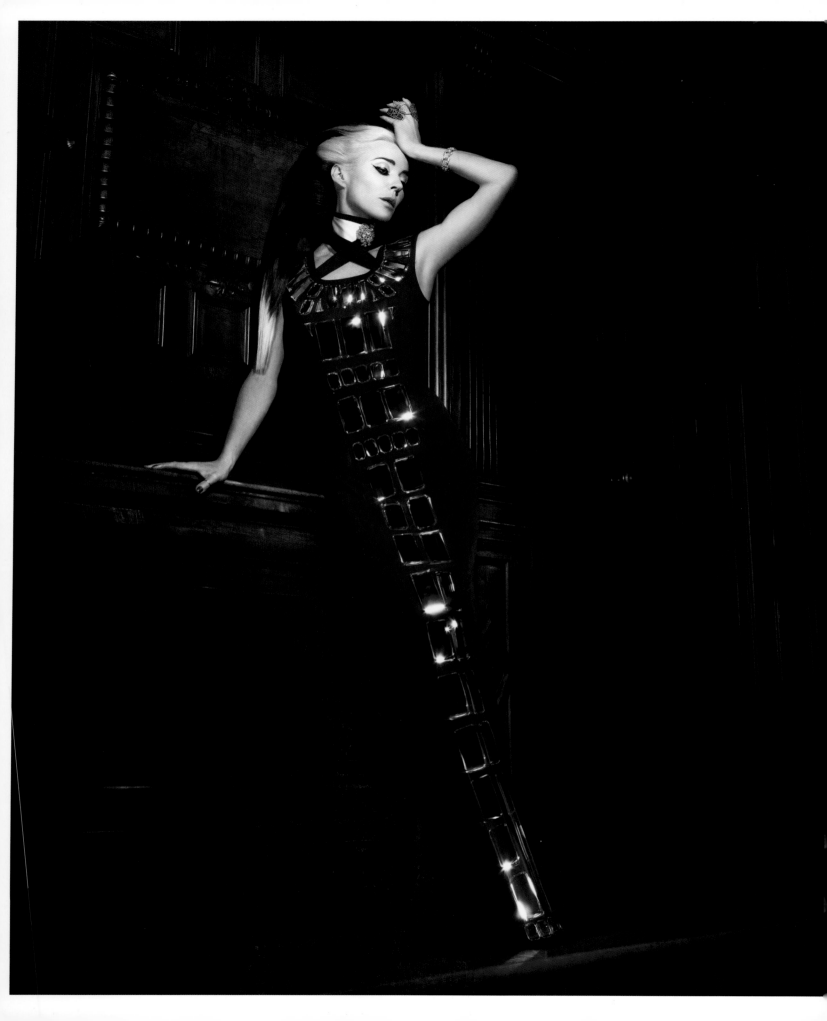

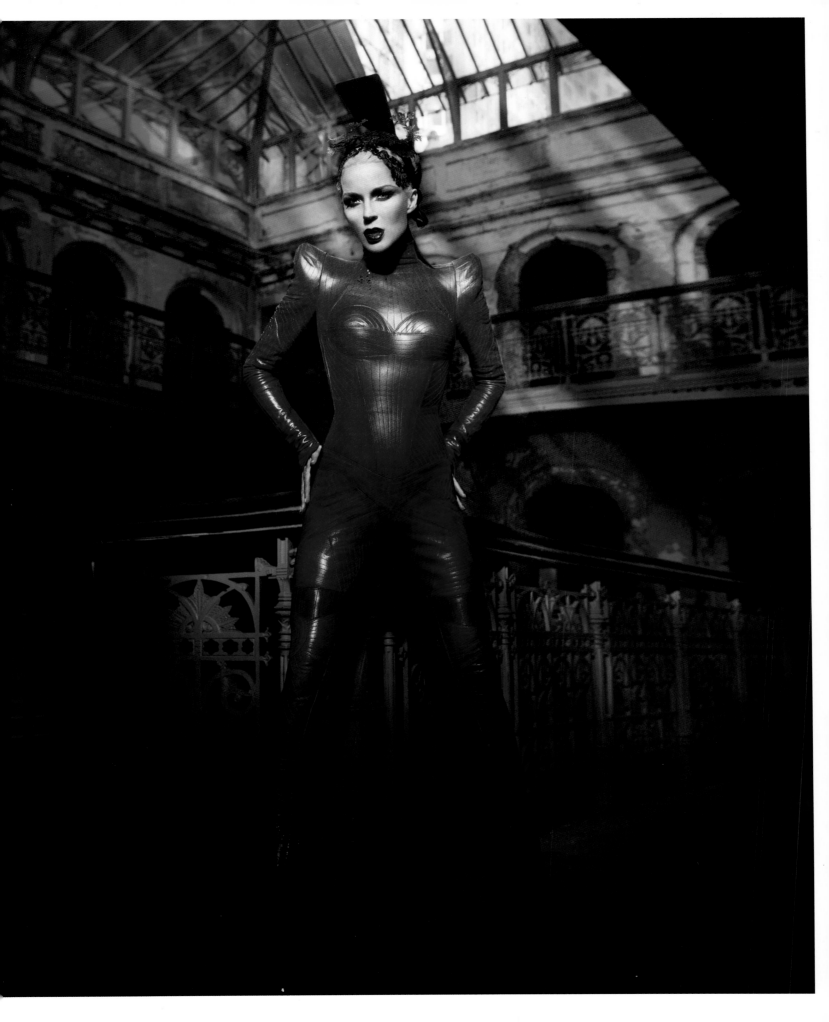

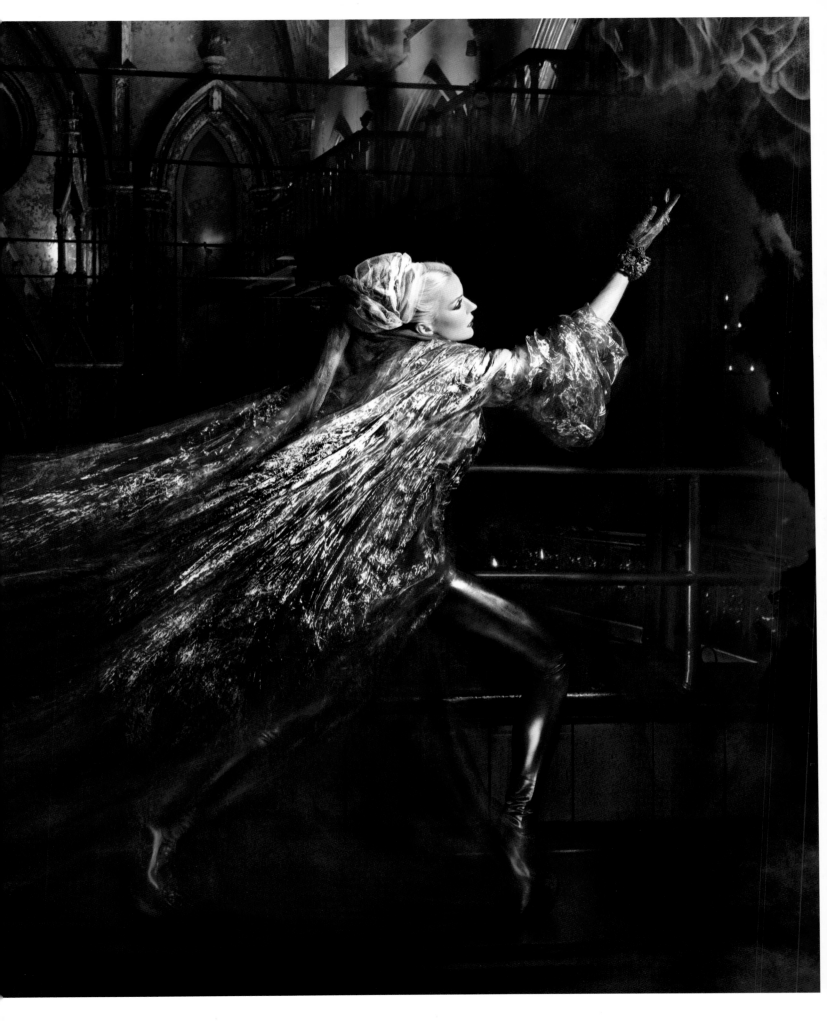

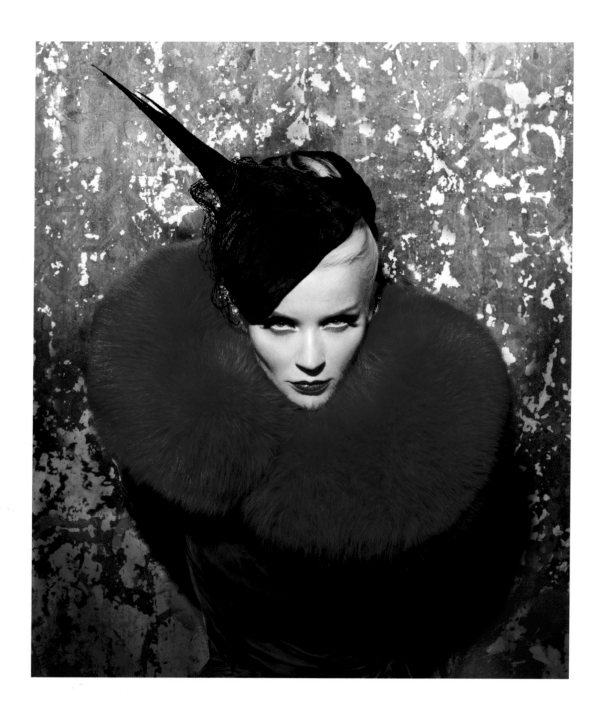

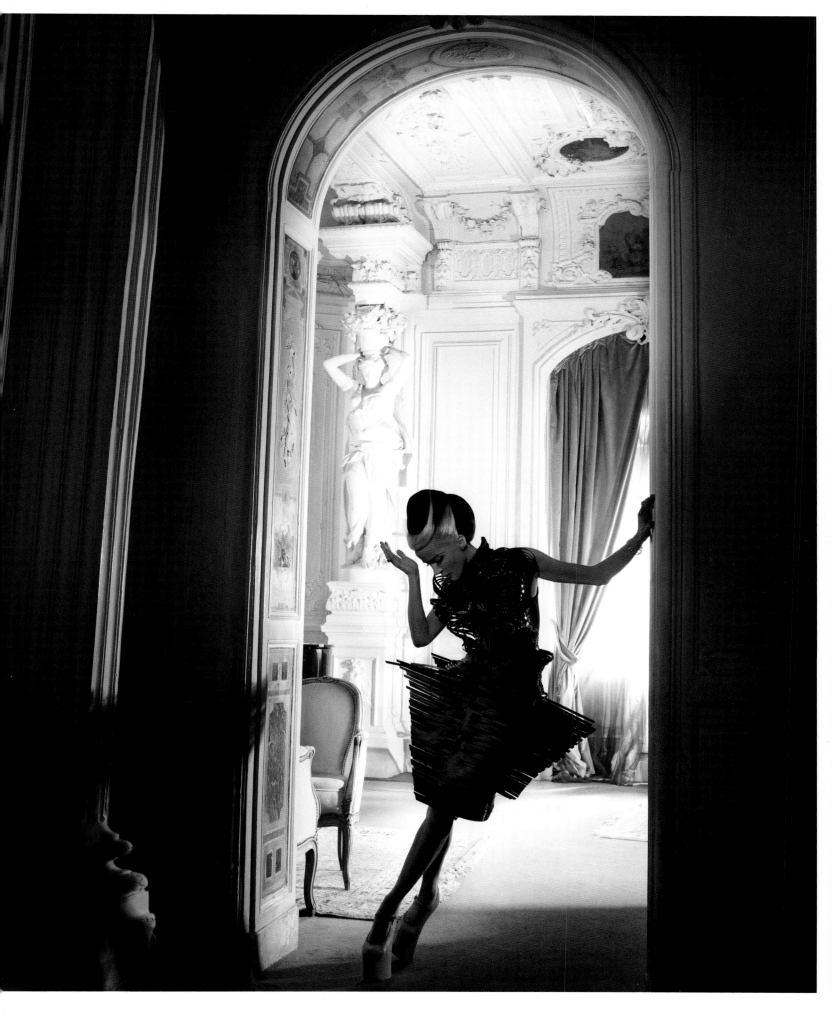

DAVID
B O W I E

Working with David Bowie was one of the defining moments in Markus and Indrani's career. They first met him while shooting the cover of *I Am Iman*, a book by Bowie's supermodel wife Iman. After observing their manner of working and the resulting shots, Bowie knew he wanted Markus and Indrani to shoot the album art for his next studio release, *Heathen*.

Bowie had very specific ideas about what he wanted. Inspiration came from the music of *Heathen* itself and the photography of legendary artist Man Ray. One can see the Man Ray references throughout the series, though Markus and Indrani's signature hyper-realism and unique ways of connecting the subject with the viewer are as evident as ever. GK's styling was on point, with specific details from Bowie on the jackets and shirts he wanted to wear to evoke a specific period.

The team worked hard together to encapsulate the complex themes of *Heathen*, which became Bowie's most successful album since *Tonight* in 1984. Markus, recalls "We felt we grew as artists and reveled in expanding our creative horizons with a true rock-and-roll legend."

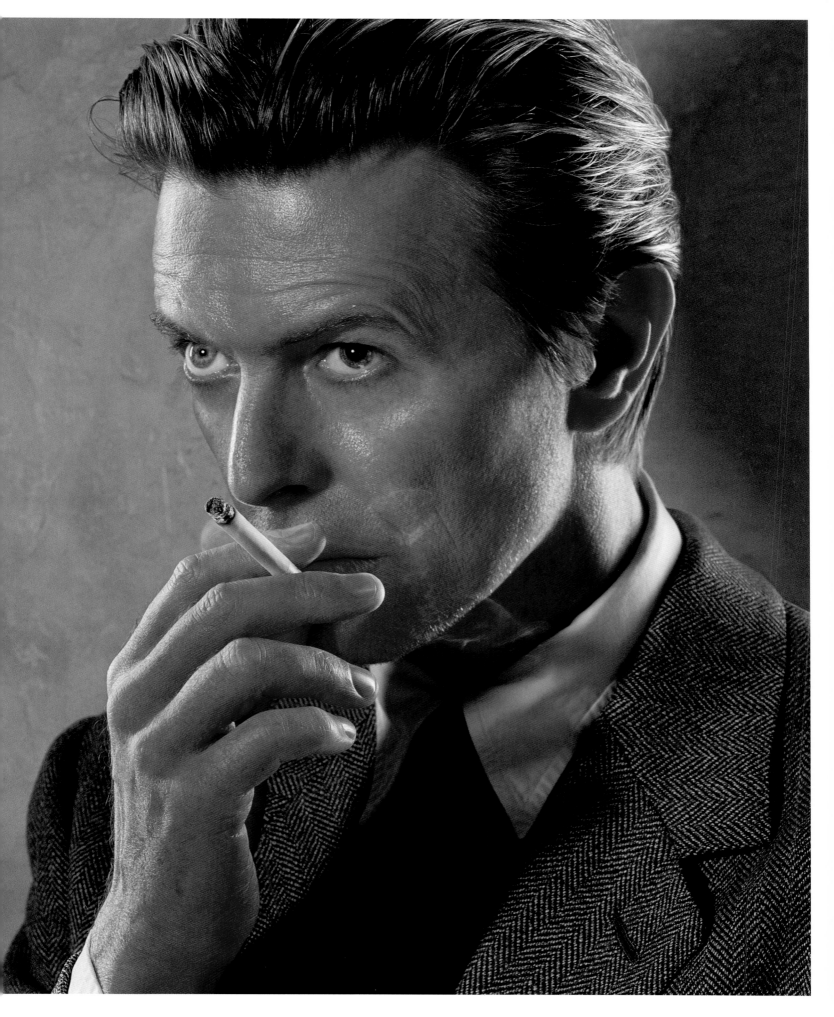

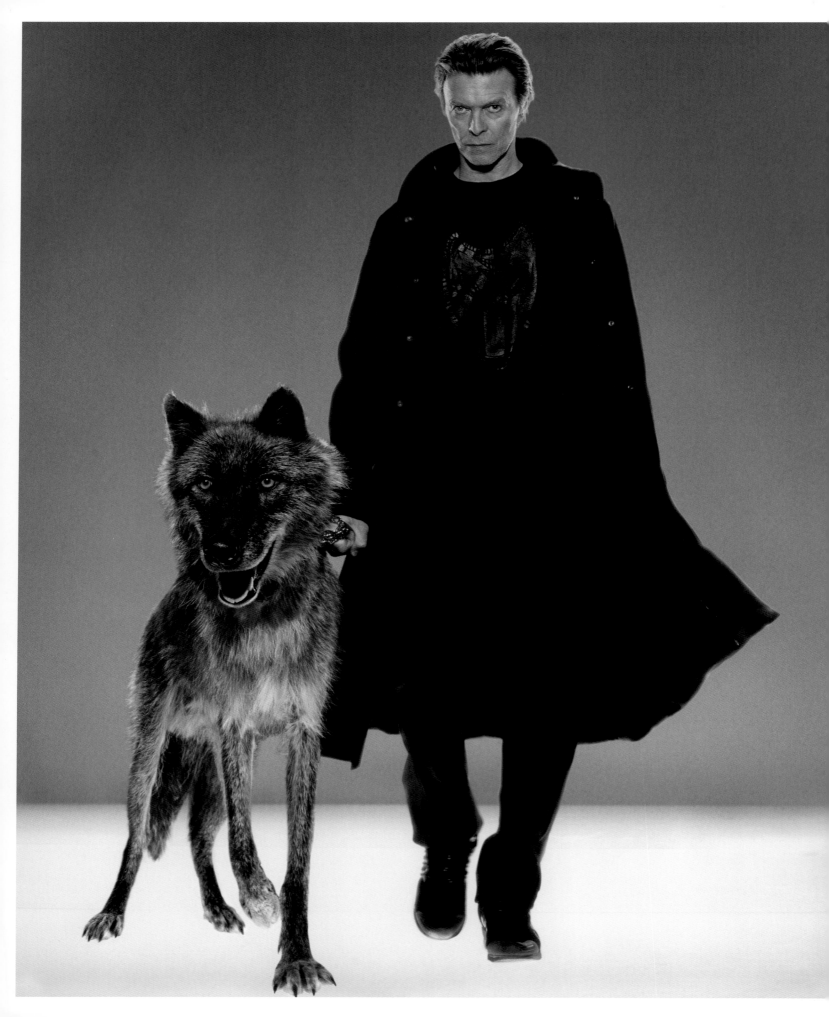

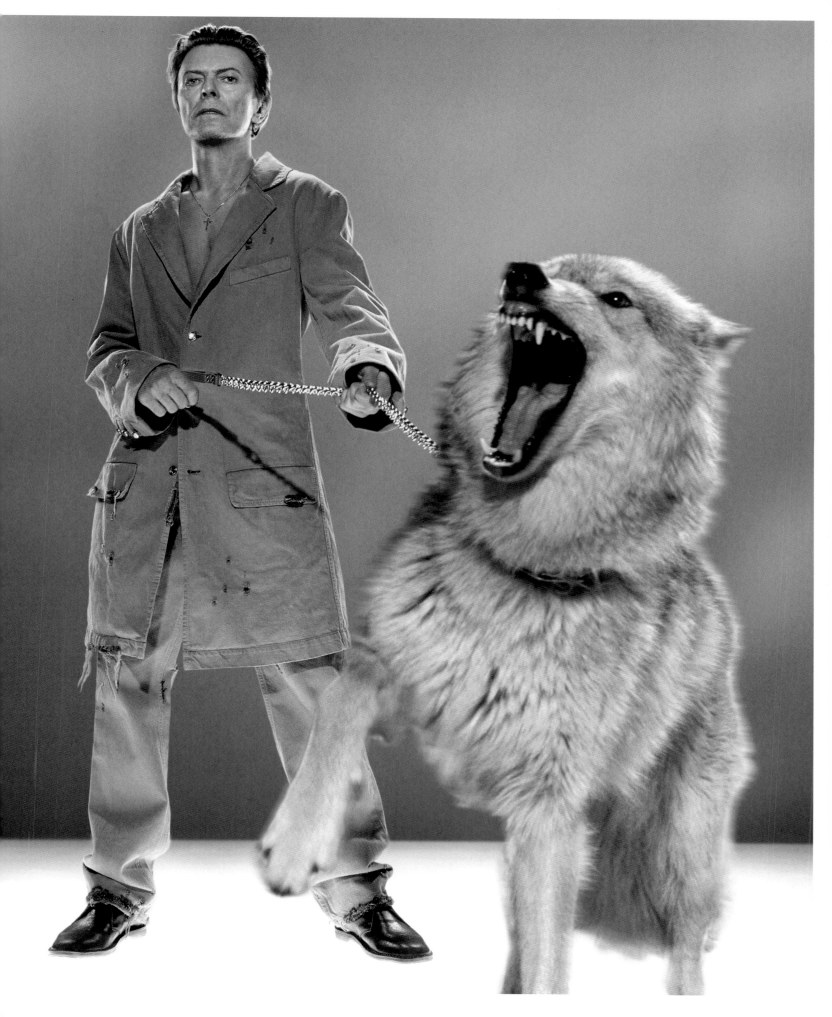

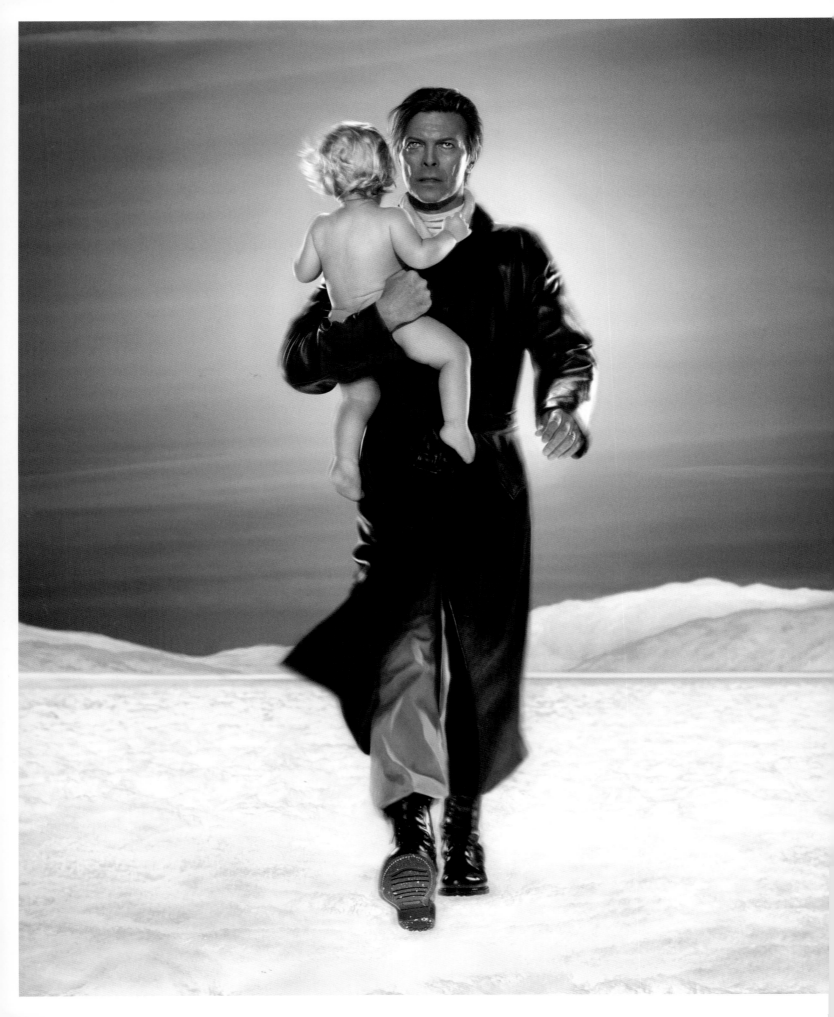

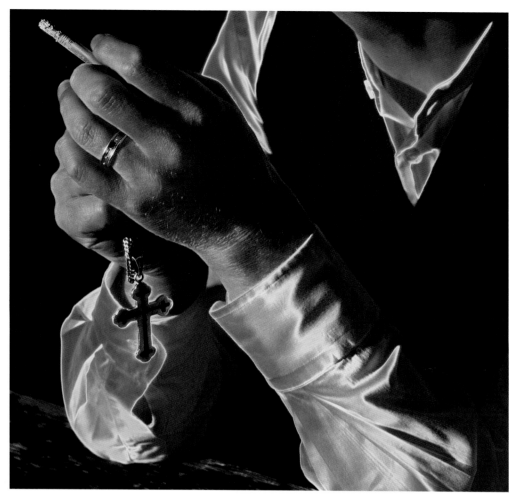

DAVID
G U E T T A

David Guetta, music producer, house recording artist, and arguably the most popular DJ in the world, has produced hits with the top music stars of today. He hired Markus and Indrani to shoot the cover of his album of house hits, *Guetta Blaster*. It was a two-day shoot. One day for David and the next day they shot a perfume campaign for his wife, Cathy Guetta. The shot Guetta selected for the cover art wasn't one of Markus and Indrani's favorites, but the composition and energy of this "water shot" is a favorite among their work.

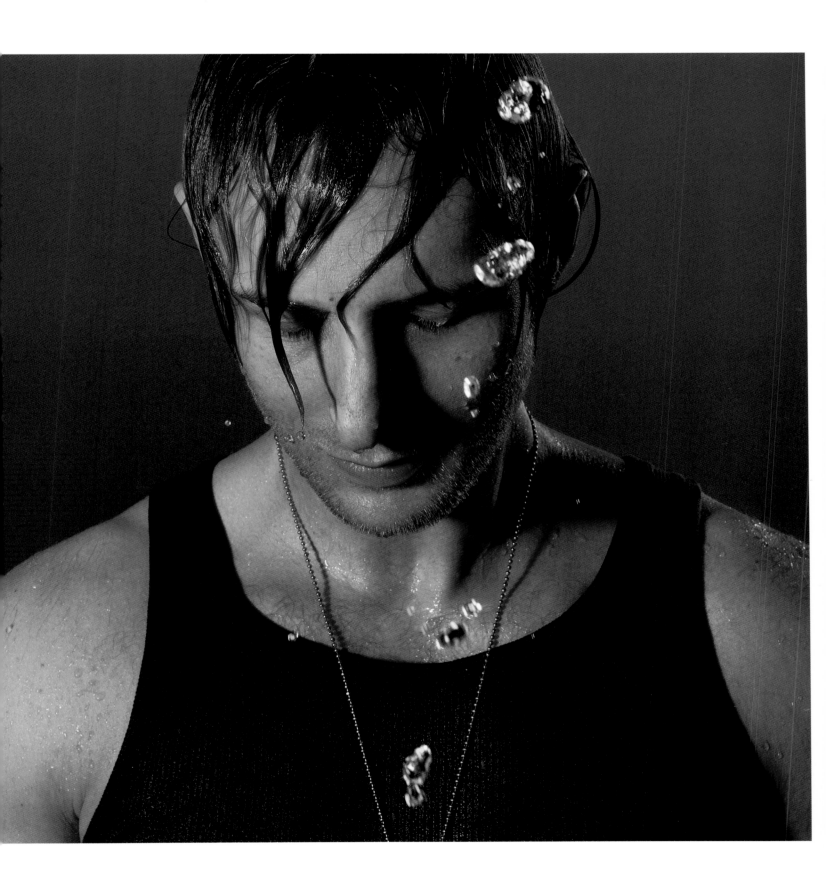

DIANE
K R U G E R

This shot of actress Diane Kruger was an early milestone for Markus and Indrani. At the time Kruger—then still known as Diane Heidkruger—was an internationally famous model, on many *Vogue* covers, the face of Chanel, and walking runways for Yves Saint Laurent, Armani, and Dior. Barely a year into Markus and Indrani's career as a photography duo, they were honored to photograph Kruger for an English magazine. Subsequently the shot also became their first magazine cover.

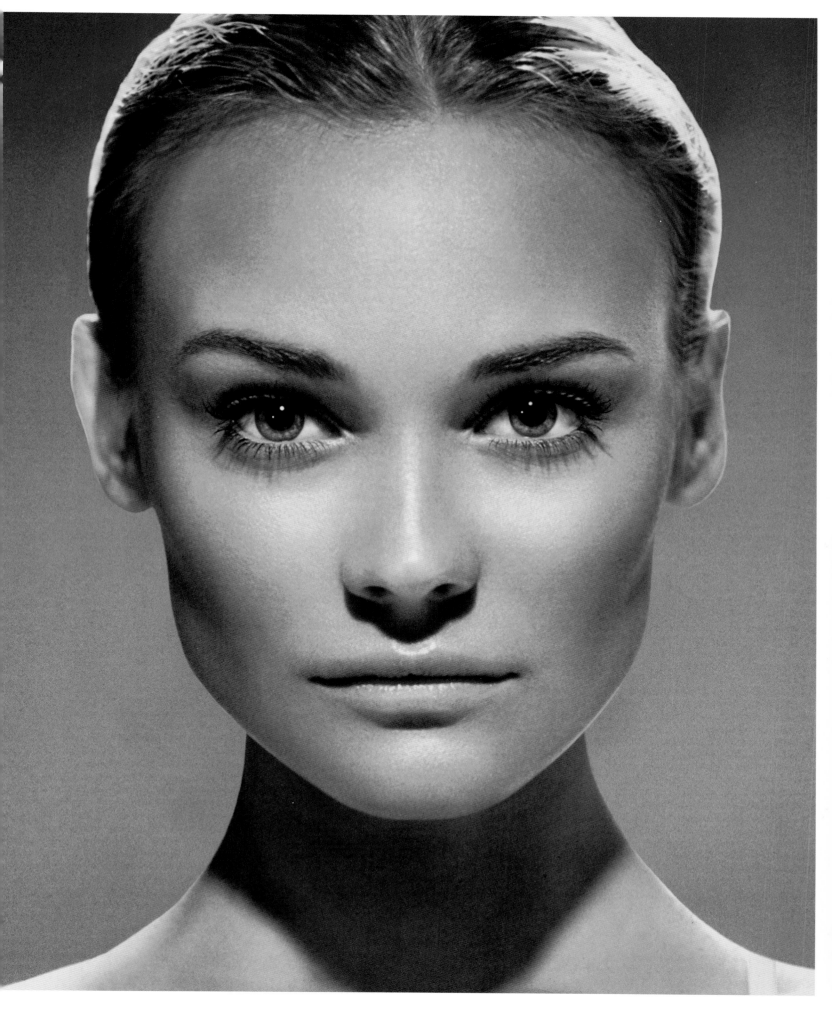

DITA
V O N T E E S E

Markus: "We were thrilled to work with Dita, burlesque star and international pop icon, because of her cool, confident attitude and her innate taste and style. She was also one of the most well-informed subjects we ever worked with—about photography, lighting, and in particular what would work for her." She was open to everything Markus and Indrani suggested and took direction well. To Markus, "It doesn't get any better than Dita. She was stunning." Dita embodies the powerful, goddess-woman that Markus and Indrani love to glorify in their work.

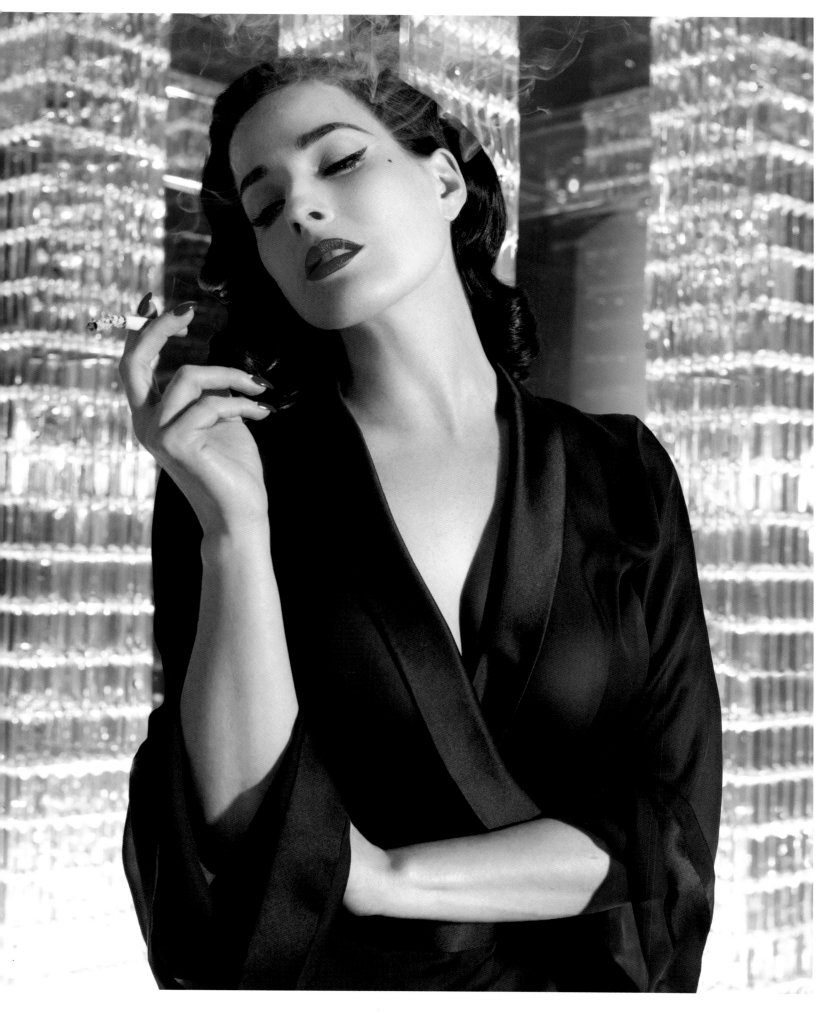

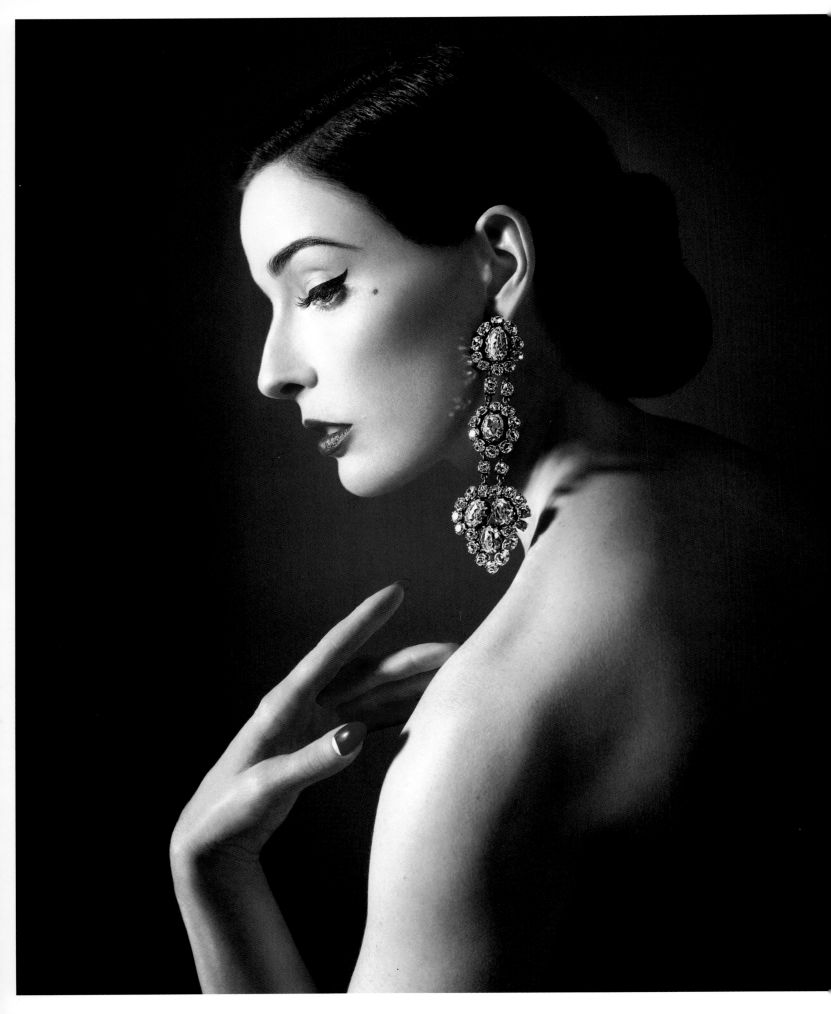

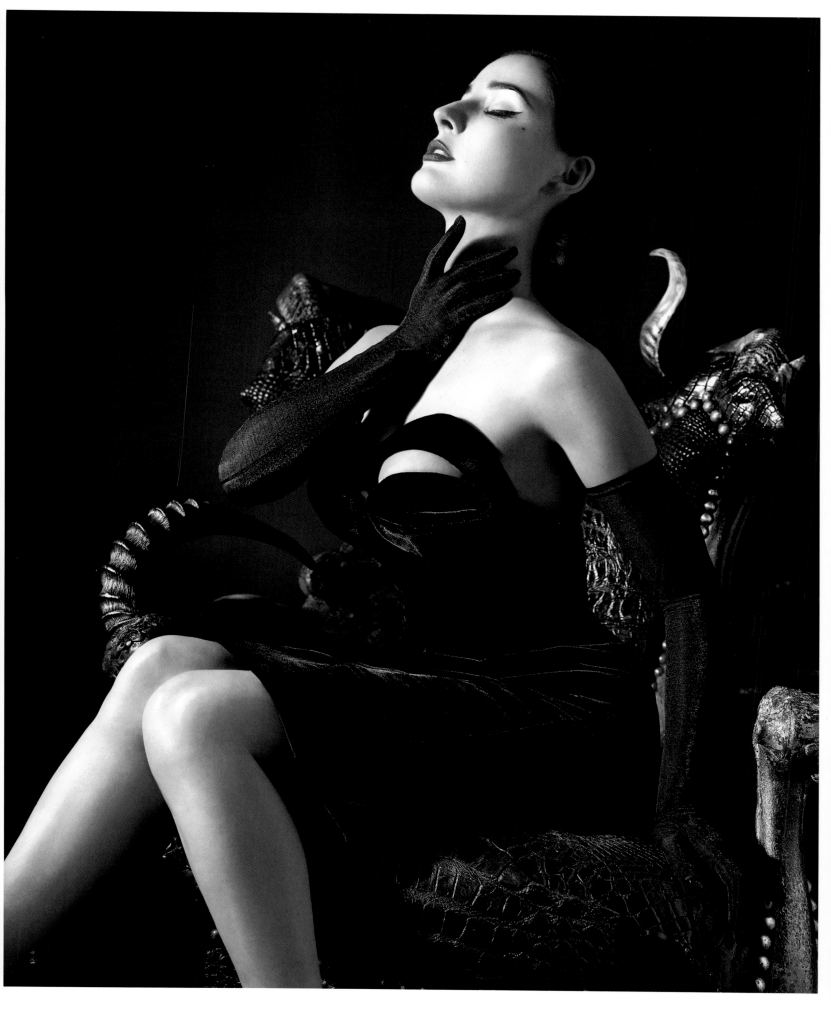

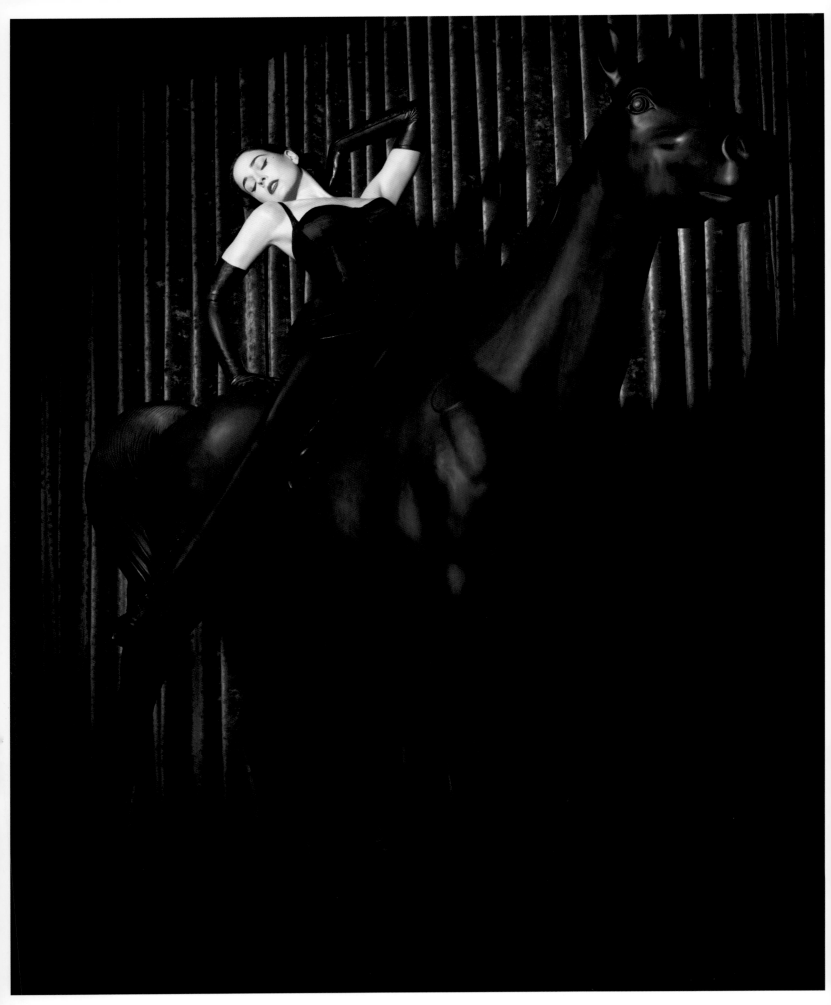

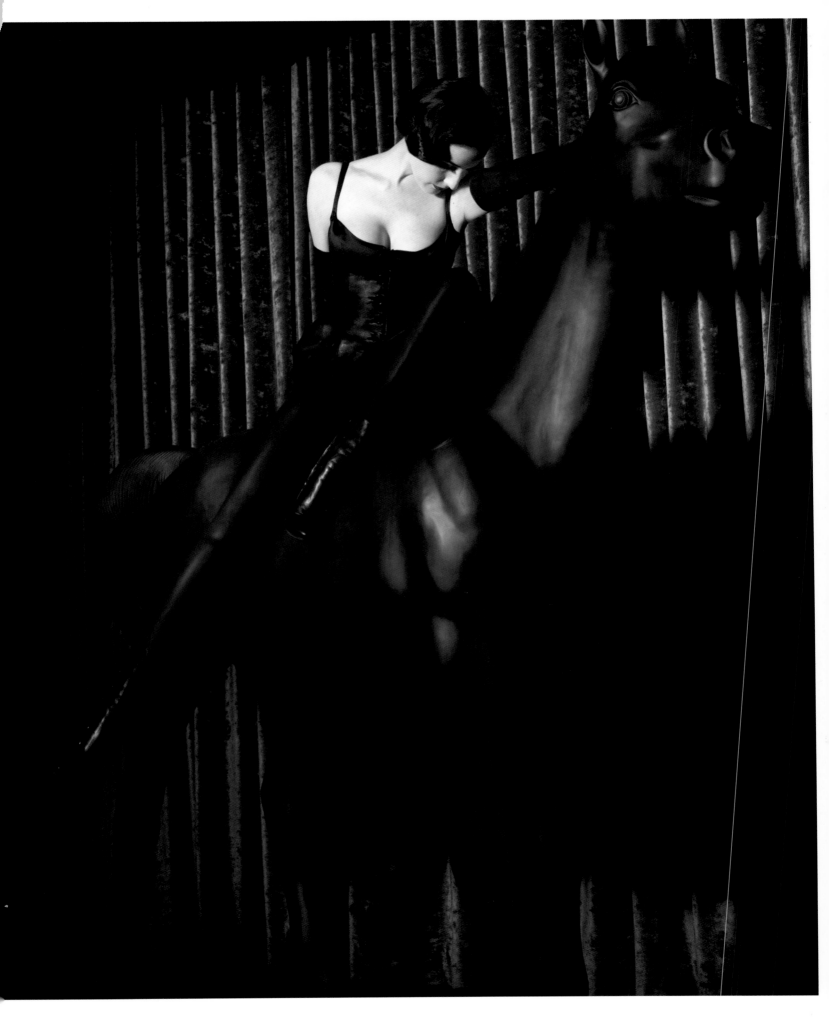

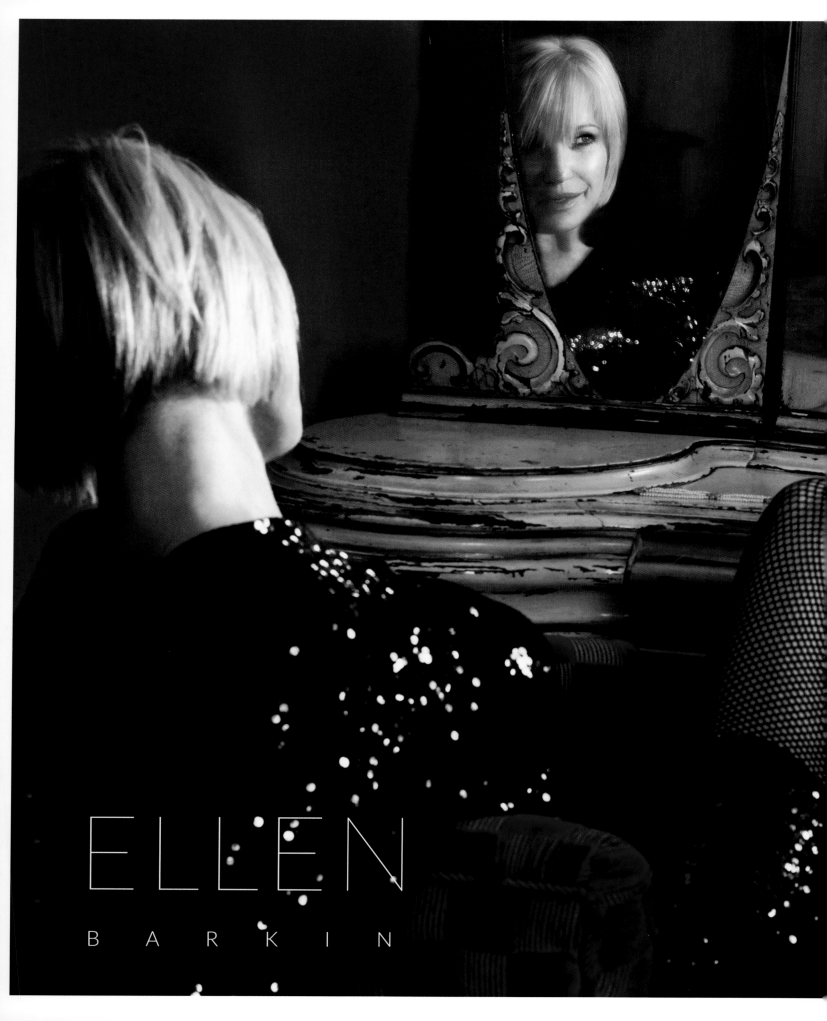

ELLEN

BARKIN

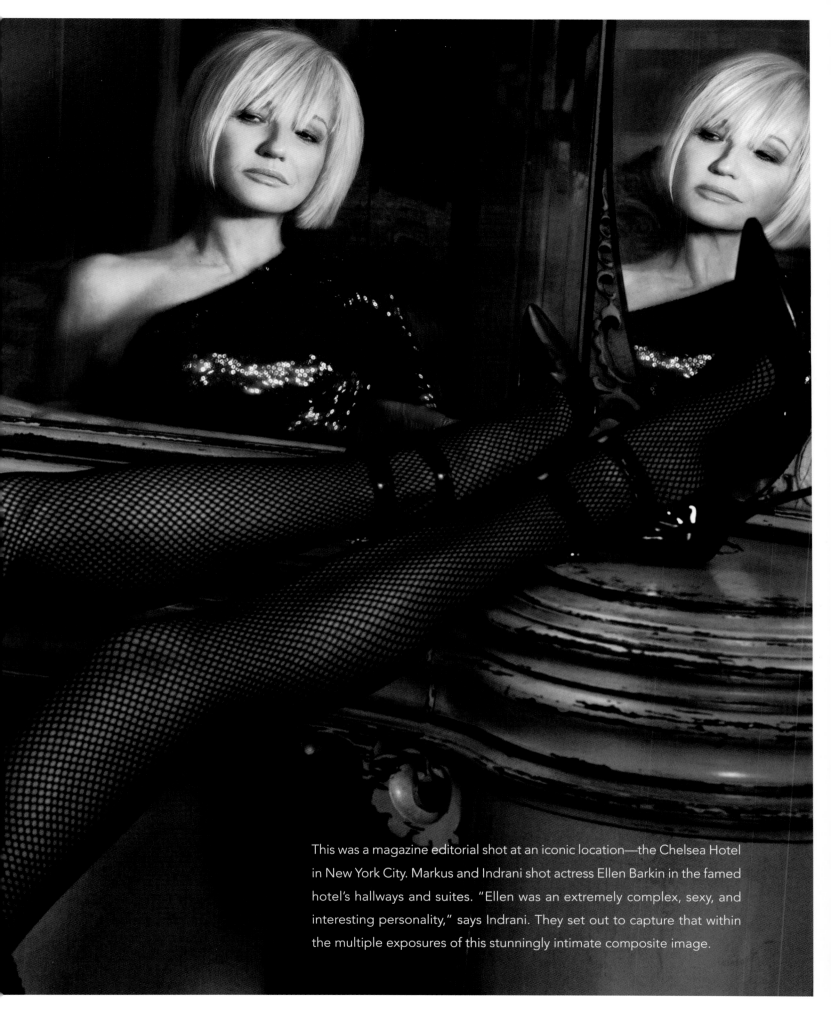

This was a magazine editorial shot at an iconic location—the Chelsea Hotel in New York City. Markus and Indrani shot actress Ellen Barkin in the famed hotel's hallways and suites. "Ellen was an extremely complex, sexy, and interesting personality," says Indrani. They set out to capture that within the multiple exposures of this stunningly intimate composite image.

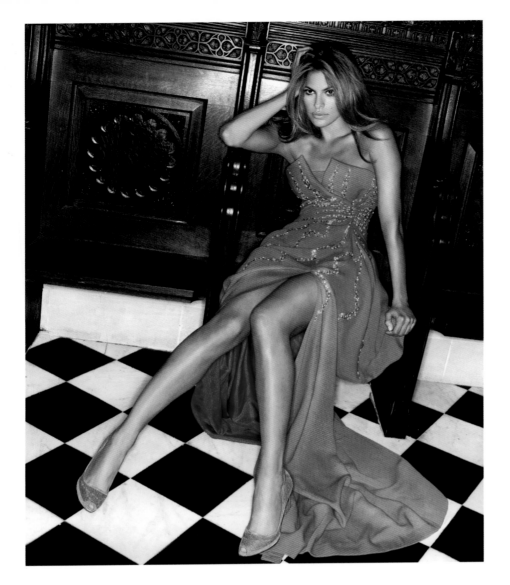

EVA

Shooting actress Eva Mendes was a particular joy for Markus. Indrani and GK, who were working in Venice at the time, gave their detailed notes prior to the shoot remotely while Markus conducted the actual session with Eva in New York City. The concept was an inspiring one—they wanted the shots to look like images from Fellini films of the '50s and '60s. They rented St. James Cathedral, where Markus "envisioned her as a sexy woman coming to church to confess her sins."

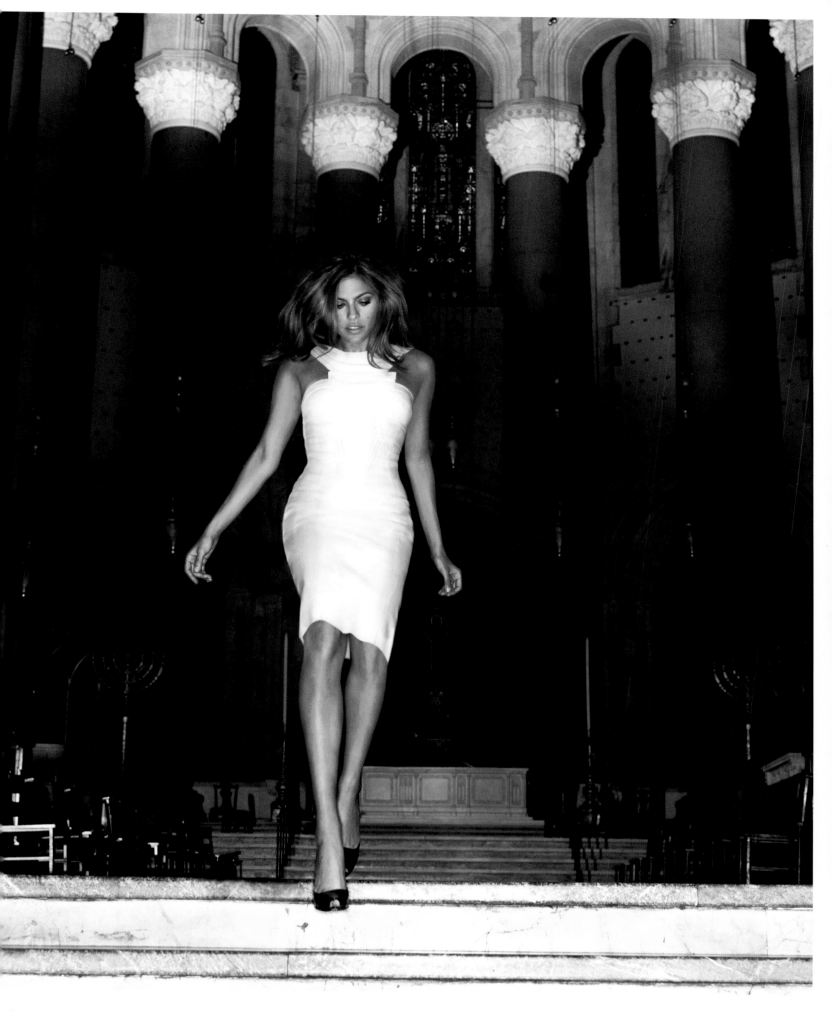

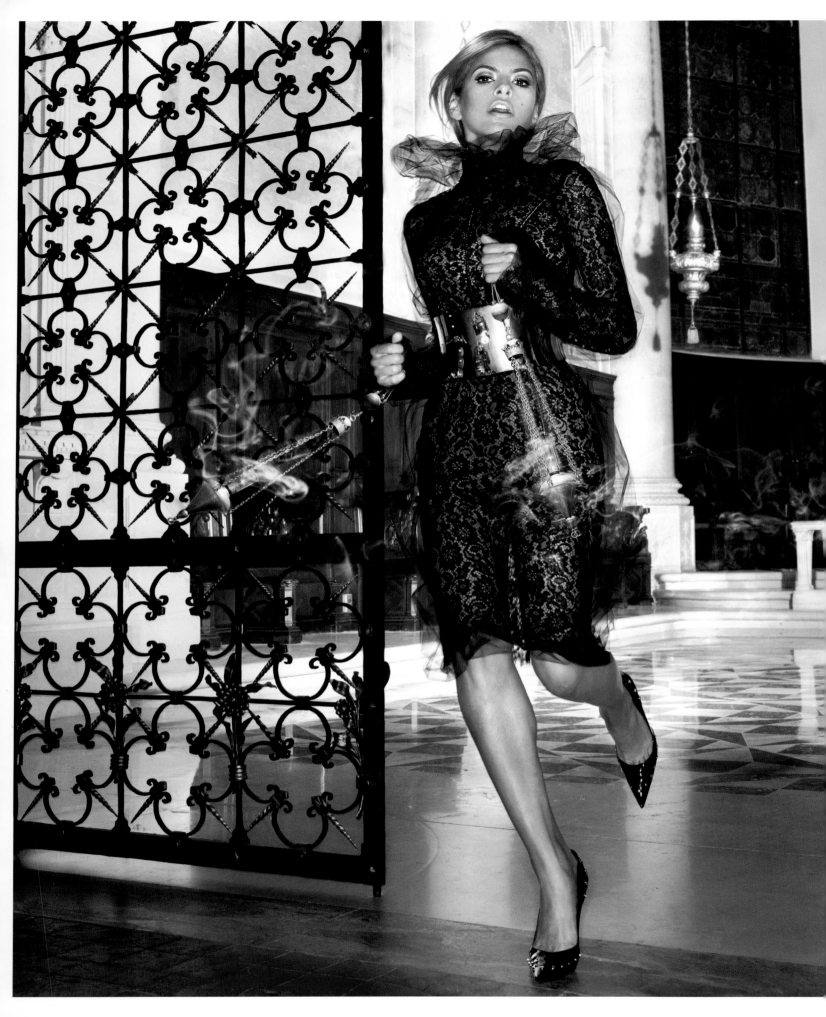

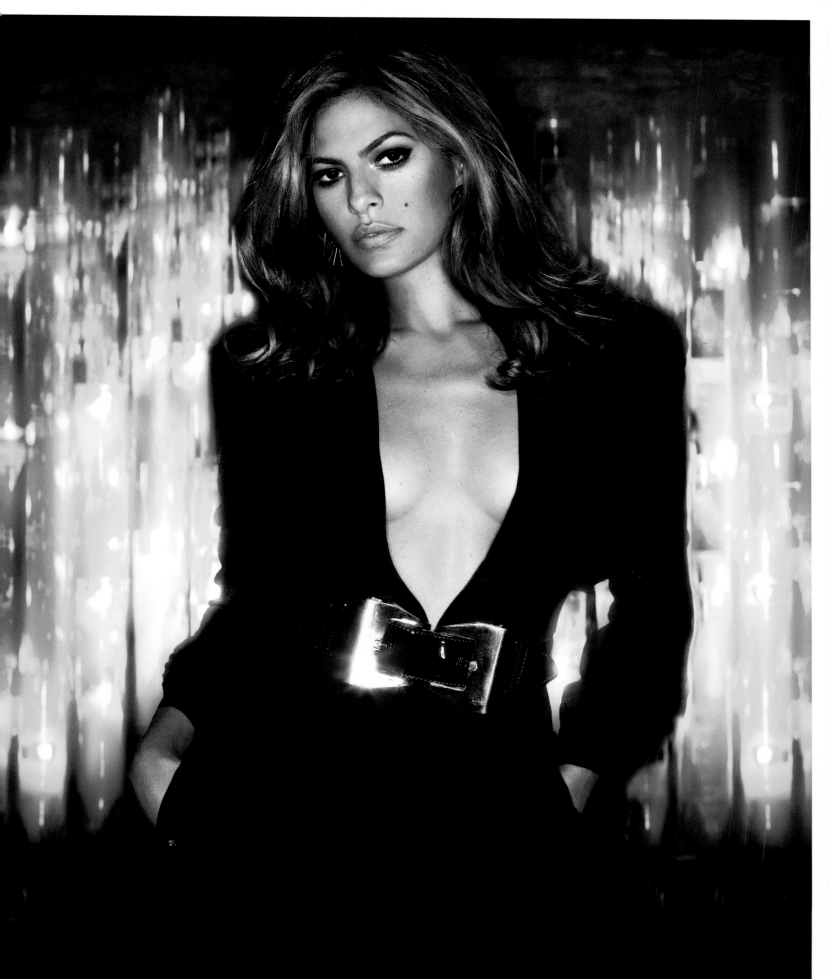

HEIDI & TIM
KLUM GUNN

Project Runway stars Heidi Klum and Tim Gunn were to appear on the cover of the Emmy Awards special issue of *Entertainment Weekly* and Markus and Indrani were commissioned to produce an iconic shot of the pair to celebrate the hit show's winning streak. Markus: "Both Heidi and Tim were a pleasure to work with, but the major issue during the photo shoot was that Heidi was very pregnant at the time but she did not want to be seen as pregnant in the pictures and neither did she want us to retouch it away." GK came up with a suitable dress for the supermodel. He picked a black bubble dress and Heidi looked as great as ever. In the photo at right Markus and Indrani had her peeking over Tim's shoulder, and in another series they made use of the theme of *Project Runway*, incorporating a bolt of fabric to billow out around the stars. The end results embodied the spirit of their hit show. Tim Gunn was so pleased he later asked Markus and Indrani to shoot the cover of his book, *Tim Gunn: A Guide to Quality, Taste, and Style.*

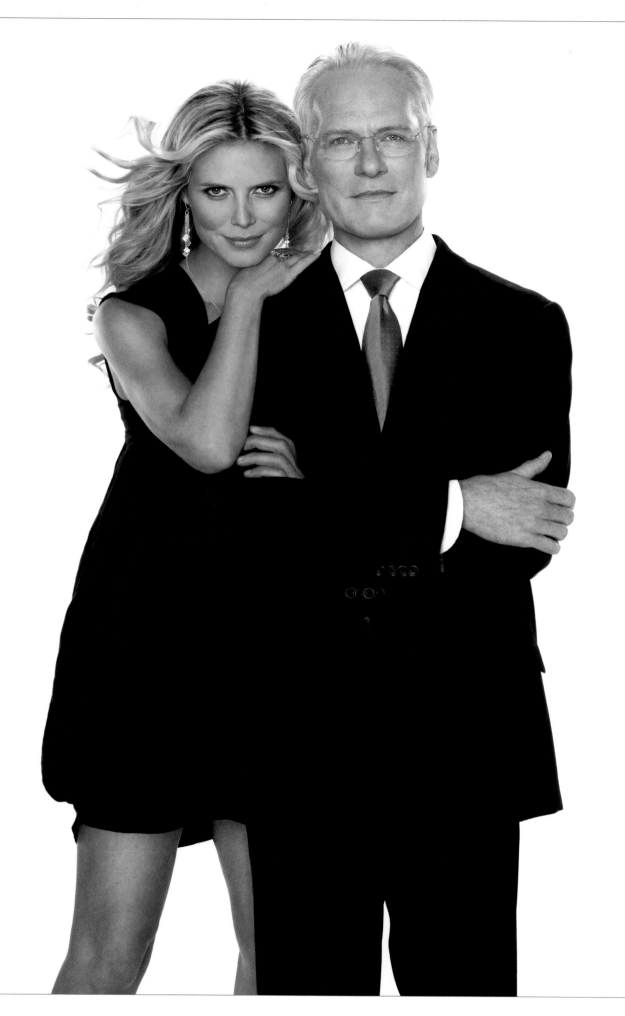

IMAN

One of the greatest photographer/star collaborations for Markus and Indrani has been with iconic supermodel Iman, who was one of their early mentors. They first shot her in 2001, when she was doing a book of the greatest photographs of the past twenty years of her career. It was filled with the work of legendary photographers including Helmut Newton, Herb Ritts, and Steven Meisel, but she chose Markus and Indrani to shoot the cover even though their work was relatively unknown up to then. "Shooting Iman's book cover was our most prestigious assignment to date and we were extremely excited about it," says Indrani.

For the front cover Iman chose a close-up, with a high gold neckpiece that GK had made to represent her Somali background. She was to appear topless but the shot was ultimately cropped for mass consumption. On the back cover, Iman set the scene on fire wearing an Alexander McQueen dress emblazoned from below, and it's where the Markus and Indrani goddess-warrior conquers.

Iman's husband, David Bowie, was on set and loved what he saw so much that he asked Markus and Indrani to shoot the cover of his upcoming album, *Heathen*. The two projects truly established Markus and Indrani among the world's preeminent photographers.

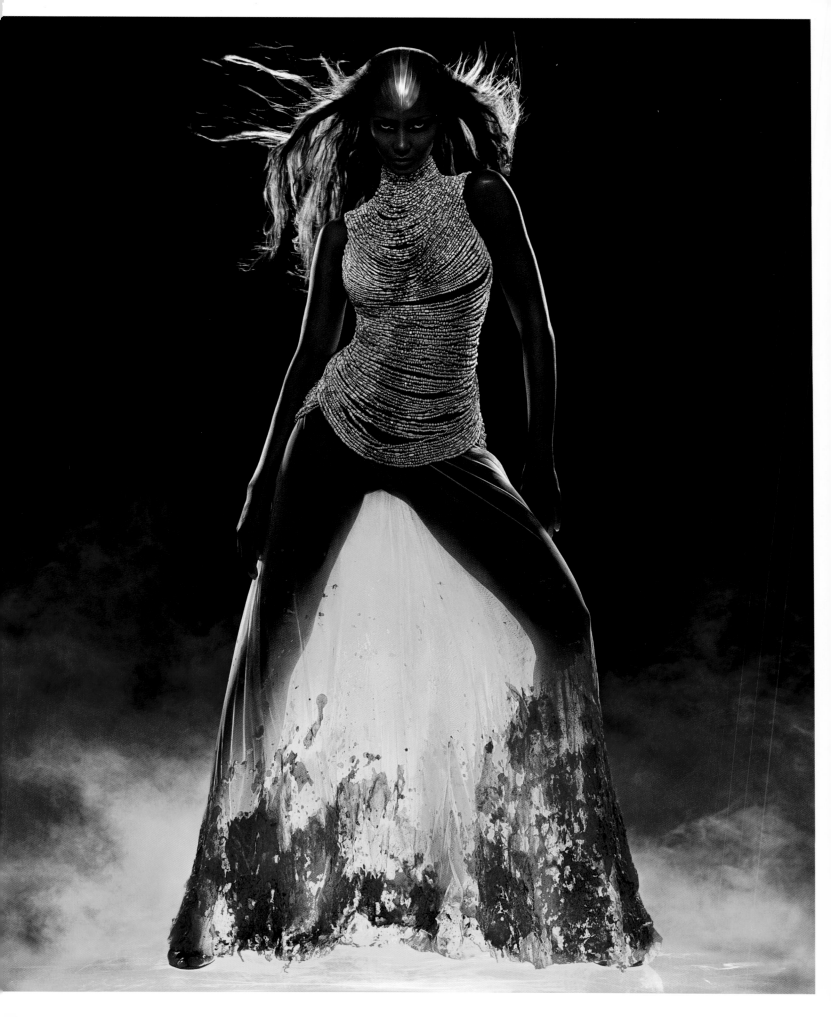

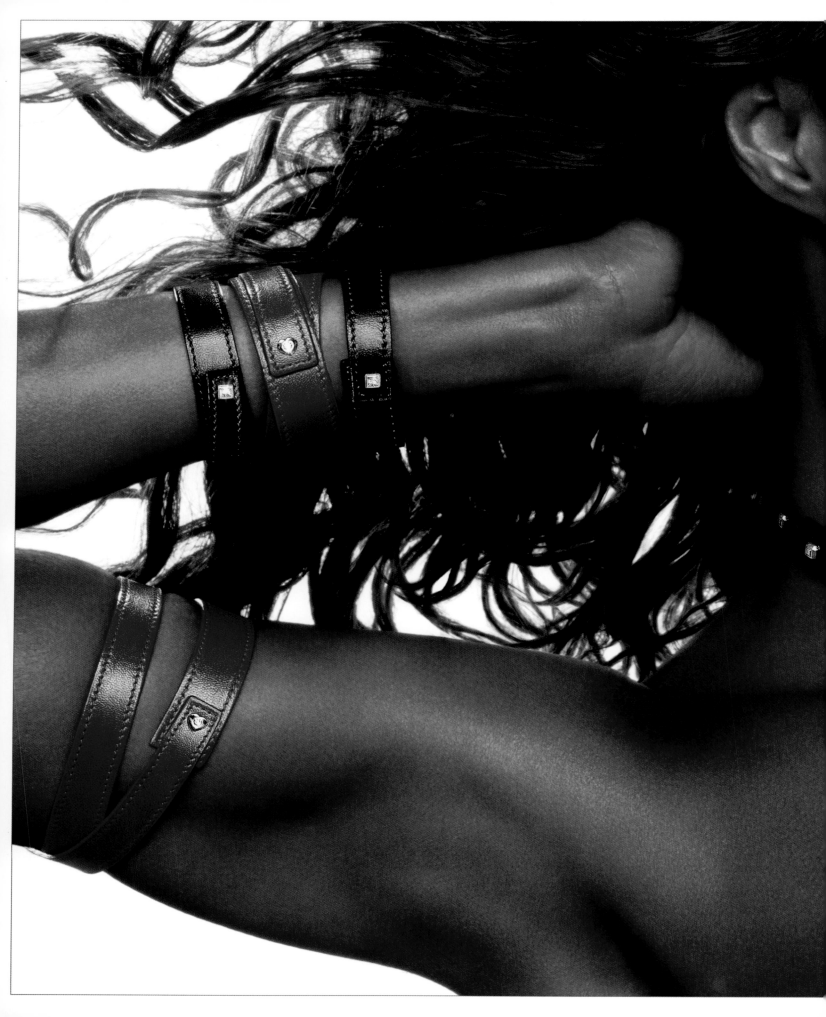

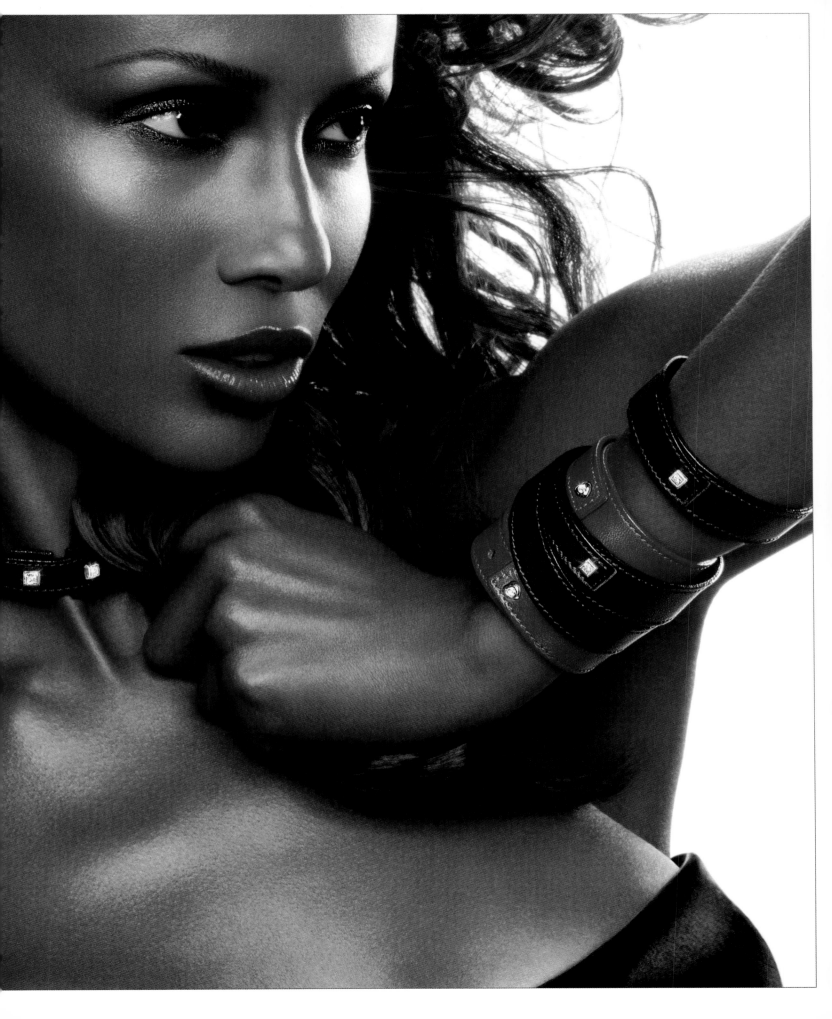

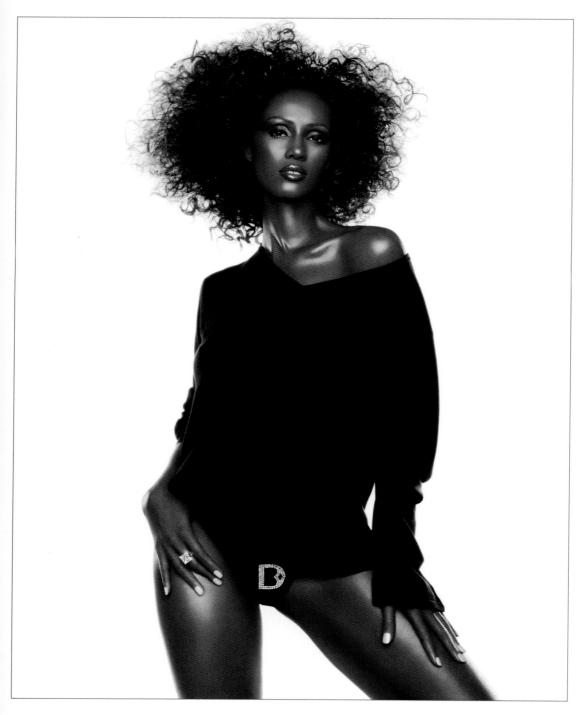

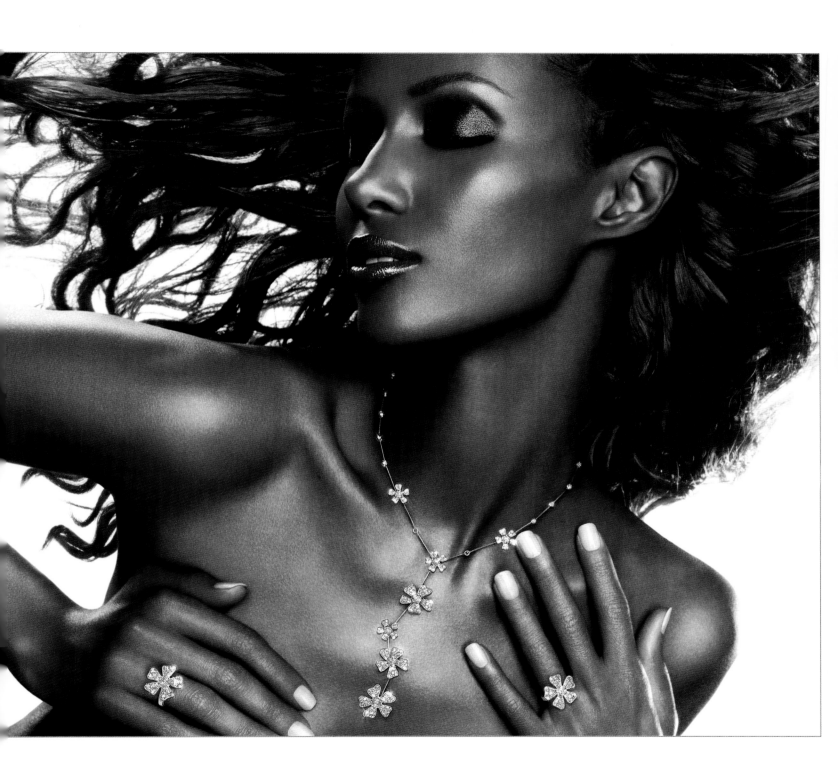

JANET
J A C K S O N

"Janet Jackson was quite shy at the beginning of our shoot but then opened up and was very friendly and very knowledgeable," recalls Markus. She wanted as few people as possible on set, though Markus and Indrani had an additional subject to make their shoot with the legendary singer even more interesting: Set before a gold Egyptian backdrop, they decided to shoot Jackson with a genuine panther at her side. Of course, the panther was added to the shot of Jackson in post-production by Indrani.

While Indrani was out arranging to get panthers prior to the shoot, Markus was looking for the biggest studio he could find so that he could shoot from afar and keep as much distance as possible between himself and the panther. Indrani, on the other hand, liked the panther and felt it brought out the parallels in Janet's own nature: "She was sweet but had a strength inside that was necessary to protect a star of her magnitude."

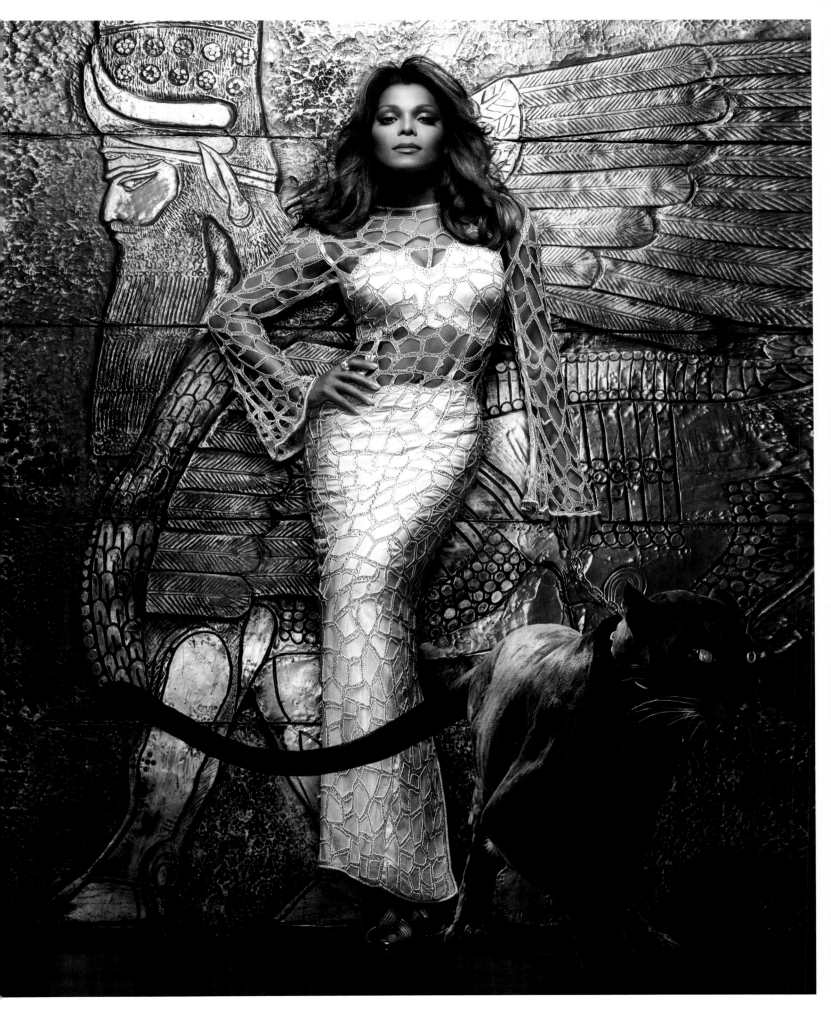

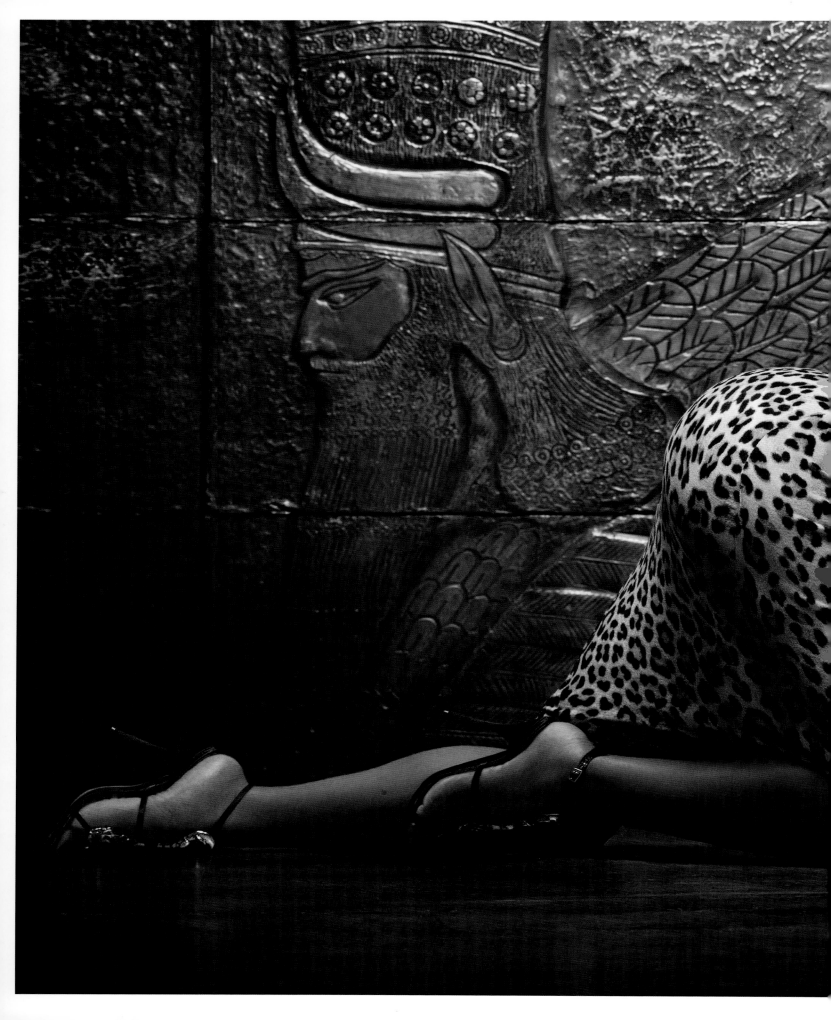

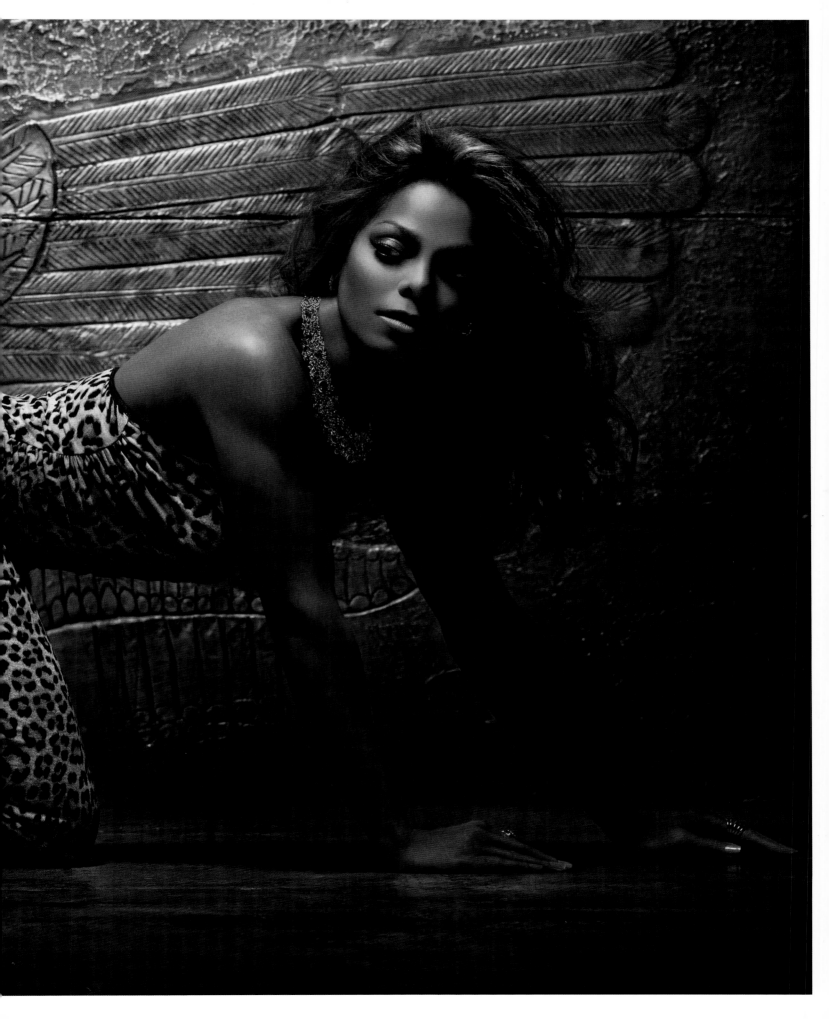

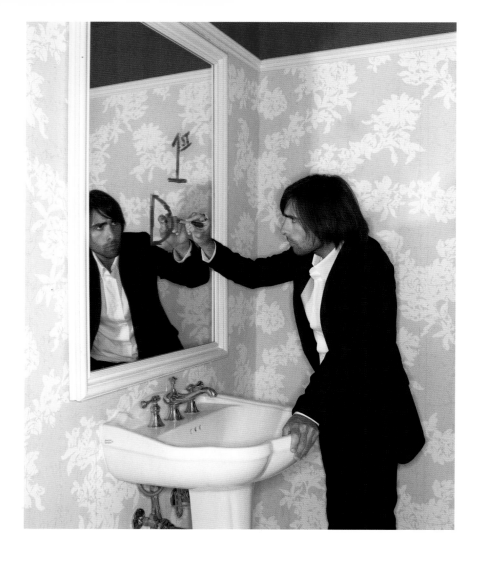

JASON

S C H W A R T Z M A N

Actor Jason Schwartzman was a terrific subject for Markus and Indrani and took to their process with enthusiasm. "He was funny and full of life, excited about finding new ways to make the shots interesting," recalls Markus. Though experimenting was fun, Schwartzman's best shot perhaps is a simple close-up that exhibits his soulful gaze.

The playful shot on this page contains an inside joke. By complete coincidence, the hotel that Markus chose for the shoot was the very same hotel in which Schwartzman had gone on his first date with his wife. He borrowed a tube of lipstick from one of the crew members and proceeded to write "1st Date" on the bathroom mirror.

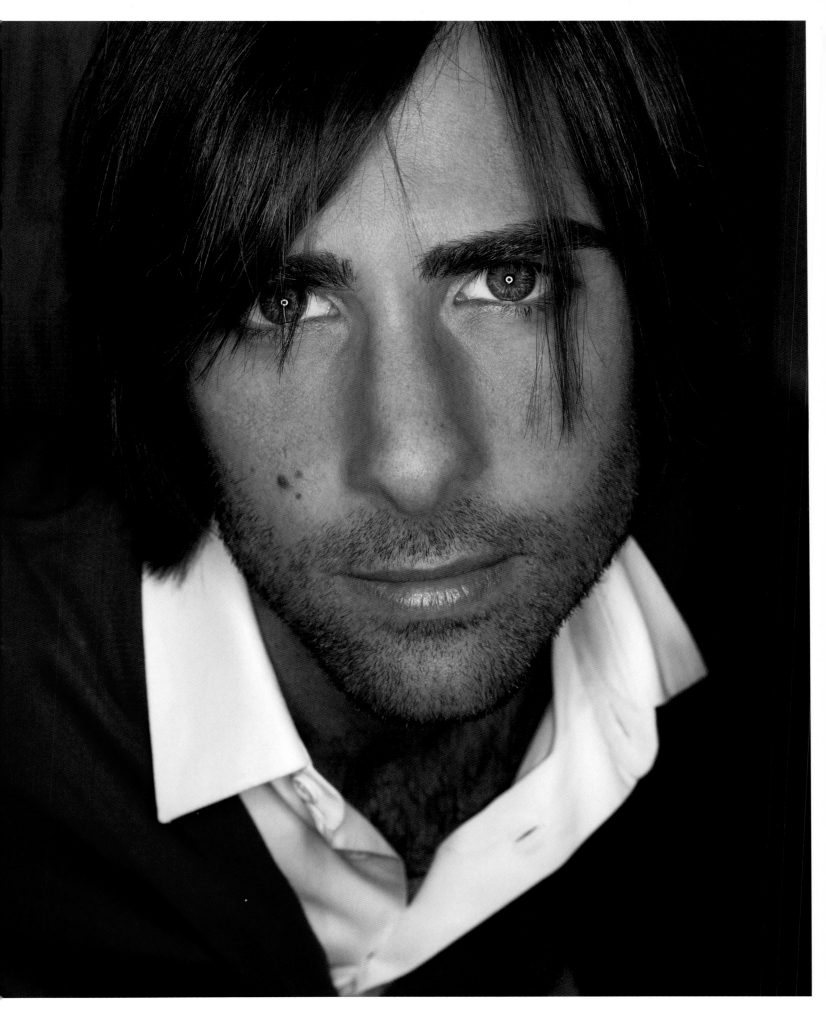

JASON
S T A T H A M

Markus and Indrani's editorial shoot with Jason Statham produced a series of powerful photographs. They shot the British actor in a studio and then went on location. The images were later combined in post-production. The location was especially thrilling for the photographers. Indrani had discovered an old bombed-out military base outside of Palm Springs. The shoot was elaborate, involving pyrotechnics to create a brilliantly dramatic atmosphere.

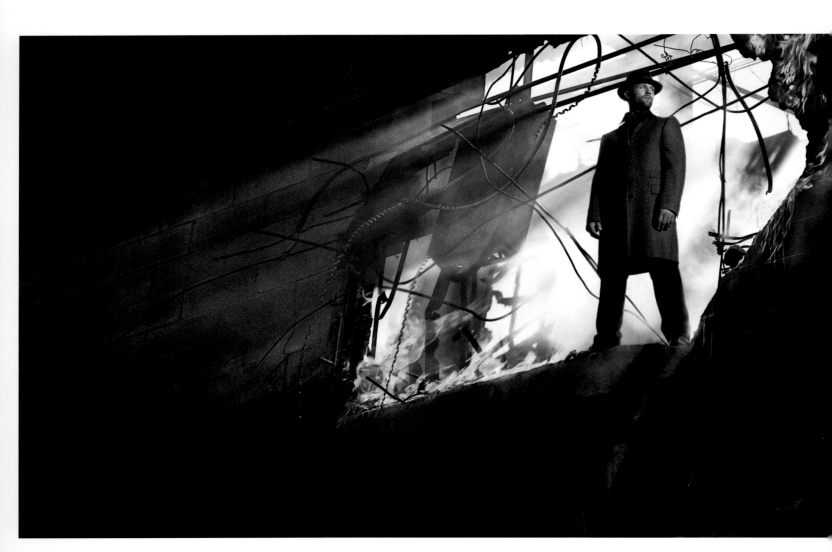

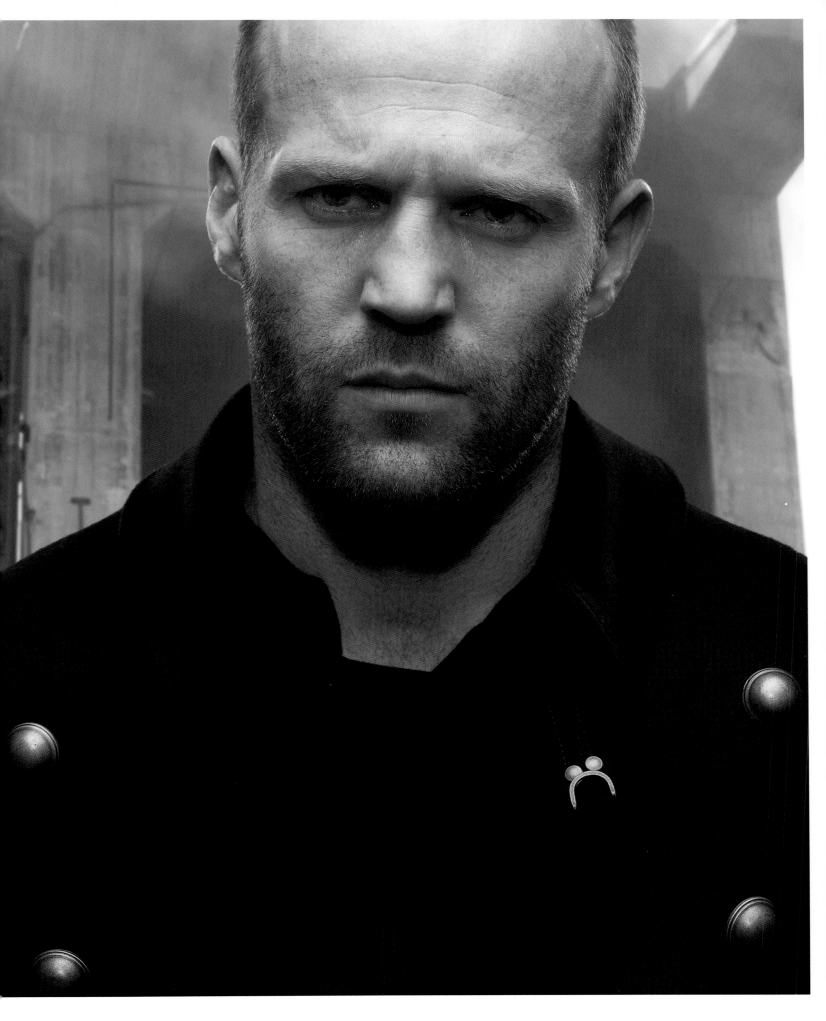

JAY-Z

Rap icon Jay-Z walked into his shoot with Markus and Indrani smiling ear to ear, saying he was happy to be working with the photographers who had created the transformative *Dangerously in Love* album cover of his then girlfriend Beyoncé. Markus and Indrani were also set to shoot a transformative image of Jay-Z, who was then transitioning from rap star to major music mogul. Markus: "The concept was to shoot this larger-than-life personality in a Gotham-like office setting, as the businessman he had become."

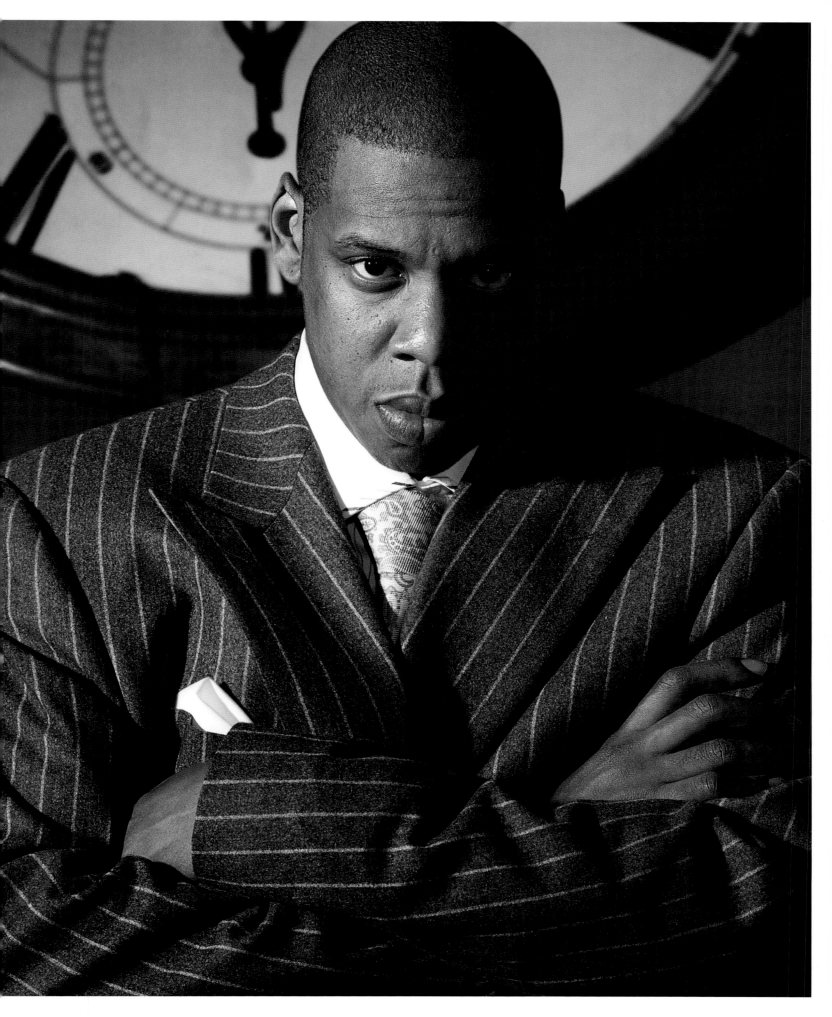

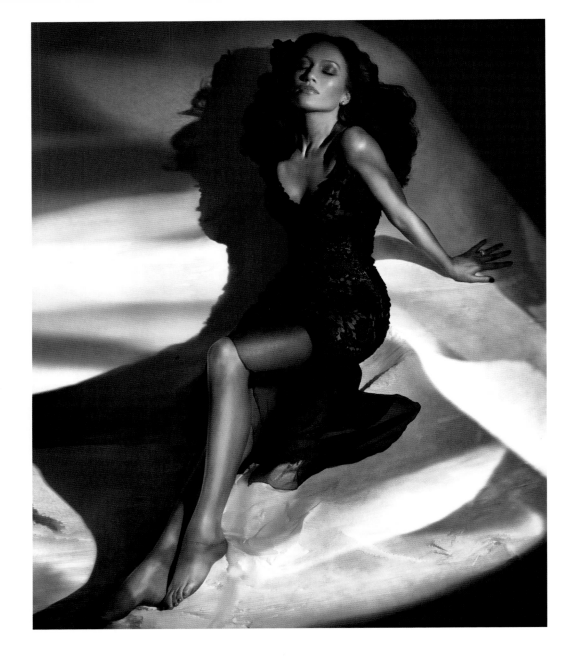

JENNIFER
L O P E Z

Markus and Indrani shot actress and pop icon Jennifer Lopez to promote her new Spanish-language album. When GK and Indrani first met Jennifer to discuss the concept of the shoot they were blown away by her intelligence and natural beauty. She had a strong vision of what she wanted for the shoot, basing it on a dream she had of a singer from the past with black lips, black hair, and surrounded by thorny black roses.

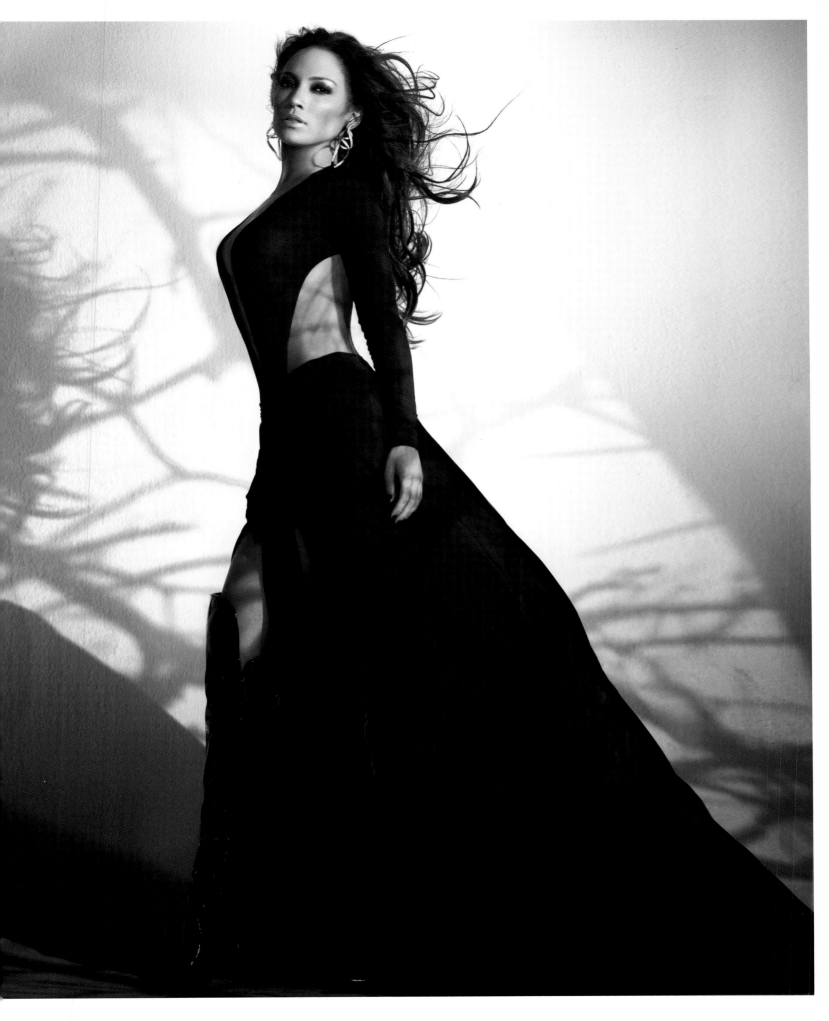

JOE
P E R R Y

This Markus and Indrani shot of Aerosmith guitarist Joe Perry breathes with rock-and-roll energy. Markus: "There was no better way to shoot him than rocking out on his guitar." Indrani: "We shot him in front of a specially rusted metal wall that reflected his personality."

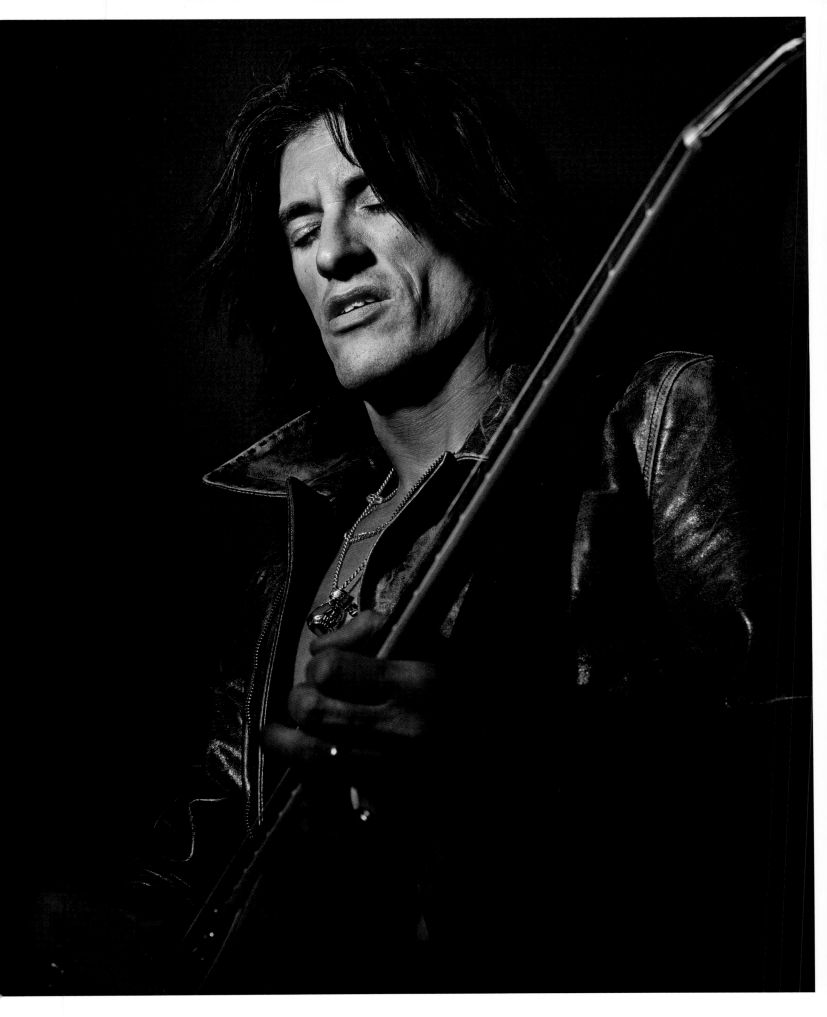

KANYE
W E S T

Markus and Indrani were struck by Kanye West's strong sense of style and his enthusiasm before the camera. He moved well and had great energy, but the best image from the shoot, cropped in tight close-up, shows the power behind the eyes of the music icon.

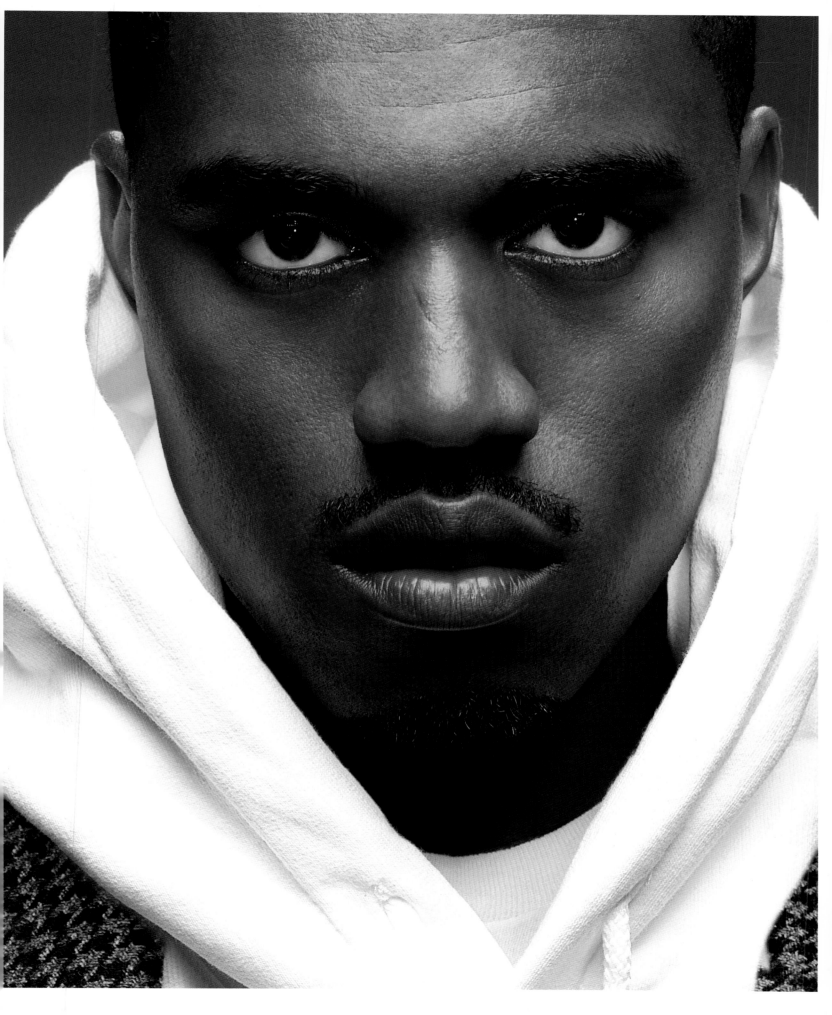

KATE
W I N S L E T

Originally commissioned by *Flaunt* magazine and then used as a cover for many magazines and as Lancôme's worldwide campaign image, this portrait of actress Kate Winslet is easily one of Markus and Indrani's most famous. No one involved could have guessed the photograph would have such an incredible life. "The shoot was short and simple," says Markus. "She wasn't feeling well, just getting over the flu and had a sick child at home as well, so it was a challenge for her. Kate was friendly and professional, but anxious to get it done quickly." The shoot was the essence of simplicity. Fifteen minutes, a black blouse, and white wall were all it took for Kate Winslet, Markus, and Indrani to create this iconic image.

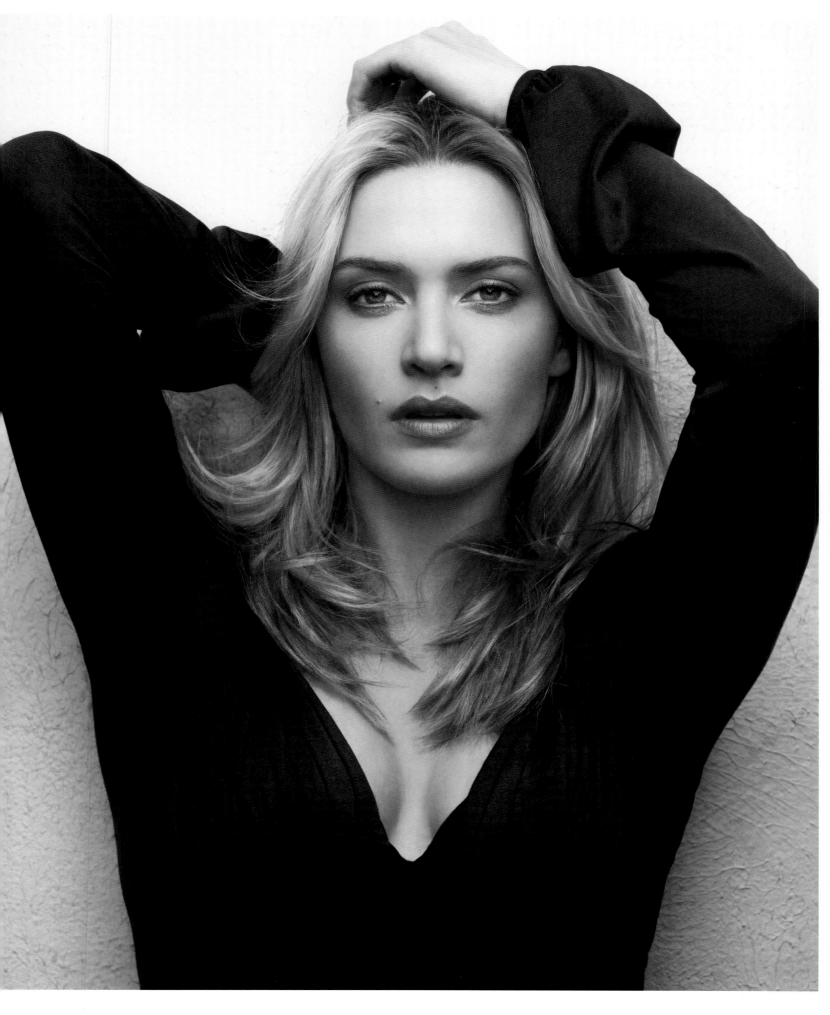

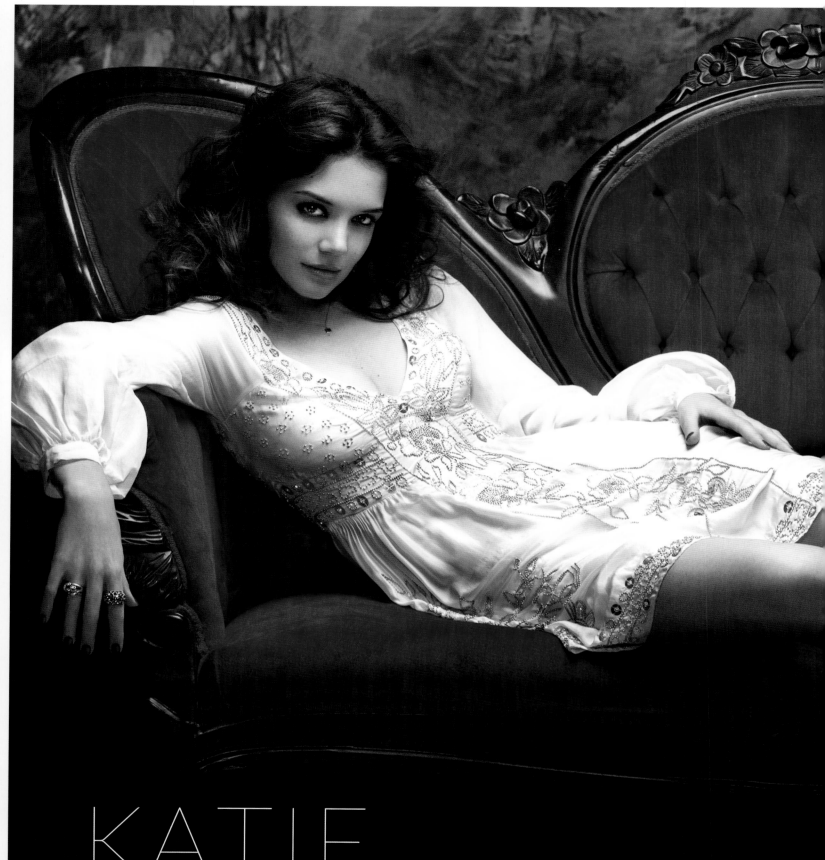

KATIE

HOLMES

Markus and Indrani's first photo session with Katie Holmes took place in 2005. She was already a star famed for the teen television drama *Dawson's Creek*, but shortly after this shoot she would make headlines as her relationship with Tom Cruise provoked mass interest in her personal life. Age twenty-seven though still thought of as a younger girl, this photo represents the mature, sexy woman she had become.

The next time Markus and Indrani shot Katie was for Keep a Child Alive. "When we first met, Katie was a very sweet, nice girl," recalls Indrani. "Five years later she had a different aura about her. As a mother, wife, and leading Hollywood actress she had achieved a certain status and was still lovely, but equally poised and striking."

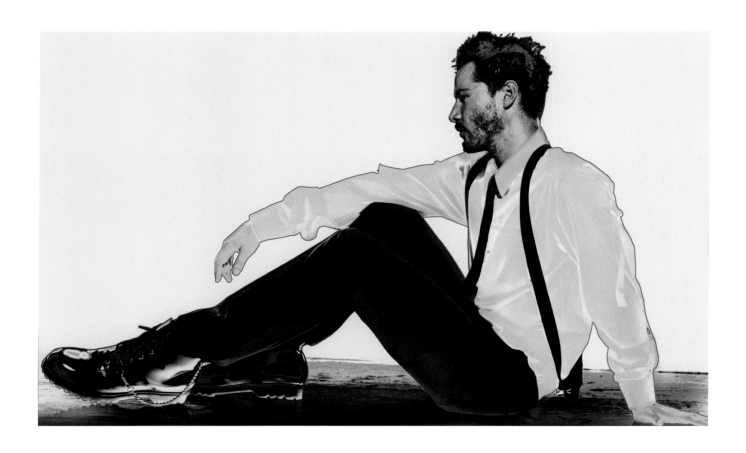

KEANU
R E E V E S

The shoot with action star Keanu Reeves showed the actor in a more emotional, artistic context. This was not the Keanu Reeves of *Wayne's World* fame, but an intense look at an artist expressing depths of personality not usually seen in the roles he often plays.

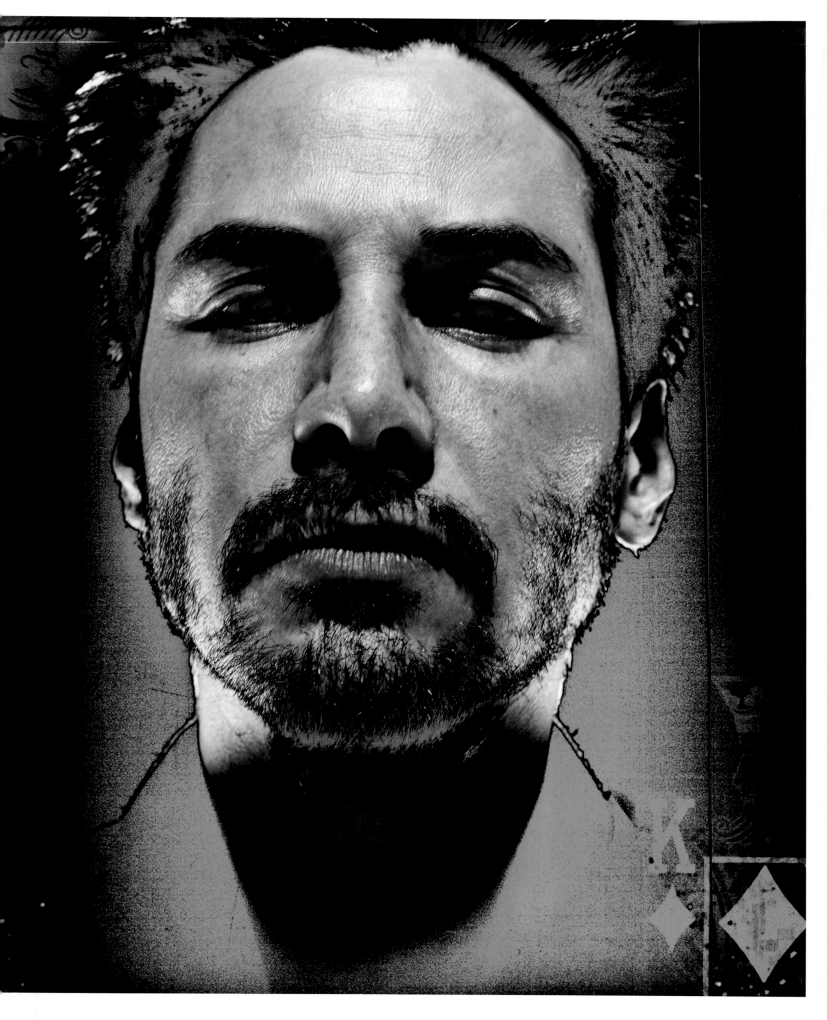

ELIJAH WOOD

KATIE HOLMES

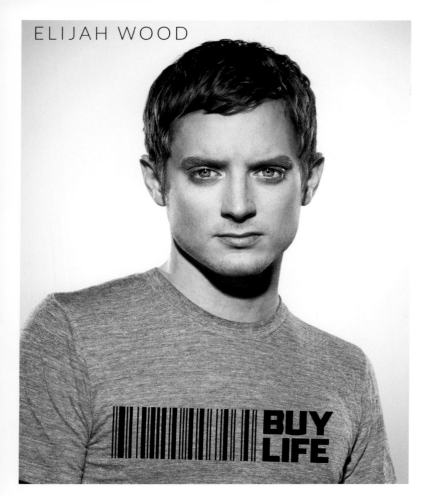
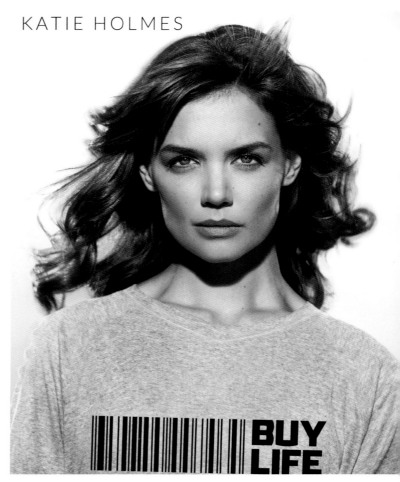

KEEP A CHILD ALIVE

Keep a Child Alive is a charitable organization with a mission to support children and families affected by HIV/AIDS in Africa and India. Markus, Indrani, and GK Reid donated their time for three campaigns, including this famed series that won two Gold Lions at Cannes and raised over a million dollars in under a week—as well as major awareness for the cause. Dozens of celebrities participated in the Buy Life/Digital Death campaign. All the stars were shot in simple gray T-shirts, and many also laid down in coffins as Markus clicked his camera from a high ladder above. Indrani filmed a PSA simultaneously.

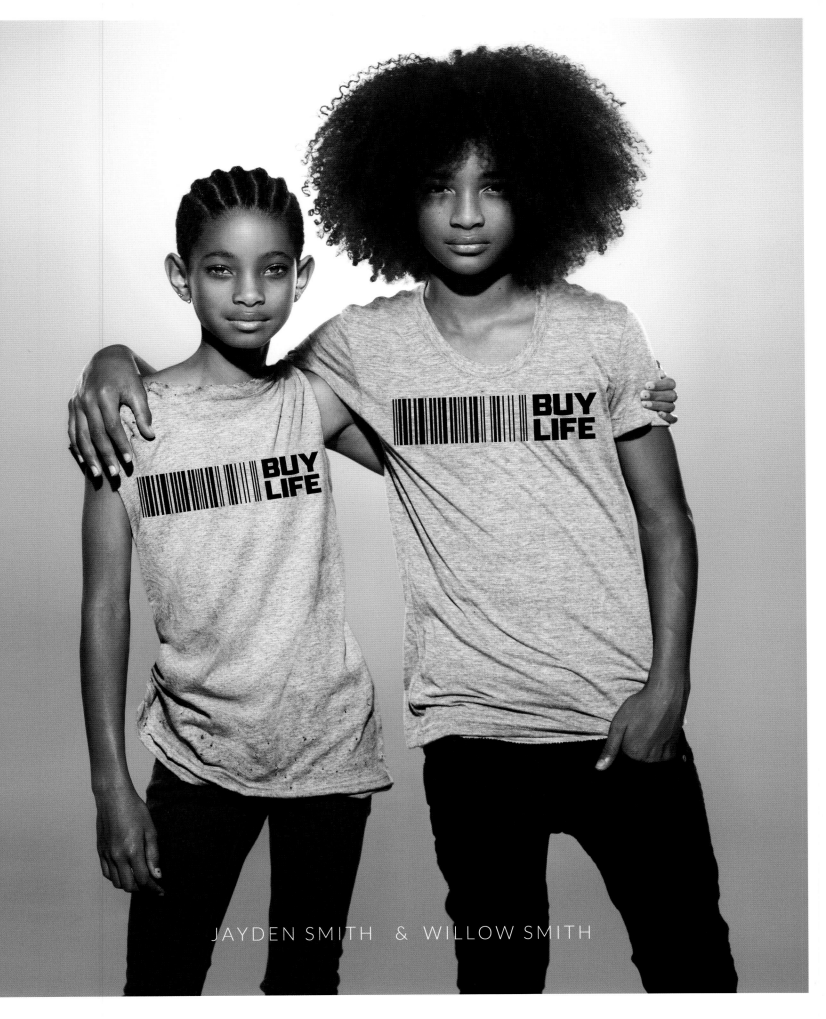

JAYDEN SMITH & WILLOW SMITH

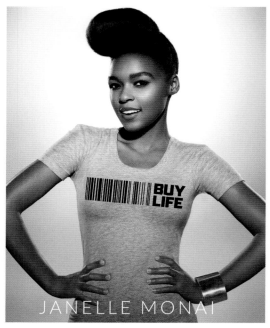

JANELLE MONAI

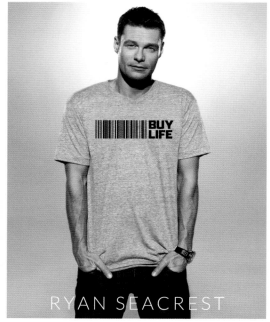

RYAN SEACREST

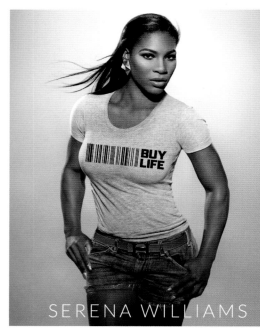

SERENA WILLIAMS

THE BURIED LIFE

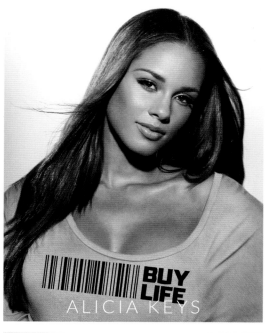

ALICIA KEYS

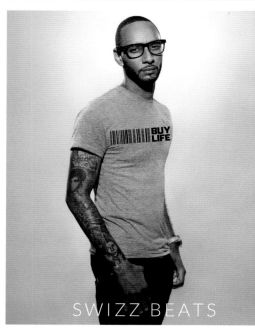

SWIZZ BEATS

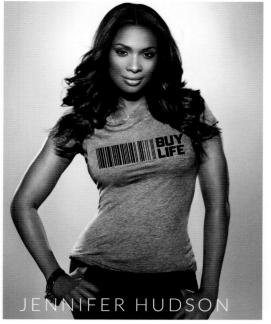

JENNIFER HUDSON

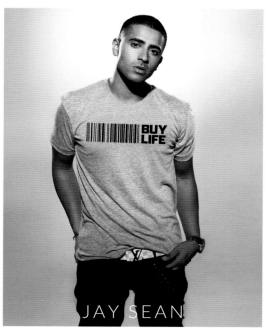

JAY SEAN

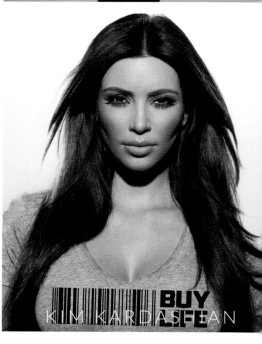

KIM KARDASHIAN

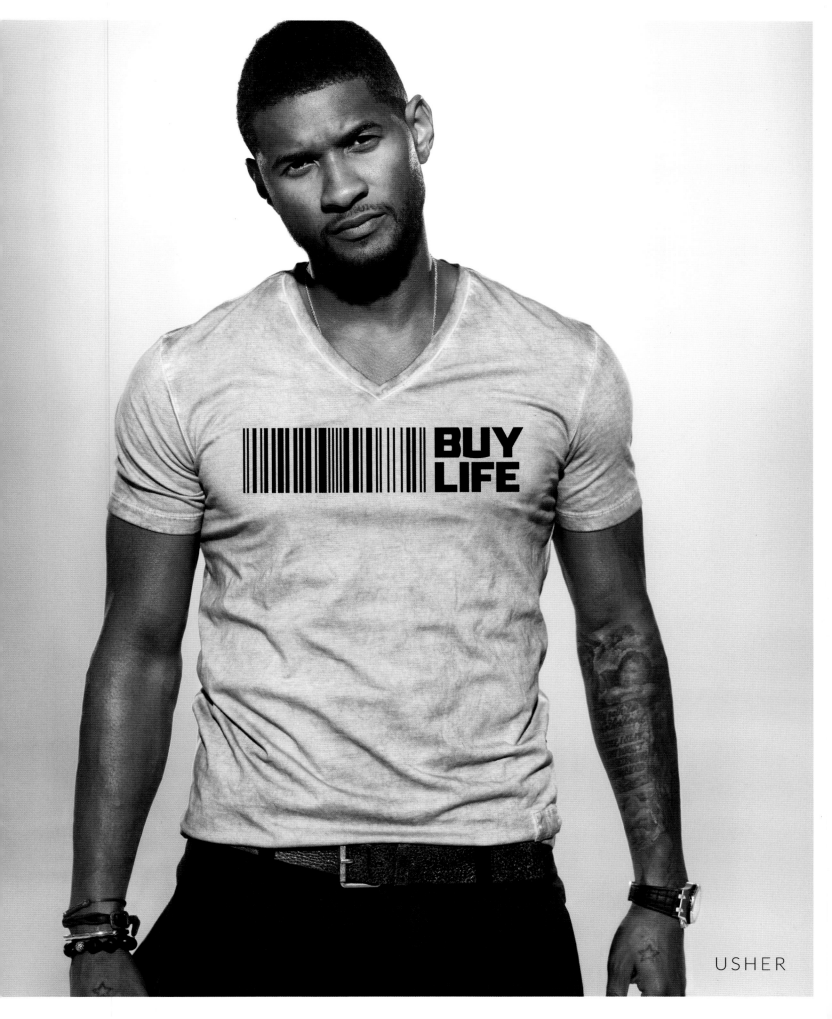

USHER

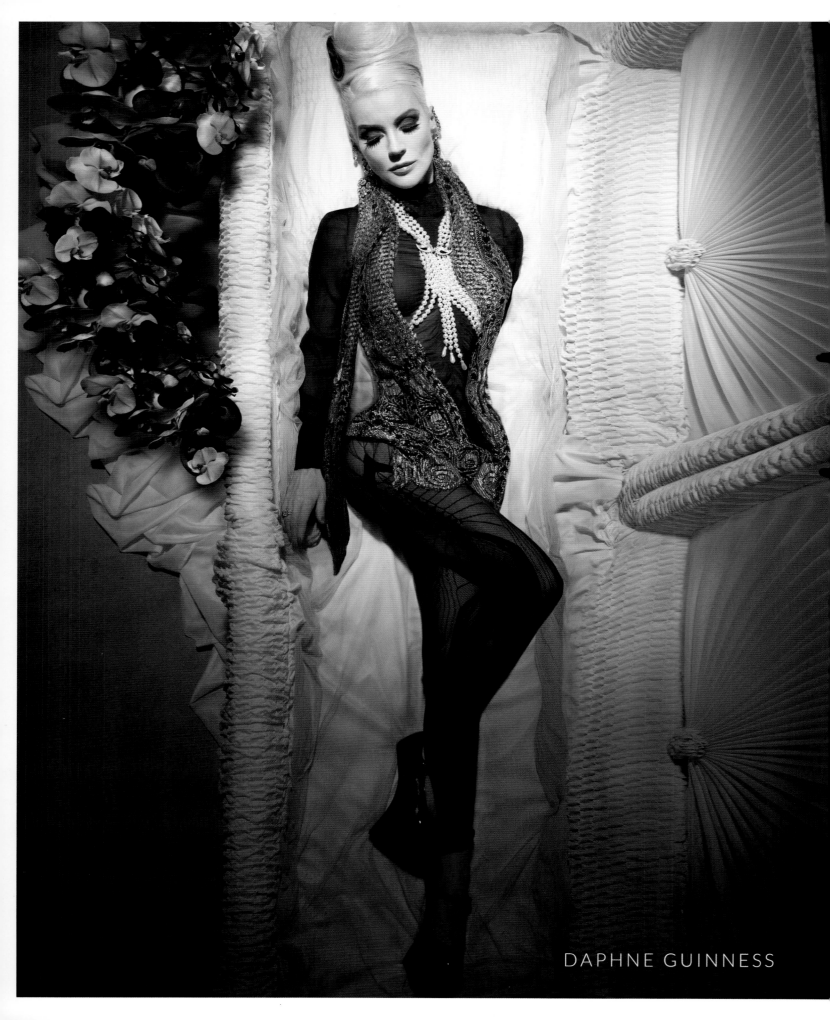

DAPHNE GUINNESS

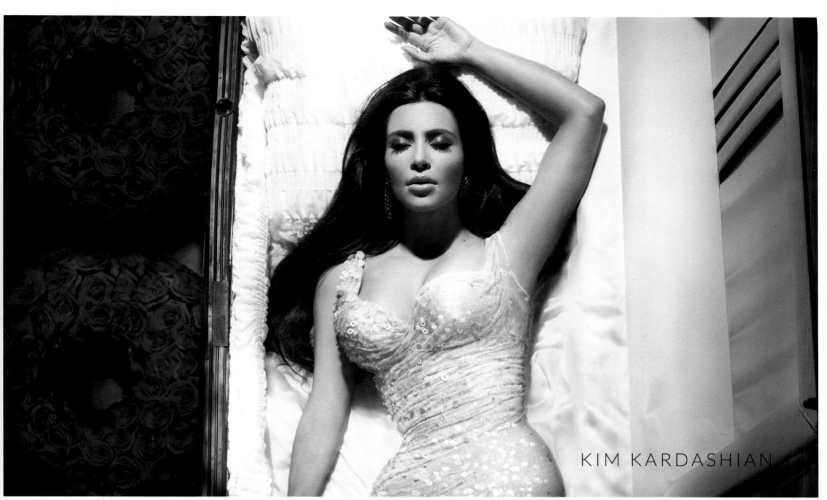

KIM KARDASHIAN

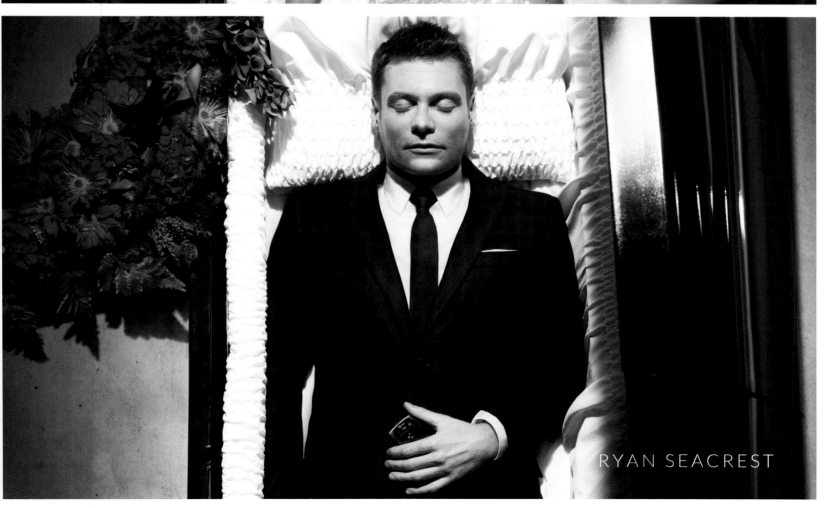

RYAN SEACREST

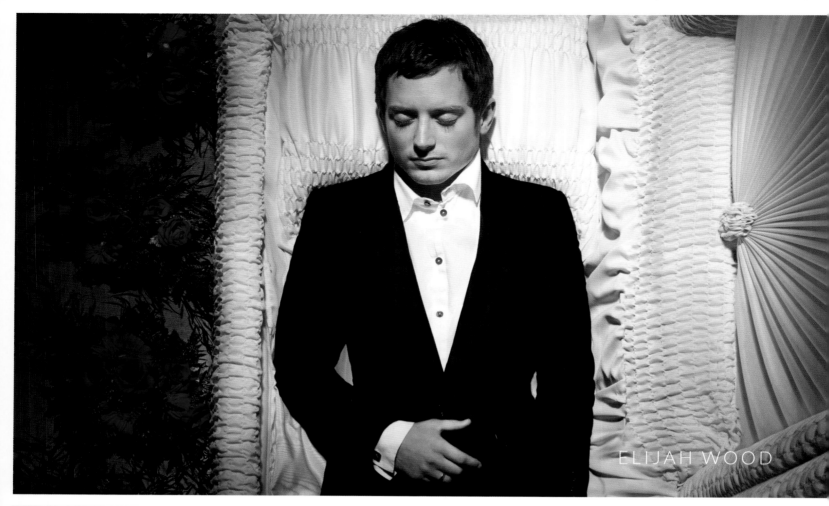

ELIJAH WOOD

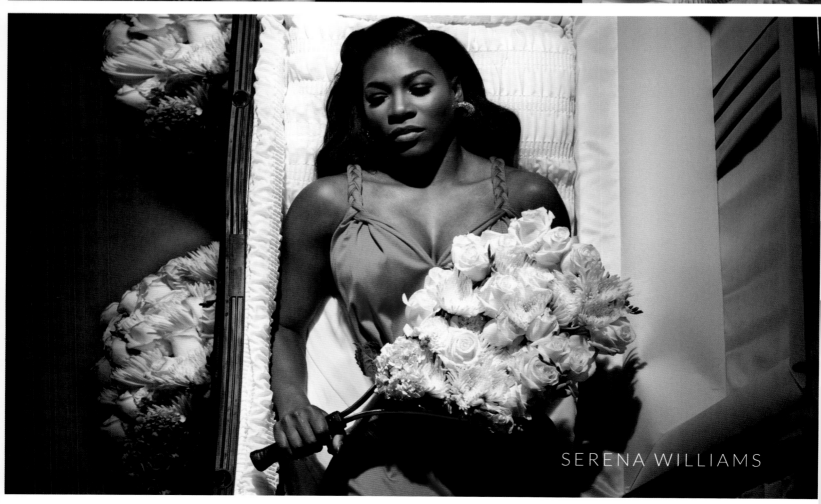

SERENA WILLIAMS

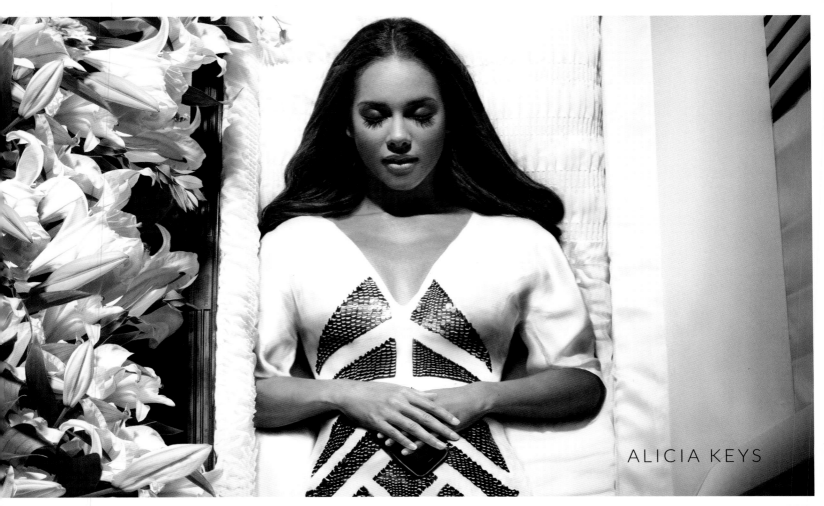

ALICIA KEYS

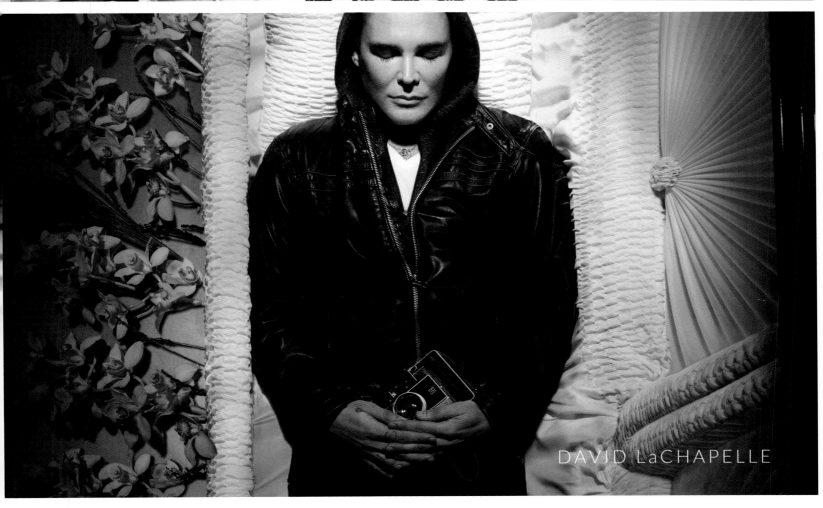

DAVID LaCHAPELLE

KELIS

Singer Kelis was precisely sure of what she wanted when Markus and Indrani shot the album art for *Tasty*, with specifics to connect with her hit single "Milkshake." She used to work in a diner and wanted the milkshake in the shot to be made exactly as those she used to serve to customers. The crew went to great lengths to replicate the milkshake, and Kelis was happy. They shot her sitting on a box and the special milkshake separately, and then placed her atop the milkshake in post-production.

Kelis hired Markus and Indrani again three years later to shoot the images for her next album, *Kelis Was Here* (opposite). This time the concept was a globe-trotting journey. The shoot with Kelis took place in a studio in Los Angeles and the settings were lit and positioned to match images Indrani had taken during her travels to foreign locales. In post-production Indrani seamlessly combined the shots of Kelis with the location photographs.

KELLY
R I P A

Markus and Indrani met television personality Kelly Ripa through hairstylist Oscar Blandi. Markus had been good friends with Blandi from twenty years before, when Blandi had worked as a stylist on Markus's first album cover for EMI Classics. Kelly Ripa was one of the famed hairstylist's celebrity clientele and Blandi asked Markus and Indrani to photograph the TV star for a book on his work. This image is an outtake from Blandi's book cover shoot. The photographers remember her as "Absolutely adorable. We were so impressed by her multiple roles in life as a wife, mother, and America's sweetheart. Our goal was to capture her limitless spirit."

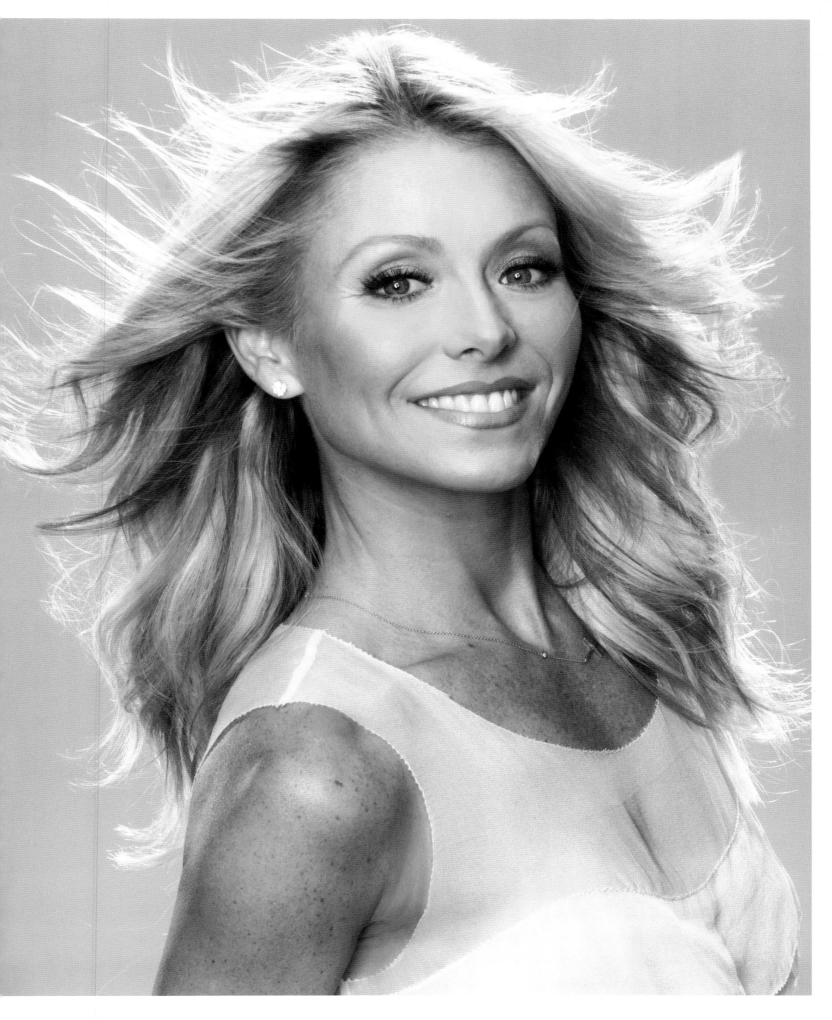

KIM
KARDASHIAN

Indrani: "We were totally amazed by Kim's natural beauty when we met her. In fact, we felt that makeup took away from her looks and I wanted to shoot her with no makeup at all." On her shoot with Markus and Indrani she wore very minimal makeup and kept her hair and wardrobe simple as well. They would soon work with Kim again for the Keep a Child Alive campaign, during which she was perfectly willing to play dead for them.

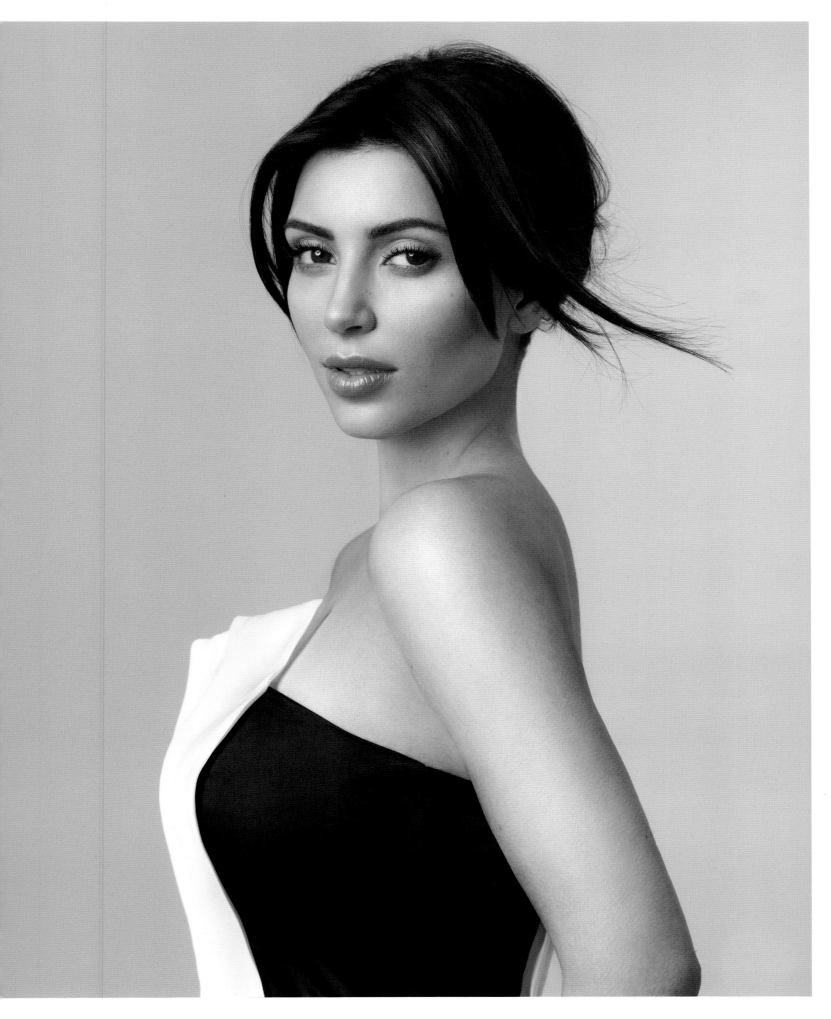

LADY GAGA

The Lady Gaga shoot instantly became a Markus and Indrani favorite. They were commissioned by Sanrio to produce a photo campaign for the thirty-fifth anniversary celebration of Hello Kitty. Markus suggested they work with Lady Gaga and of course Sanrio loved the idea. This shoot was central to one of the episodes of *Double Exposure* and thus garnered a great deal of media attention.

The fact that it was filmed for television also made it uniquely challenging. Indrani had located a Masonic temple for the shoot. "I wanted to work with mystical symbolism to illustrate Gaga's extraordinary powers." It was the best possible setting for the "high priestess of pop," as Markus called her, but space was limited and they needed to plan each shot in detail ahead of time. Lady Gaga worked closely with GK during the shoot, and the stylist truly outdid himself with each look topping the last, culminating in an amazing work-of-art dress made up of Hello Kitty stuffed animals. The star was game for everything, literally doing the shoot with her eyes closed when it was time to paint giant Hello Kitty eyes over her closed lids.

Markus says, "Lady Gaga has been one of the most extraordinary people to photograph because she's so creative and so open to going all the way with our ideas. . . . She's a very powerful figure, like a goddess—larger than life." The end of the shoot was memorable too. Indrani recalls, "When it was over we dressed Markus in the Hello Kitty dress and Lady Gaga kissed him on the lips, but our reality TV cameras missed that perfect moment."

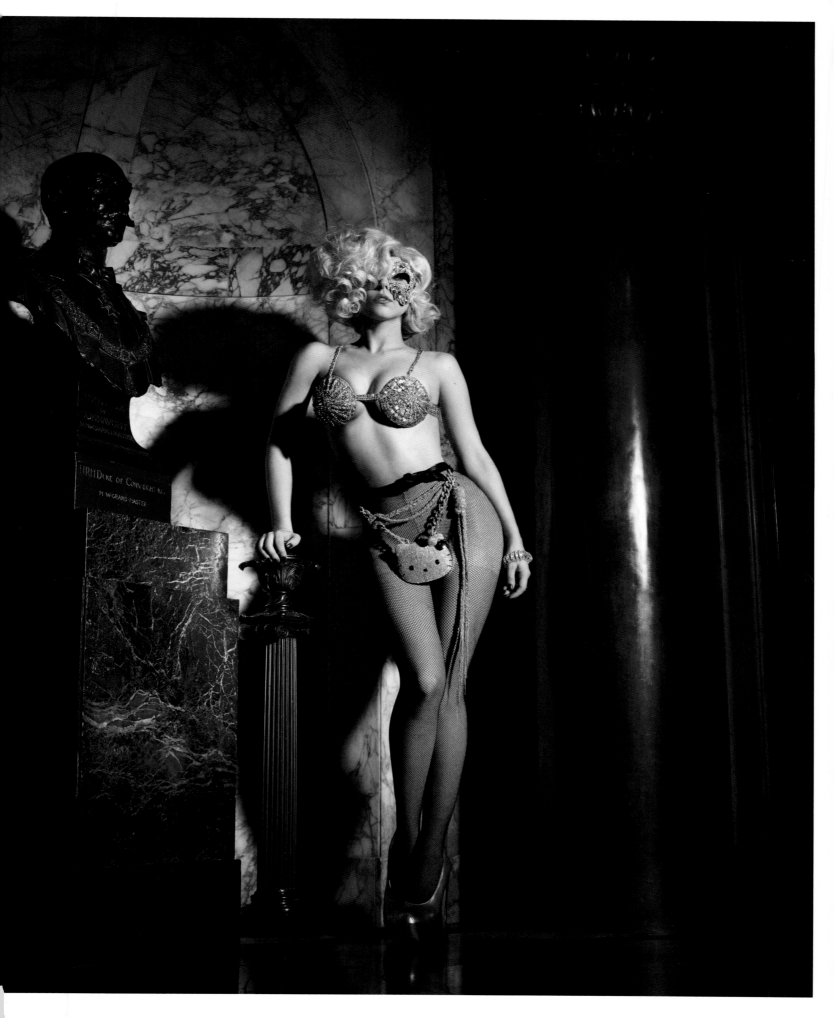

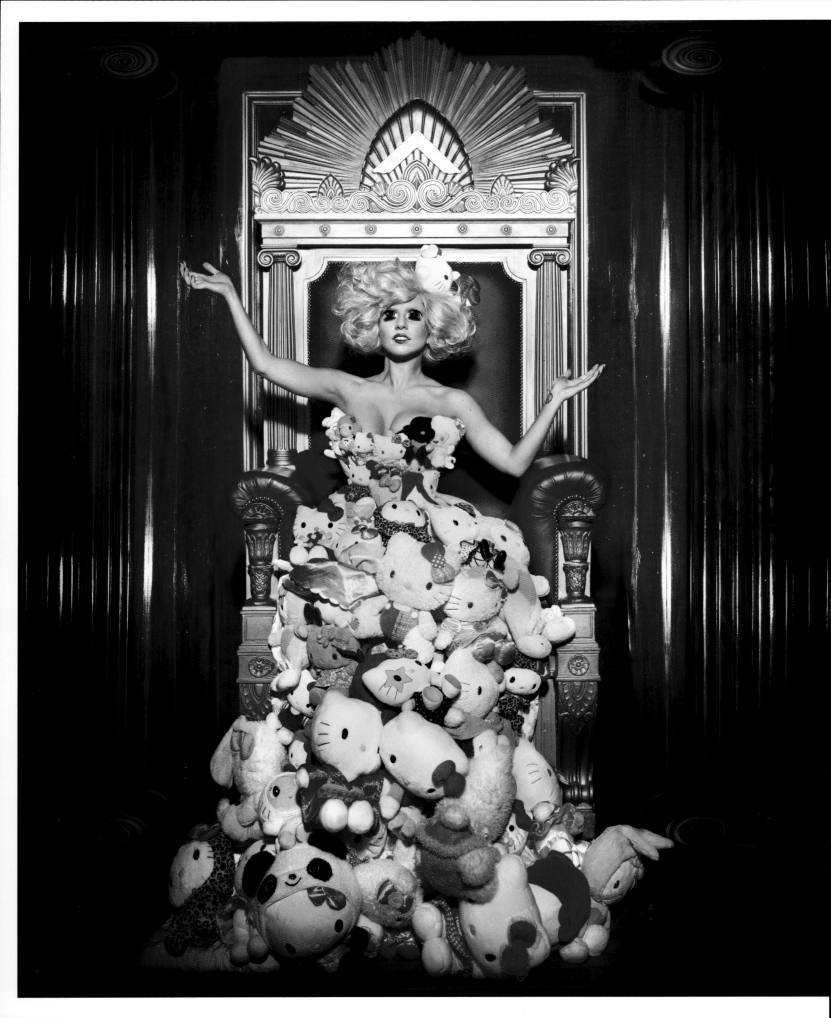

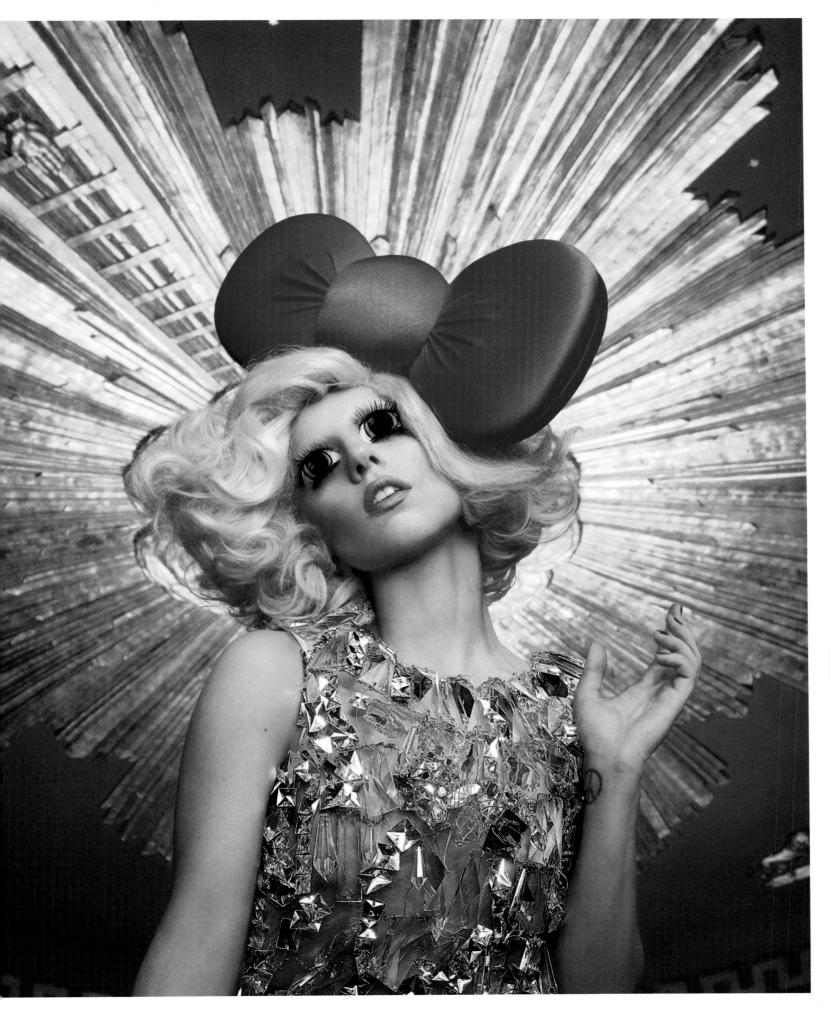

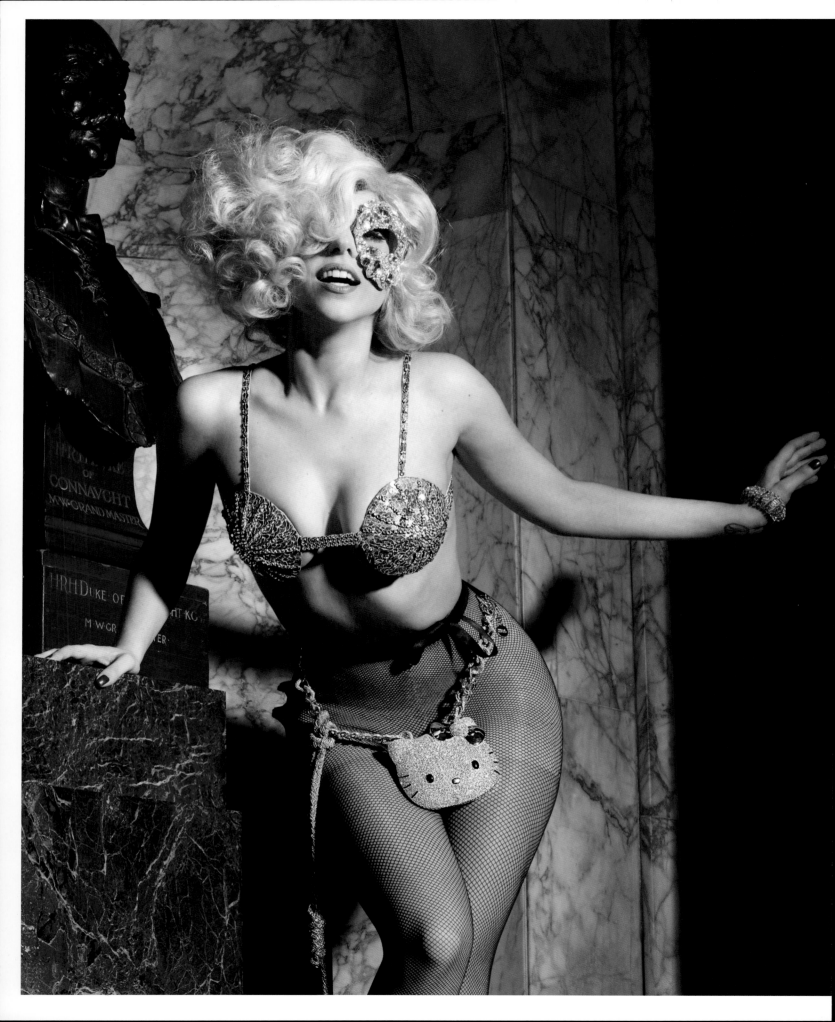

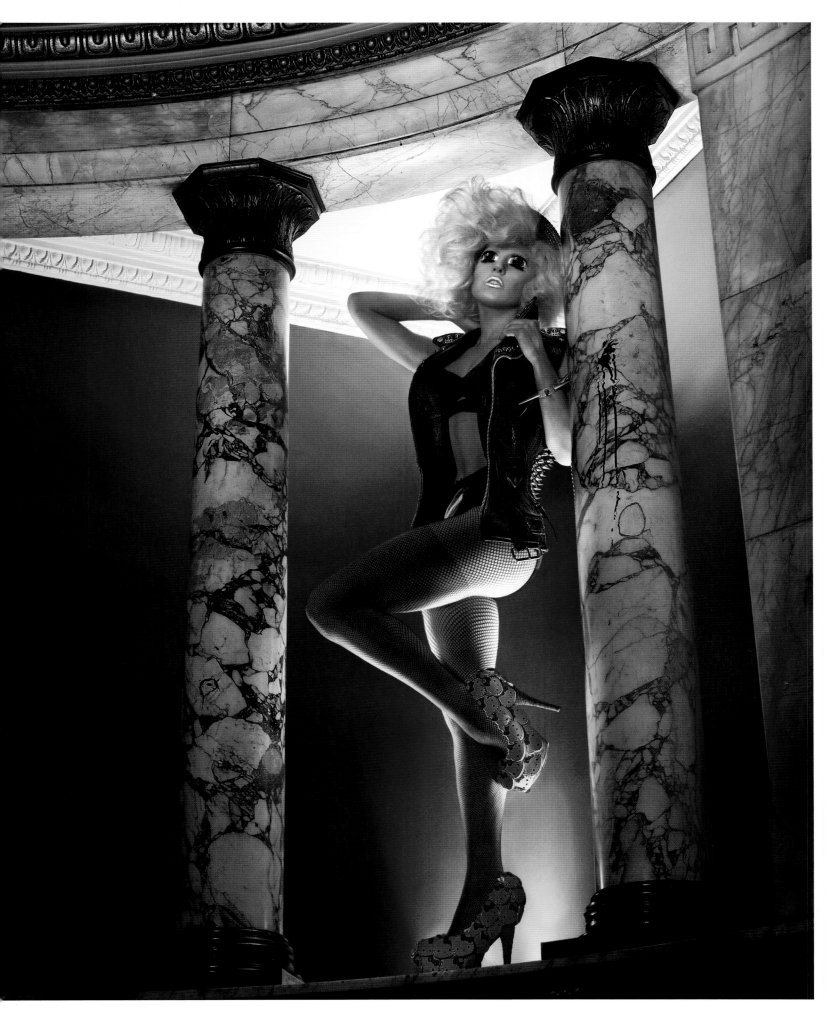

LAETITIA
C A S T A

Indrani met Laetitia Casta long before they ever photographed her. As teenagers they were with the same agency and worked together on modeling jobs. Years later, Laetitia became a supermodel, celebrated as the face of France. Markus and Indrani shot her nearly nude for spectacular jewelry ads as well as for several cosmetic campaigns for L'Oréal Paris.

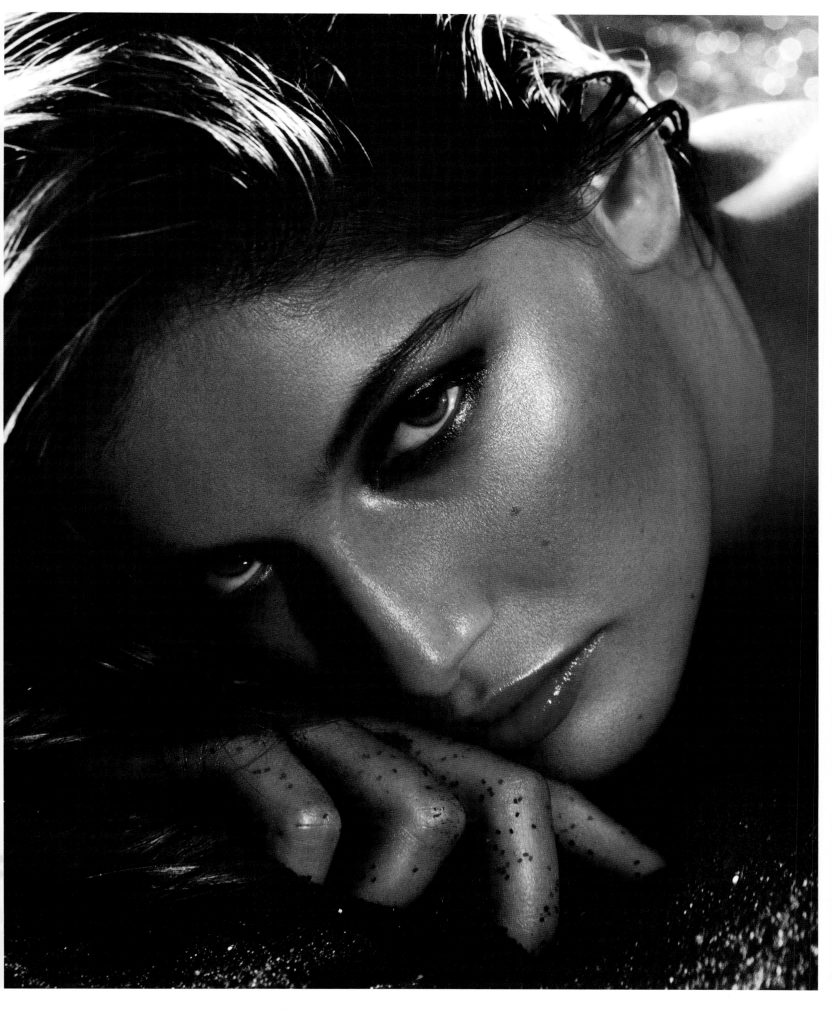

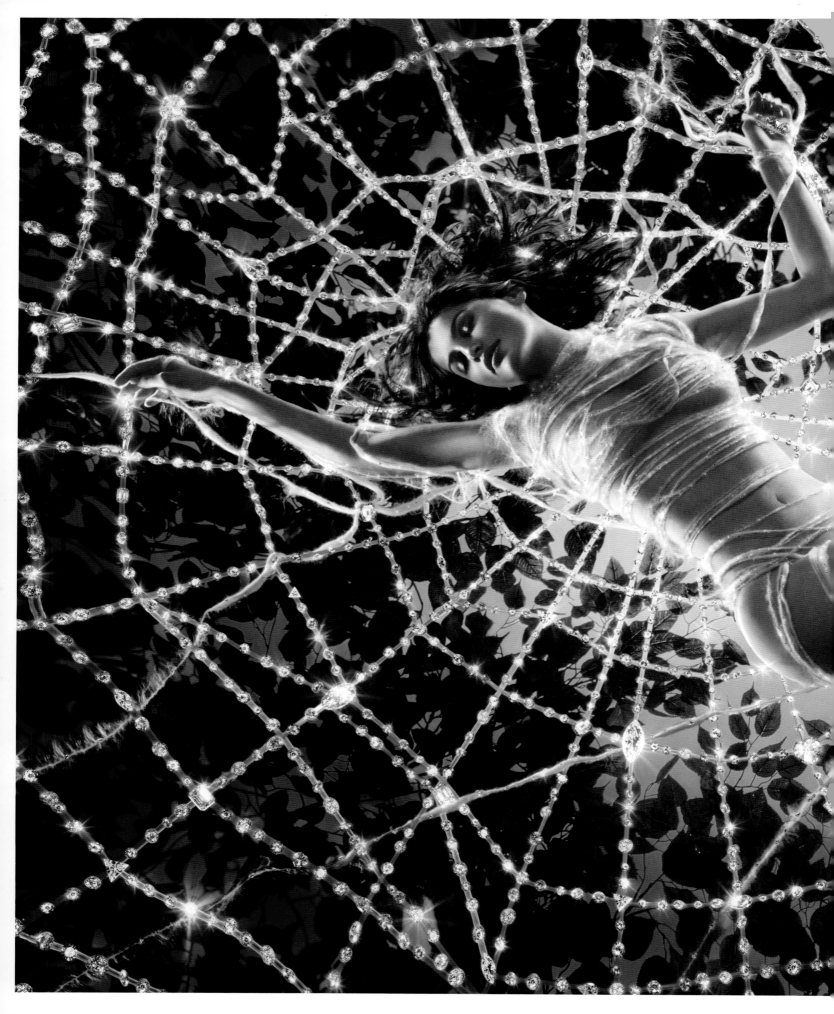

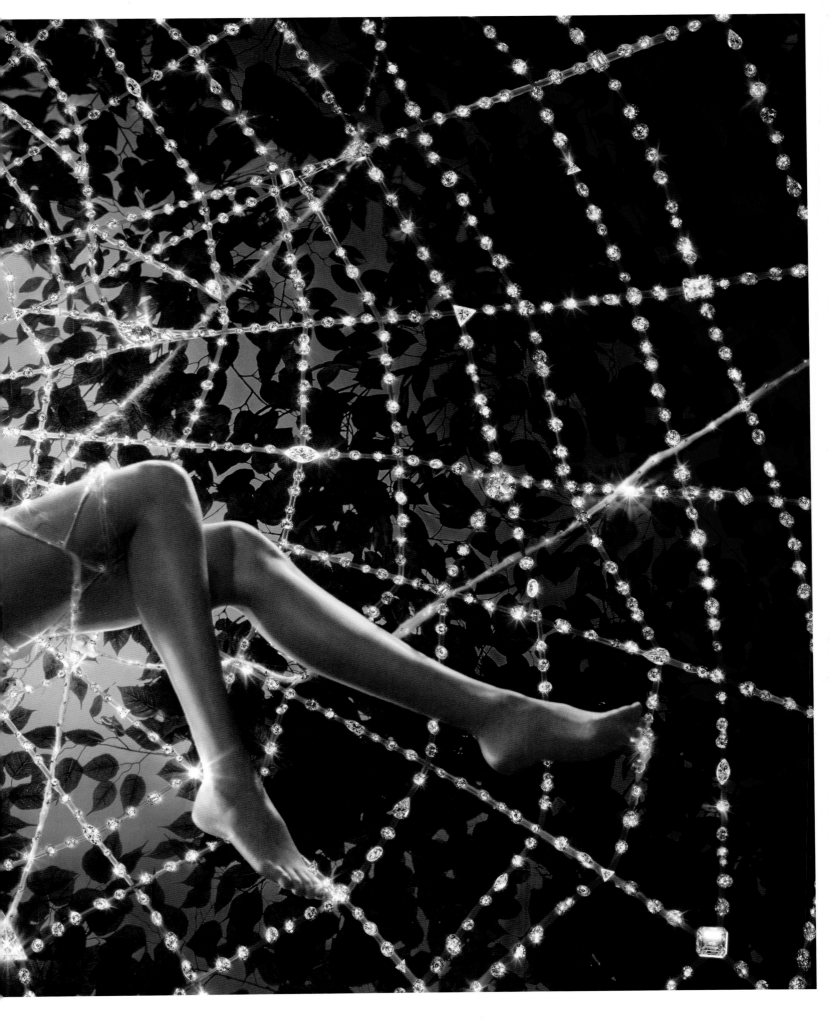

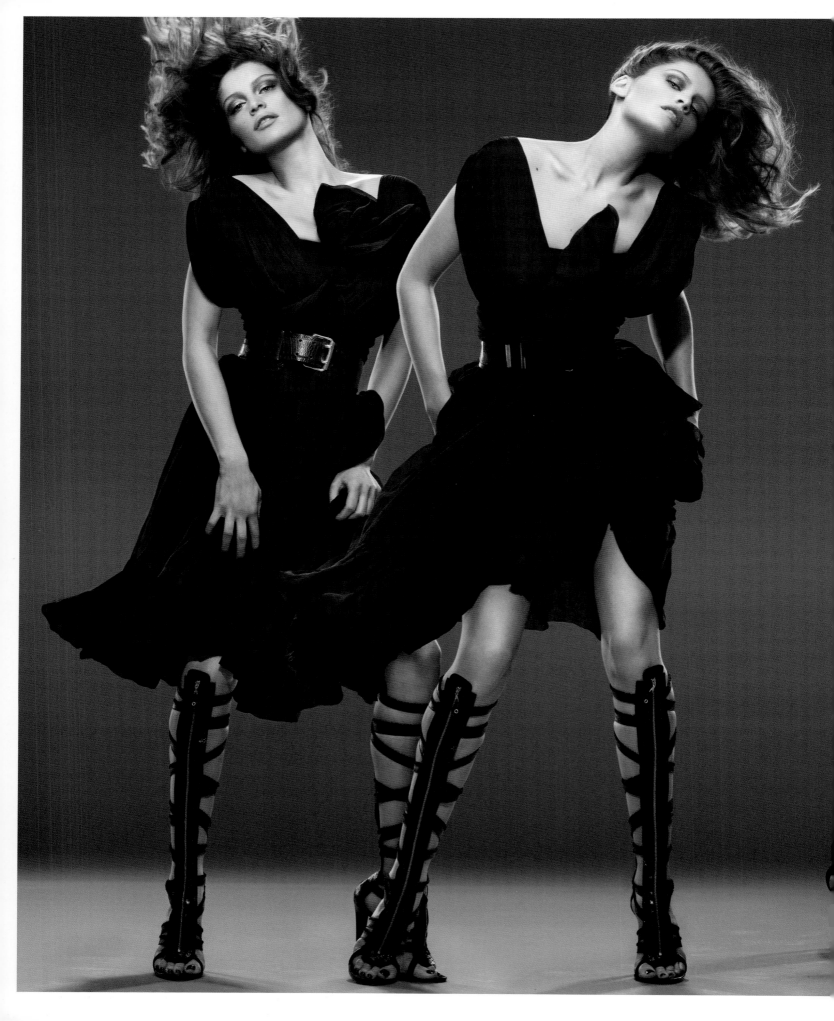

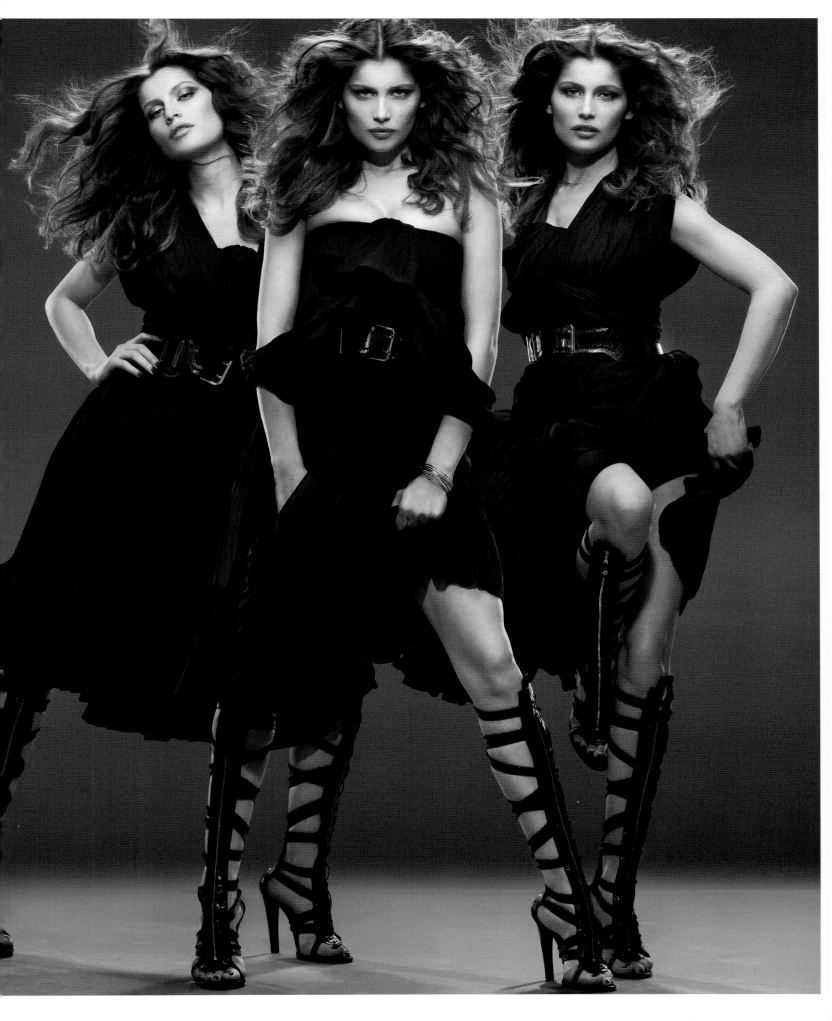

LINDSAY
L O H A N

Lindsay Lohan wanted a new look for the cover of her album *A Little More Personal* (*Raw*), so she turned to the photographers who had produced transformative images of so many other performers. She wanted to incorporate the Chinese character for "raw." Markus and Indrani decided to shoot her in the raw and project the symbol on her back. The result was exactly what Lindsay wanted, though Markus and Indrani prefer the image without the Chinese symbol and in black and white.

The photographers went on to shoot Lindsay a few other times and they developed a close friendship. In fact, Indrani and Lindsay seemed so friendly that the press had a field day circulating rumors that Indrani was Lindsay Lohan's new girlfriend. Interest in their purported relationship peaked with Indrani briefly becoming the third most Googled name in America. Lindsay had gone to India and shot a BBC documentary on child-trafficking. In reality, Lindsay and Indrani bonded talking about India and the problems faced by that nation's children.

Lindsay also appeared on *Double Exposure*, with much of the drama circulating around her being eleven hours late for a shoot to promote her new line of fashion tights, 6126. Markus and Indrani were not angry with her and were thrilled once she was in front of the camera. The photographers agree, "We think Lindsay's very misunderstood. She's extremely passionate about her acting, has huge potential, and is very smart. . . . Lindsay has always been a fantastic subject, very photogenic and high energy."

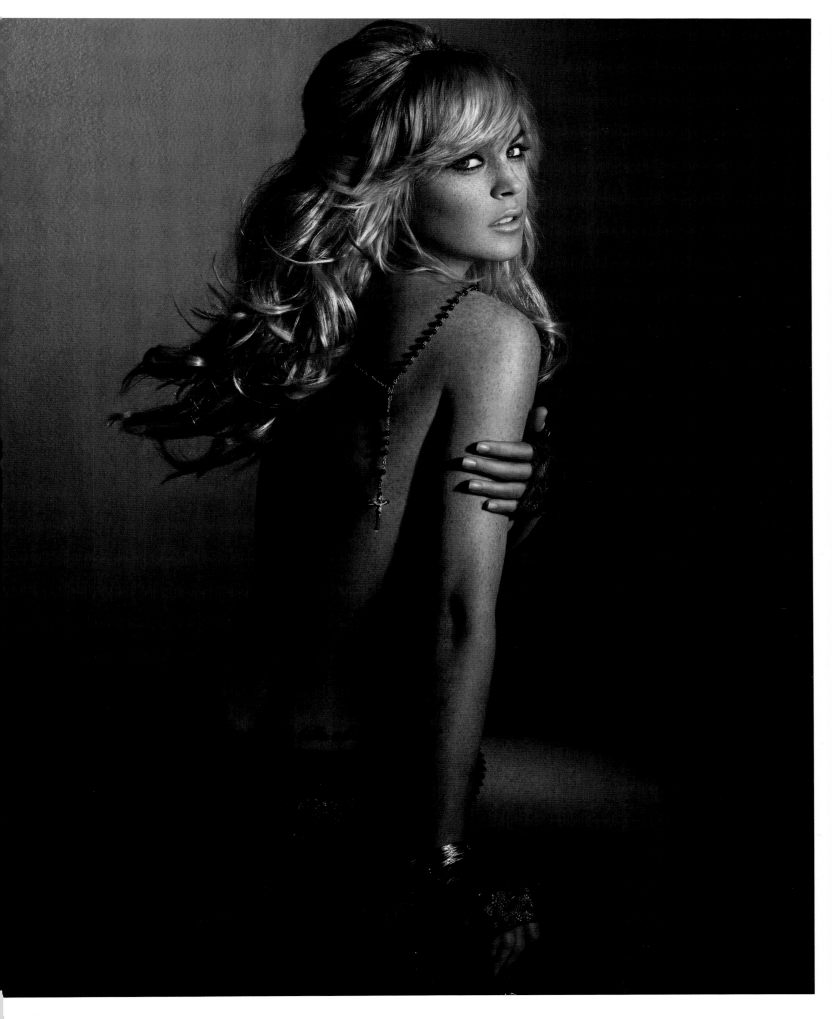

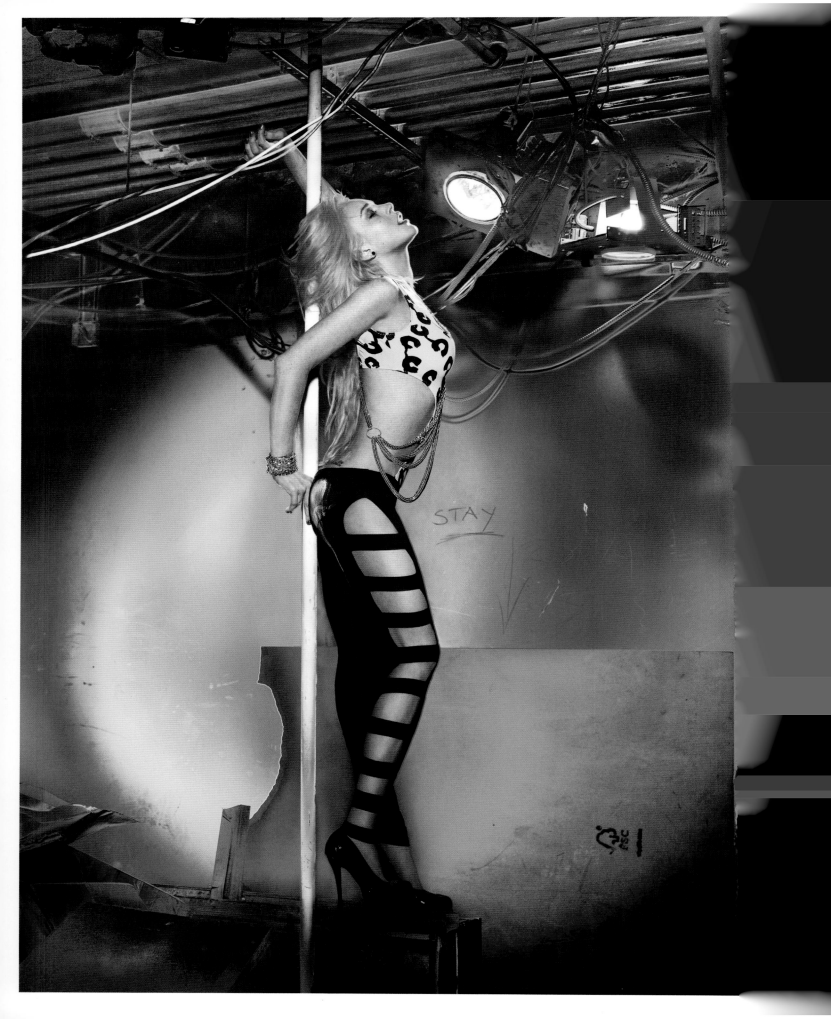

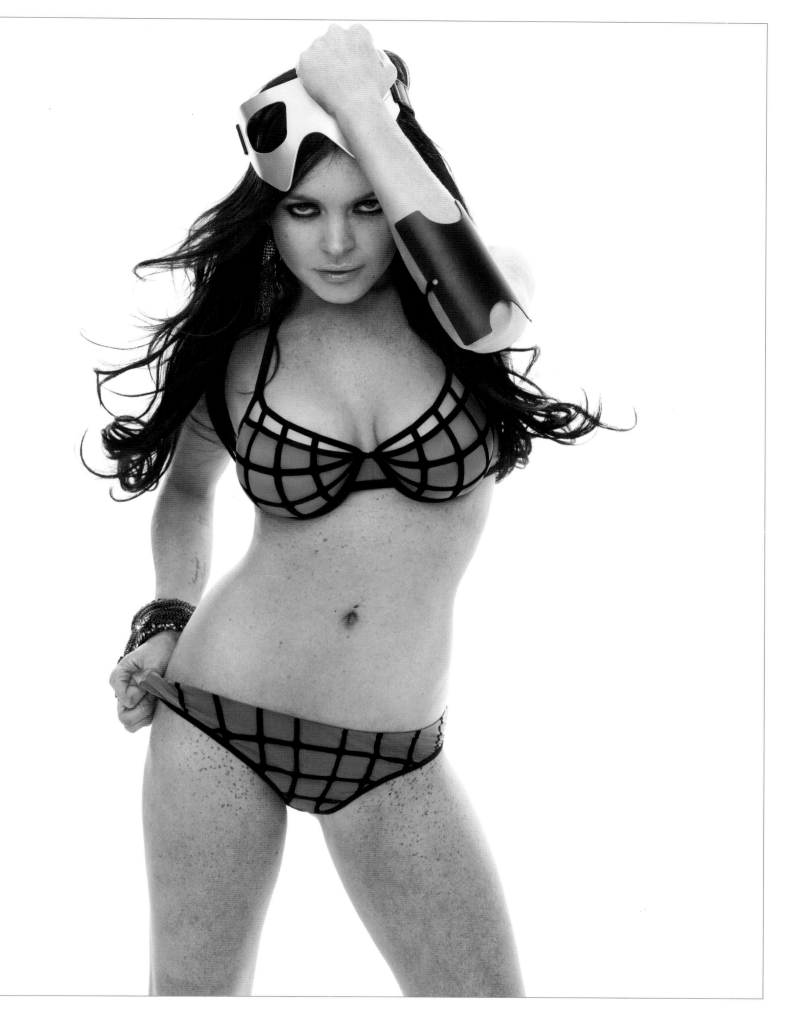

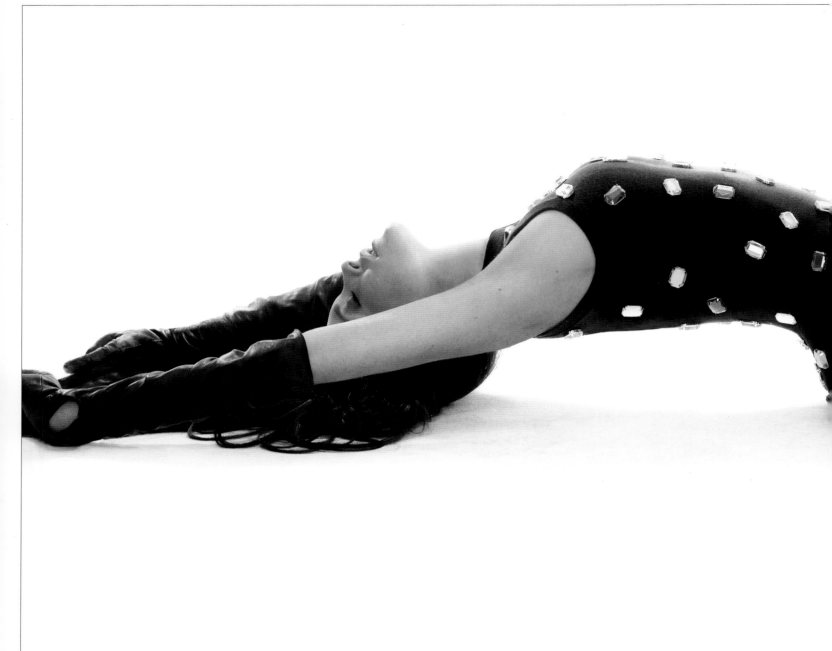
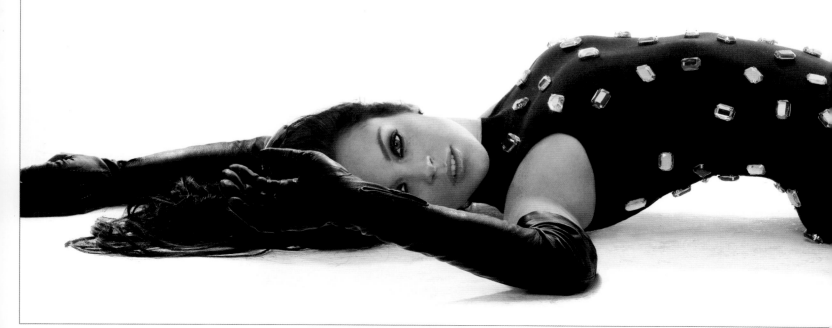

LYDIA & AUBREY

HEARST O'DAY

Markus and Indrani met supermodel Lydia Hearst and actress/singer Aubrey O'Day on their shoot for fashion designer Richie Rich. Hearst, a publishing heiress, and O'Day, former member of the singing group Danity Kane, are in some ways opposite characters, but they were both fabulous together amongst the acrobats and fire-breathers in the circus tent Markus and Indrani found.

Markus later suggested O'Day to *Playboy* and all were thrilled, including Indrani, who was eager to shoot O'Day with a lion (though the magazine scaled down to lion cubs due to safety concerns). "The cubs certainly made for an extraordinary mood on set," remembers Indrani, though in the end the magazine featured images without the cubs, preferring not to have competition with Aubrey's ample feline qualities. It was a very successful cover story for the magazine.

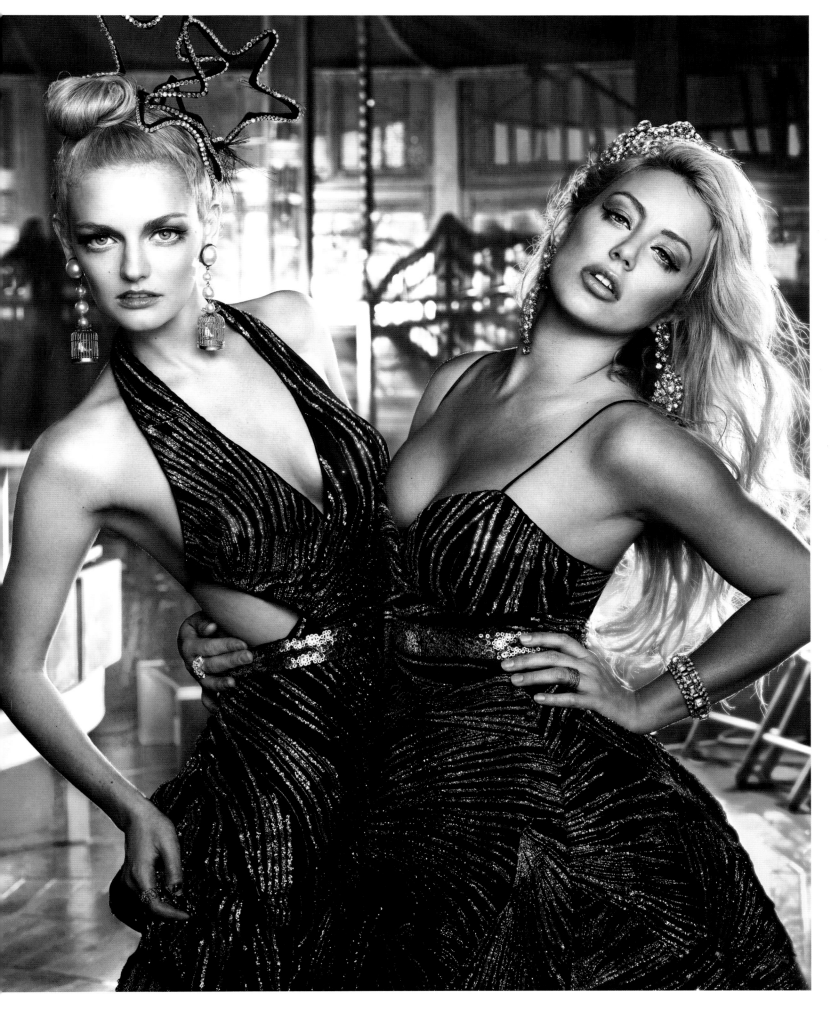

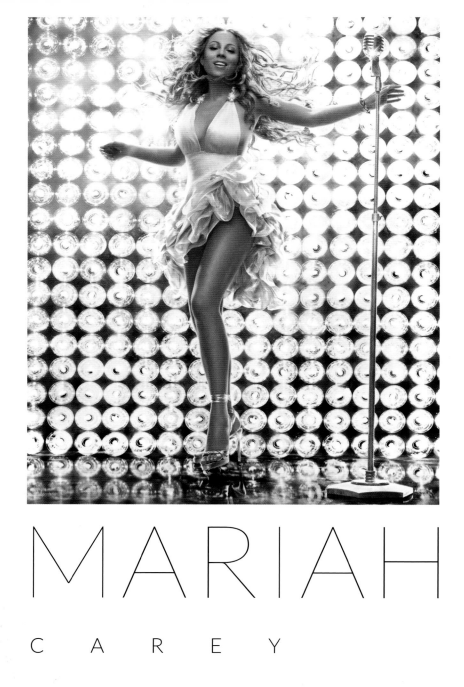

MARIAH

CAREY

"We received a phone call in the middle of the night, from Mariah and her manager Benny Medina," recalls Markus. "They wanted us to shoot her album art for *The Emancipation of Mimi* within the next seventy-two hours." Following a low point in the singing superstar's career, another star photographer had been hired to photograph her, but the results were not what she or her label wanted. Mariah was determined to make a stunning return to top form with an album cover that would blow people away, and met with Markus and Indrani to brainstorm ideas.

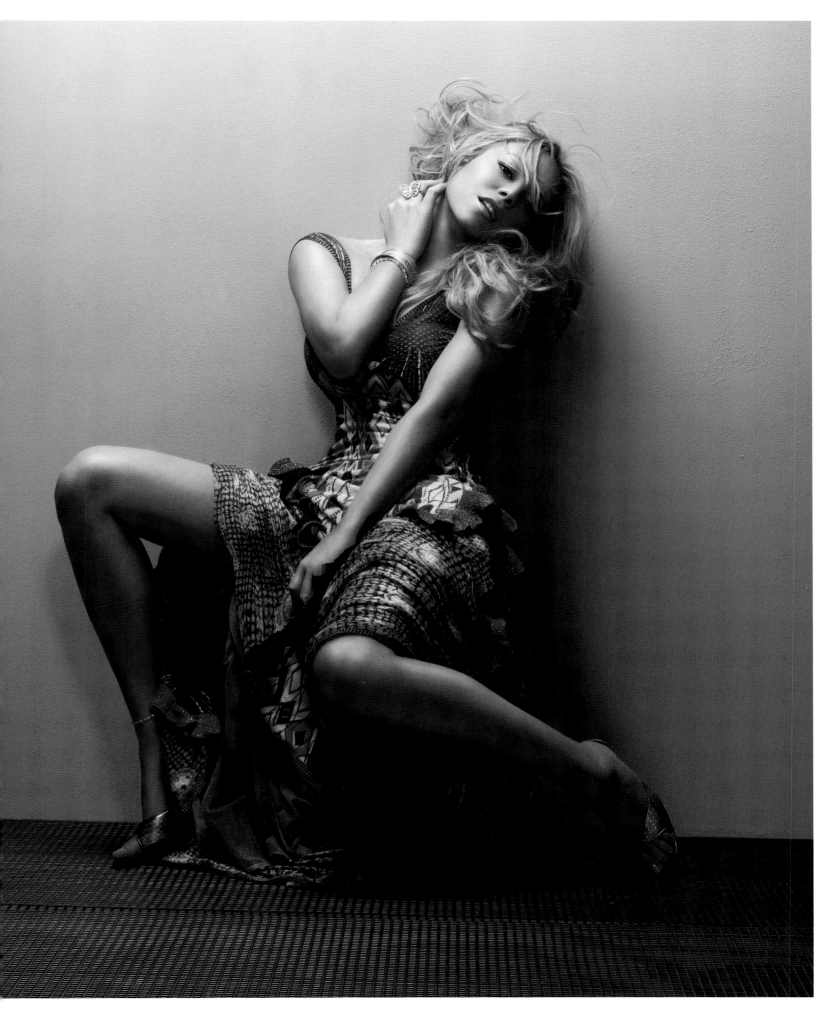

Indrani says, "I wanted to convey her strength and power as a woman, no longer trapped by other's expectations." GK introduced Mariah to many new fashion styles and the team experimented with different directions. The final album cover was inspired by the gold tones and movement of an image by Markus and Indrani for Wolford, which Mariah loved. The team customized a look for Mariah to bring out her inner superhero. LA Reid, head of the label, came to the final post-production session with Indrani. She laughs, "He said he was so thrilled that he owed us a huge favor—which we have yet to take him up on!"

The Emancipation of Mimi was a massive success. Chart-topping tracks included "It's Like That" and "We Belong Together," which *Billboard* later named "Song of the Decade." The album has since sold more than twelve million copies worldwide, and became Mariah's top-seller of her career. Building on this epic collaboration, Mariah requested Markus and Indrani for numerous other projects, including her *Playboy* magazine cover, tour posters, and Pepsi ad campaigns.

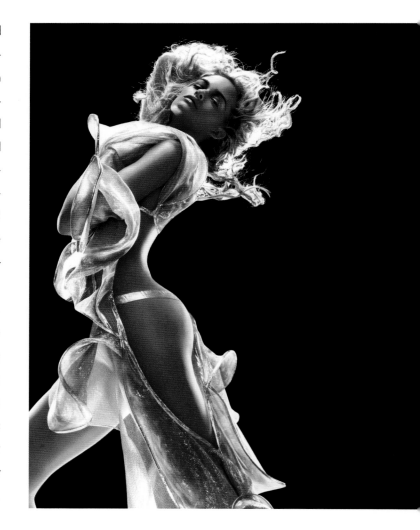

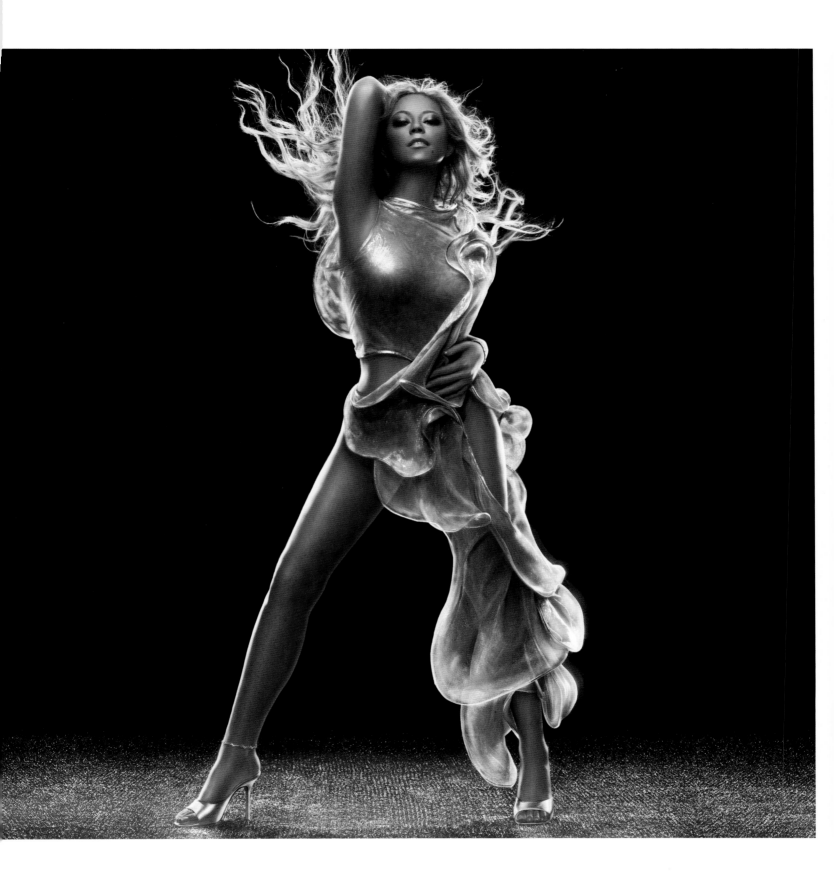

MARY J.
BLIGE

Since she came on the scene in 1992, Mary J. Blige has earned countless accolades, including numerous Grammy Awards, and is a platinum-selling recording artist many times over. Markus and Indrani have formed one of their longest and most fruitful collaborations with her. It began with Blige's seventh album, *The Breakthrough*.

Many of Markus and Indrani's subjects have tended to explore their darker side with the photographers; it was the opposite with Blige. In the past she had a rougher persona and she was now looking to project an image that represented her ultimate happiness and spirituality after overcoming struggles of the past. *The Breakthrough* eventually sold more than seven million copies worldwide and was one of the top five selling albums of 2006. Since then Markus and Indrani have photographed her for three more album covers.

"Mary is great to work with," says Indrani, "She communicates a general idea or feeling that she would like to achieve. It's always a powerful image, like she's been through hell and come out on top. It's important to her to focus on the positive in her life now and uplifting people. Every shoot with her has been fun but also filled with gravitas." Simultaneous with their photo shoot for Blige's tenth album, *My Life II . . . The Journey Continues*, Indrani directed the TV commercial to promote its release.

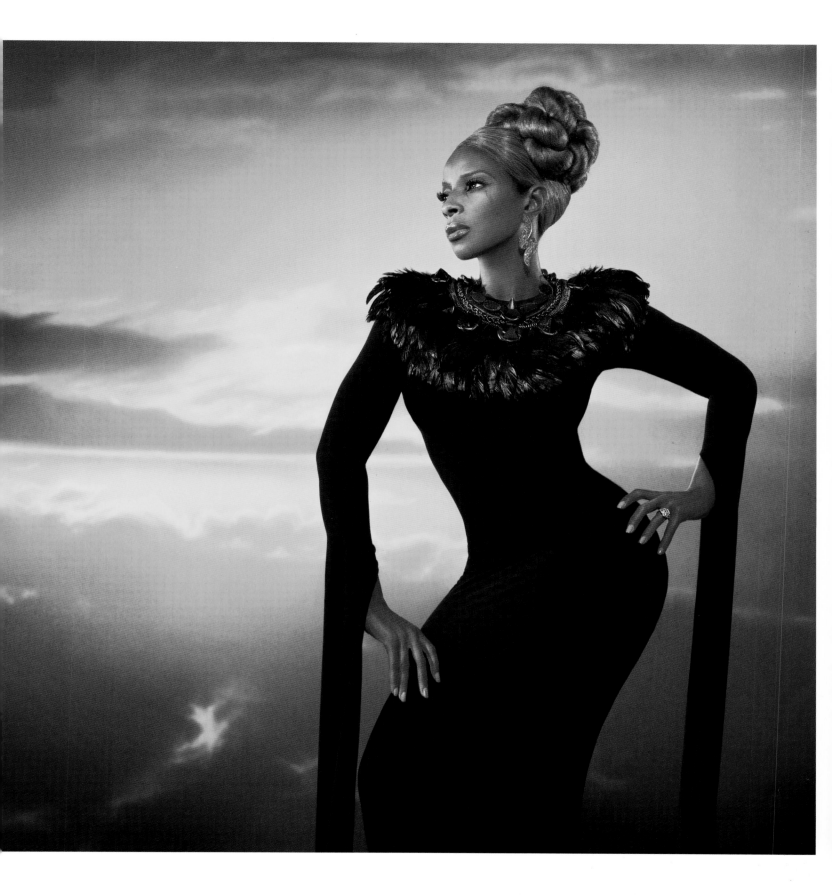

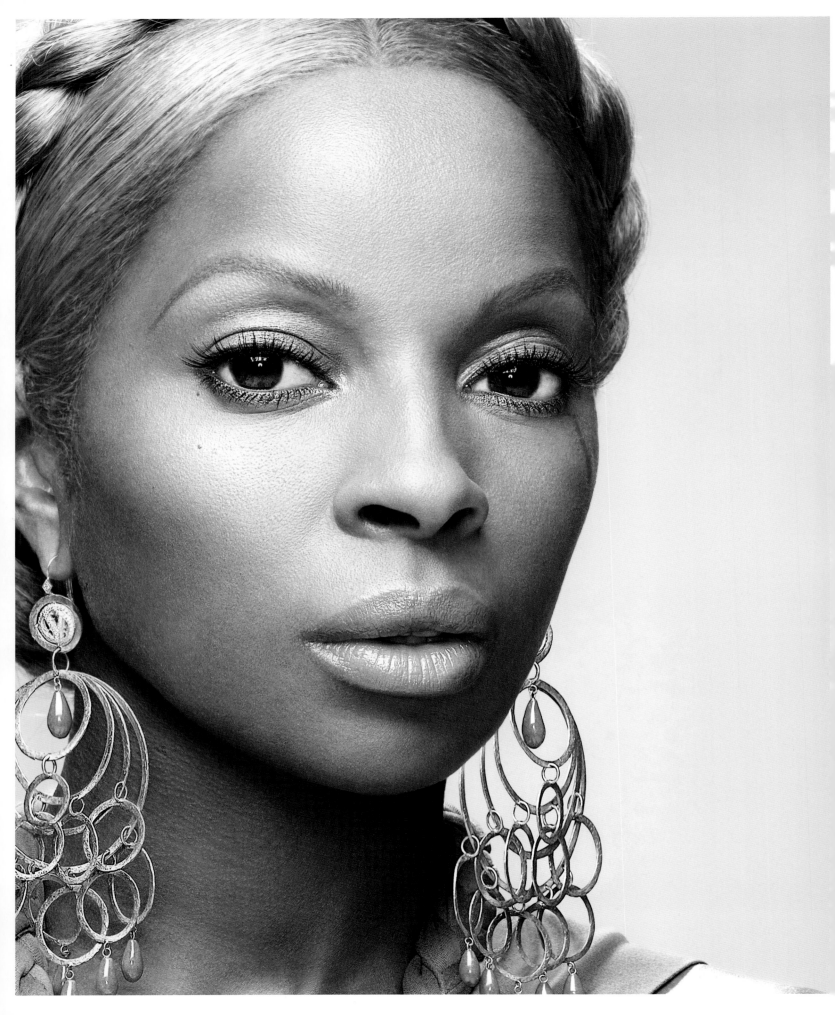

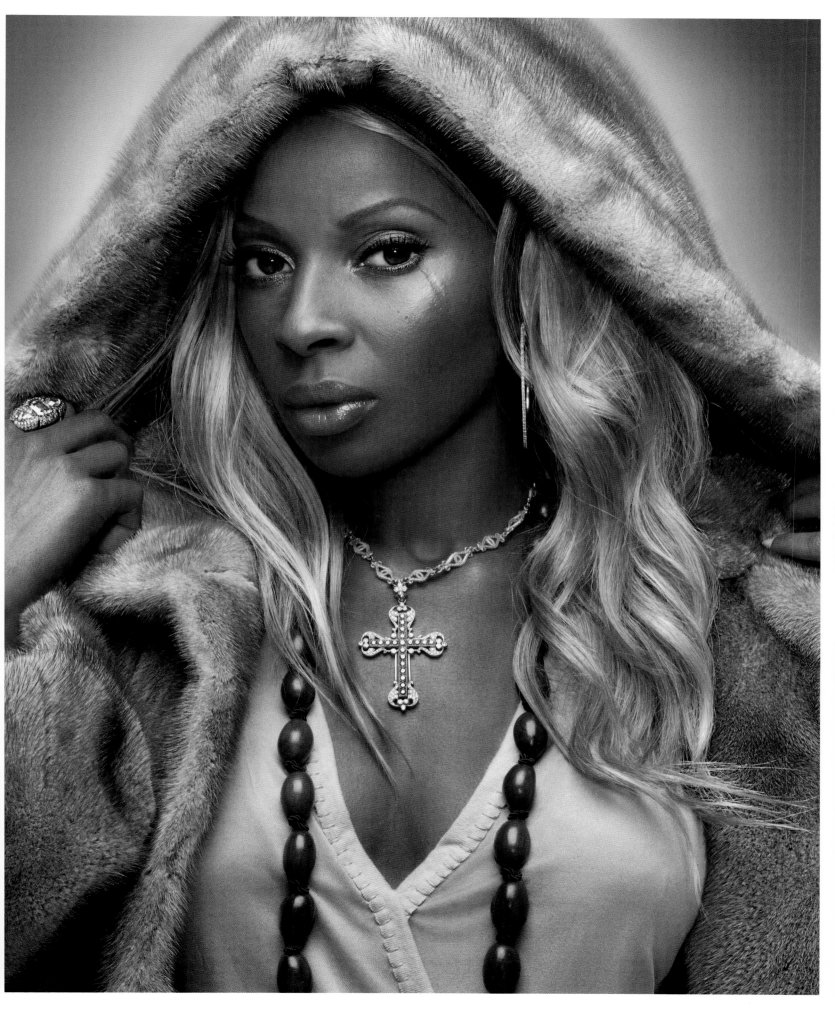

MATT
D I L L O N

This image of actor Matt Dillon was for a poster for a film festival. Markus recalls, "People think I'm girl crazy. If there is one person I have met who is even more girl crazy it's definitely Matt Dillon. He charmed every woman on the set. Needless to say, he was very friendly, very good looking, and we quickly learned that the camera loves him."

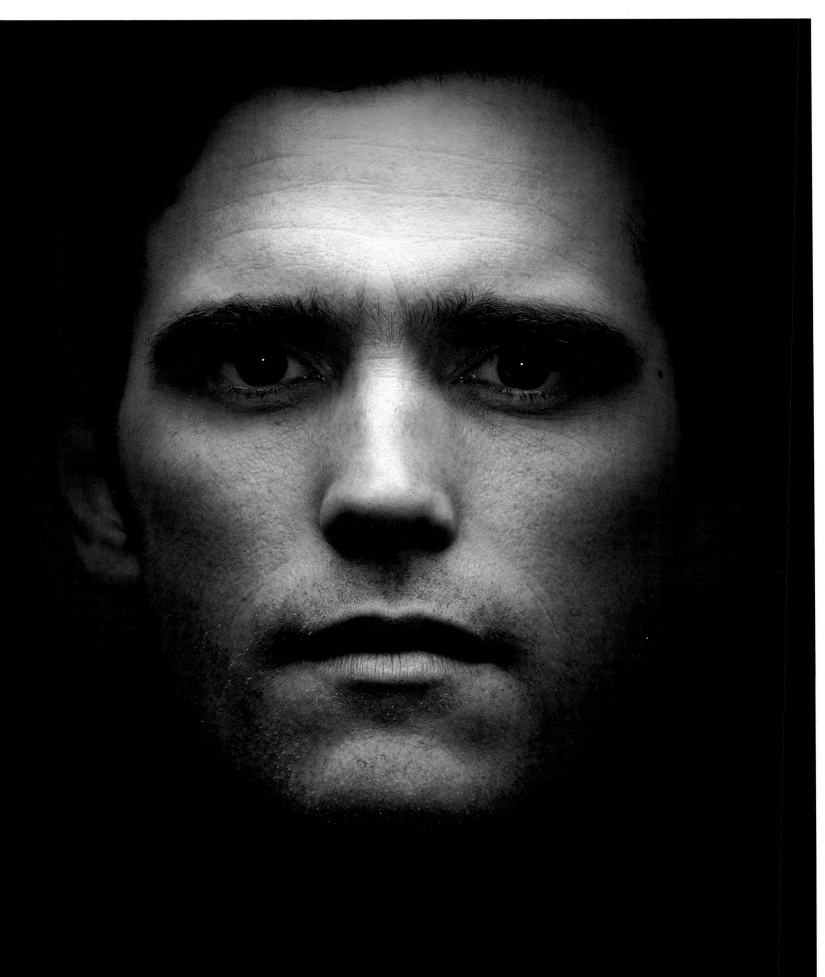

MICHAEL

M A D S E N

Actor Michael Madsen has more than 150 film credits to his name, including *Reservoir Dogs* and *Kill Bill*. Markus and Indrani enjoyed working with him for *Maxim* magazine. Markus: "Michael was a fascinating character, and invited us into his house by the beach for the shoot. There we photographed this American classic behind the wheel of his favorite vintage '50s Cadillac." Indrani: "The challenge was to make the car in the car park appear to be part of a dramatic film set, so we carefully placed it, rearranged the bushes, etc., and added lights so the reflections would be interesting."

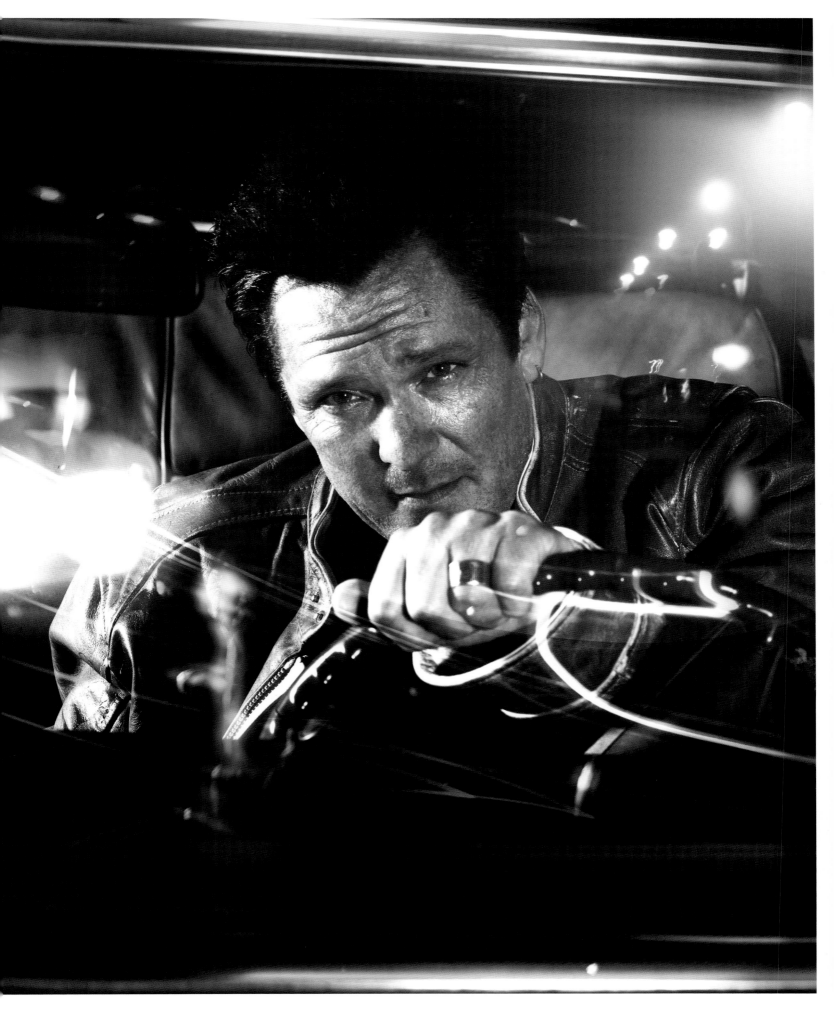

MOLLY
S I M S

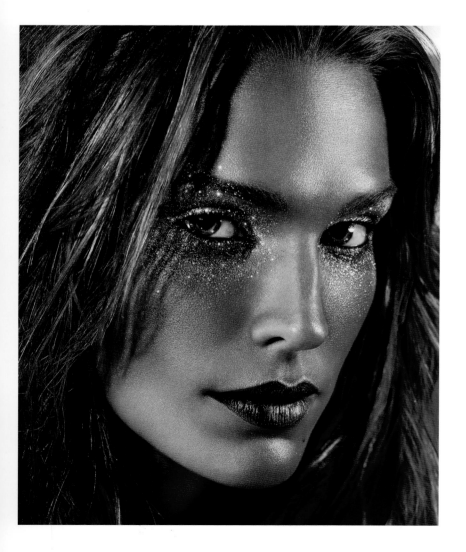

"We had fun with Molly Sims," says Indrani. We used a lighting technique that brought out this intensity and blue tones. In close-up we created a hyper-dramatic landscape of sparkle and jewels around her eyes." These shots were outtakes from a shoot for British *GQ*, for a series that Markus had suggested to the magazine called "Pin-up 2000."

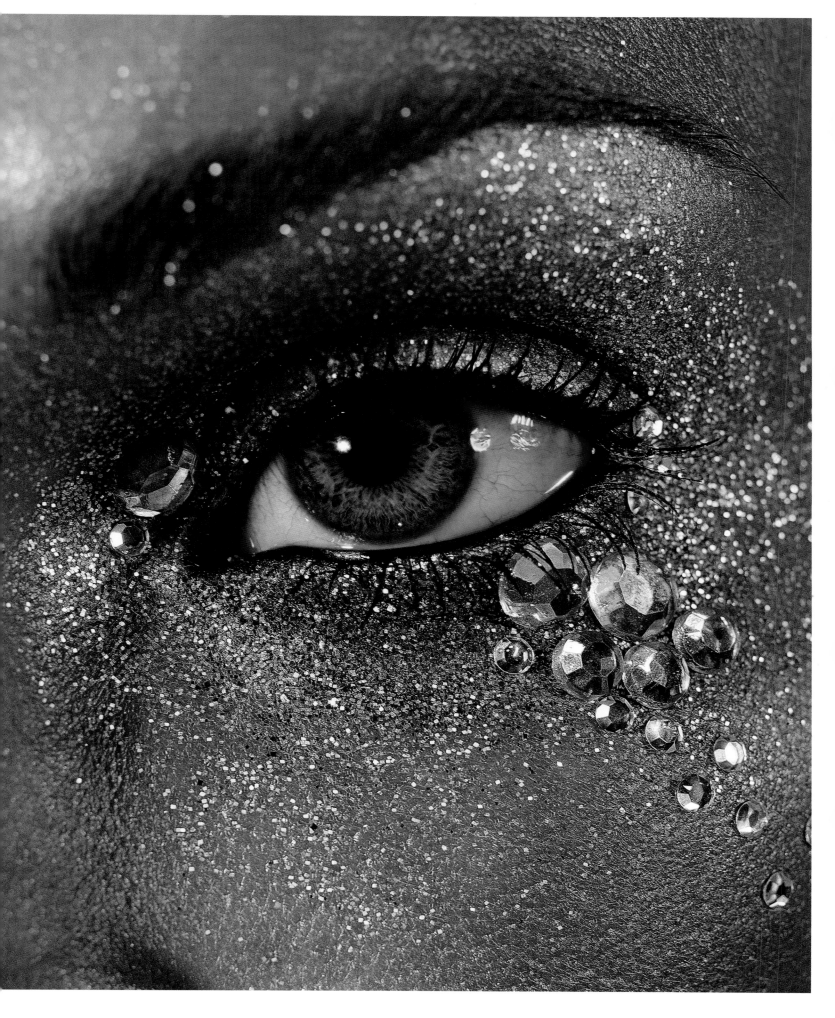

NAOMI

C A M P B E L L

The prestigious photography publication *American Photo* decided to dedicate an issue to Markus and Indrani in 2010. They were honored and chose to photograph Naomi Campbell for the cover of the special issue. Campbell was excited about it too and flew herself to London from Spain for the shoot, while Markus and Indrani flew in from New York. For all the trouble of traveling to London, their perfect location ended up being a parking lot. Markus describes Naomi as "a veteran—knows exactly what she's doing. She was great."

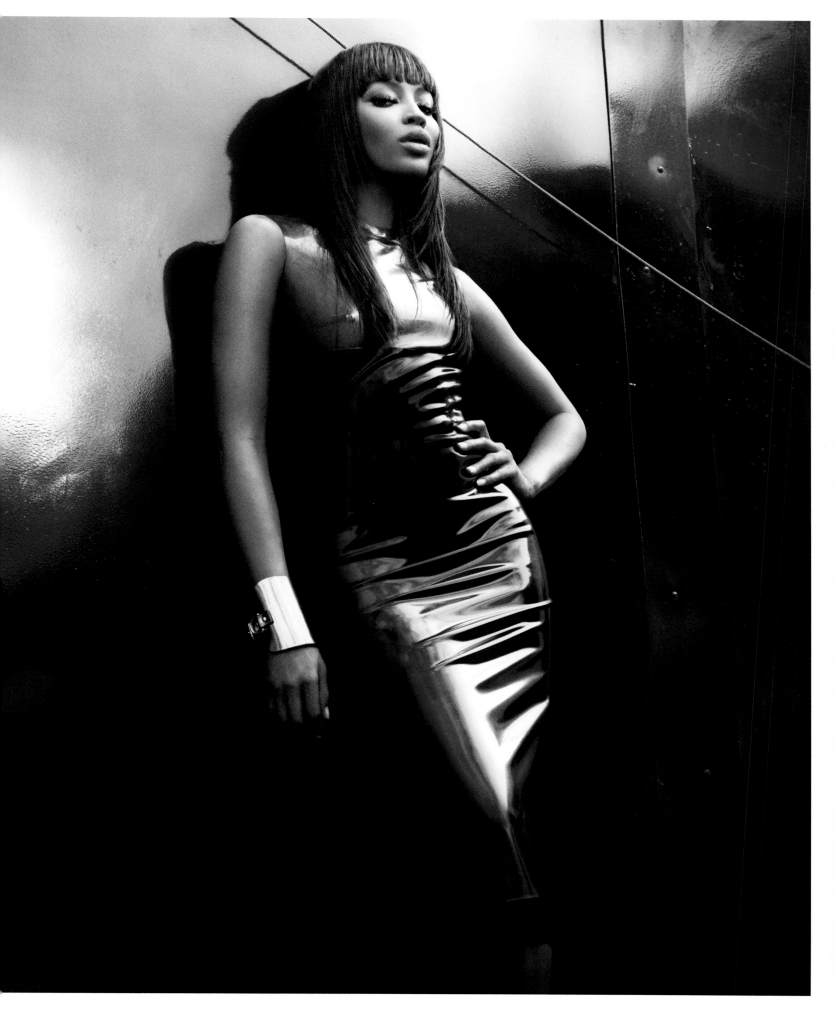

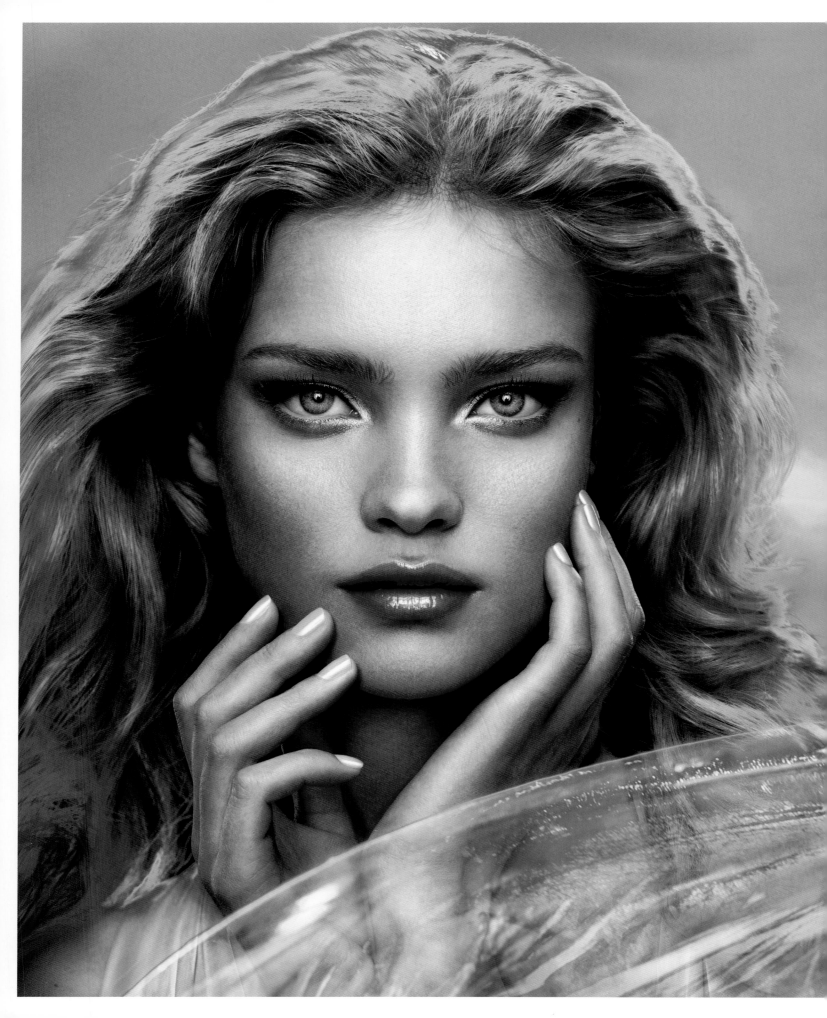

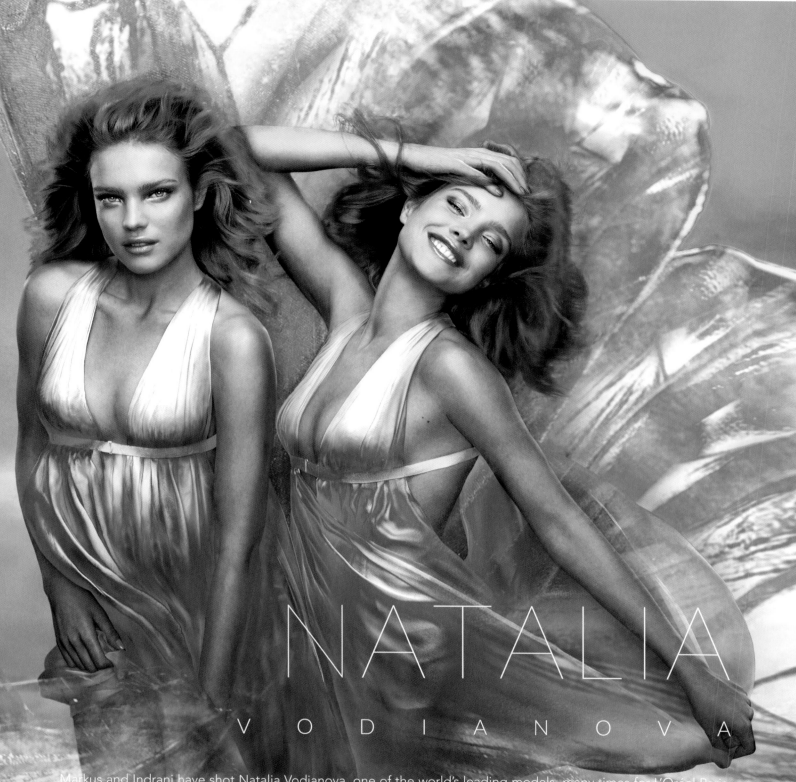

NATALIA
VODIANOVA

Markus and Indrani have shot Natalia Vodianova, one of the world's leading models, many times for L'Oréal Paris. Their first shoot with her was a milestone for the photographers because it took place during the time they made the switch to digital photography, then still new to the industry. Markus shot it with a Leaf 22 megapixel digital back and a Mamiya 645 camera. In addition to producing breathtaking images, this also started Markus and Indrani's longstanding role as spokespersons for Leaf and Mamiya.

As to Natalia, Markus and Indrani were thrilled to work with her. Markus was especially taken by her, "Rarely do I see someone in person who with no artifice or lighting tricks, is even more beautiful."

NELLY
F U R T A D O

On their shoot with singer Nelly Furtado Indrani wanted to capture some of the feeling of the movie *Blade Runner*, so planned the shoot at the landmark Bradbury Building in downtown Los Angeles, where the movie had been filmed. "What was intimidating about this shoot," says Markus, "was living up to the greatness of the location." For this shot they had Furtado lay down on one of the upper floors and shot her from above, with the building's central atrium in view below, creating a sense of vertigo.

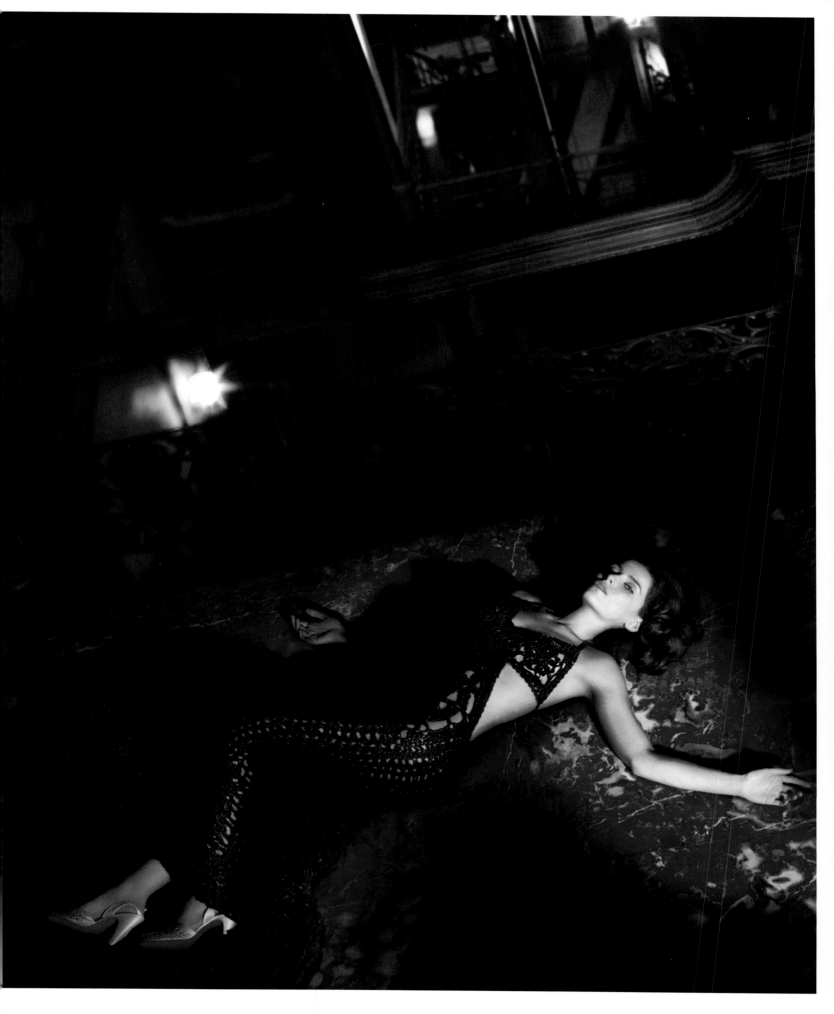

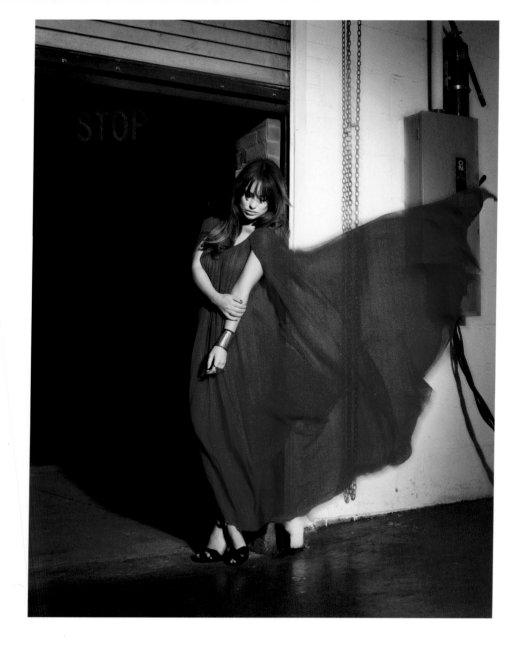

OLIVIA
W I L D E

"Olivia is an incredible actress," says Indrani, "We were excited to shoot her in a way that would bring out her depth of character. As a background for one of the shots we had a garage door with an industrial quality that we thought would juxtapose with her softness and femininity and we planned to enhance it in post. She didn't see how it would work but eventually overcame that concern and did a great job. I think that tension adds to the sexiness of this series. You can see complexity in her eyes."

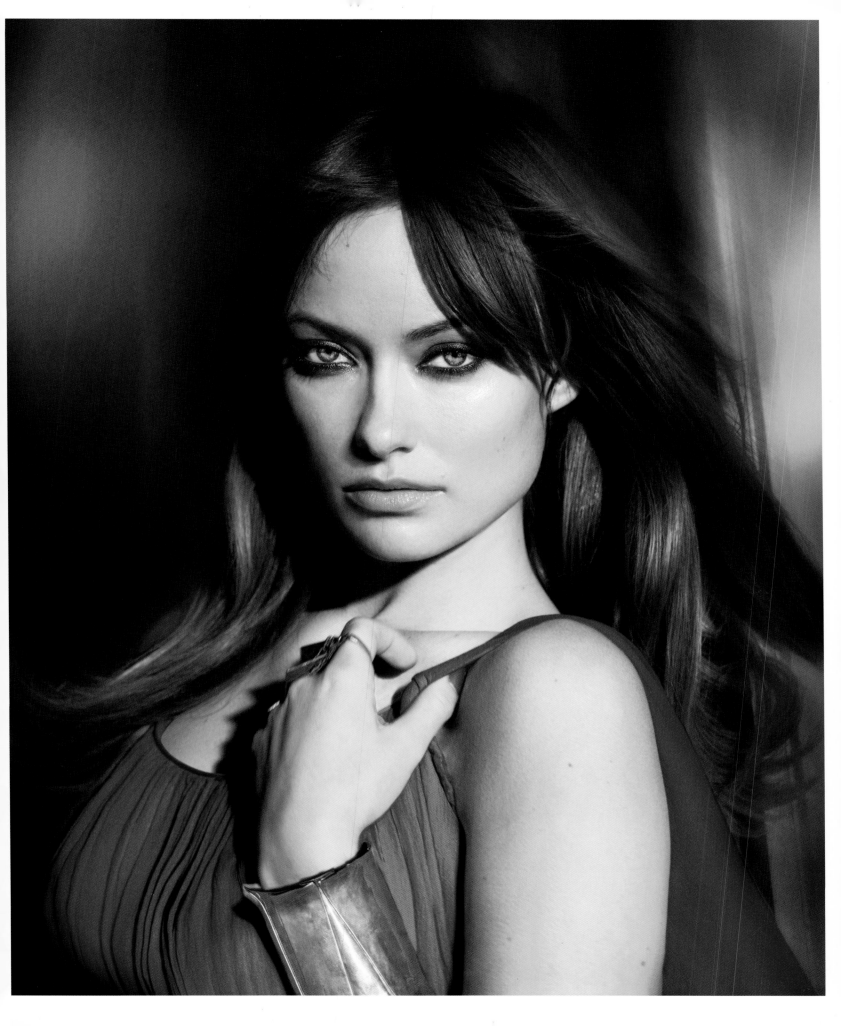

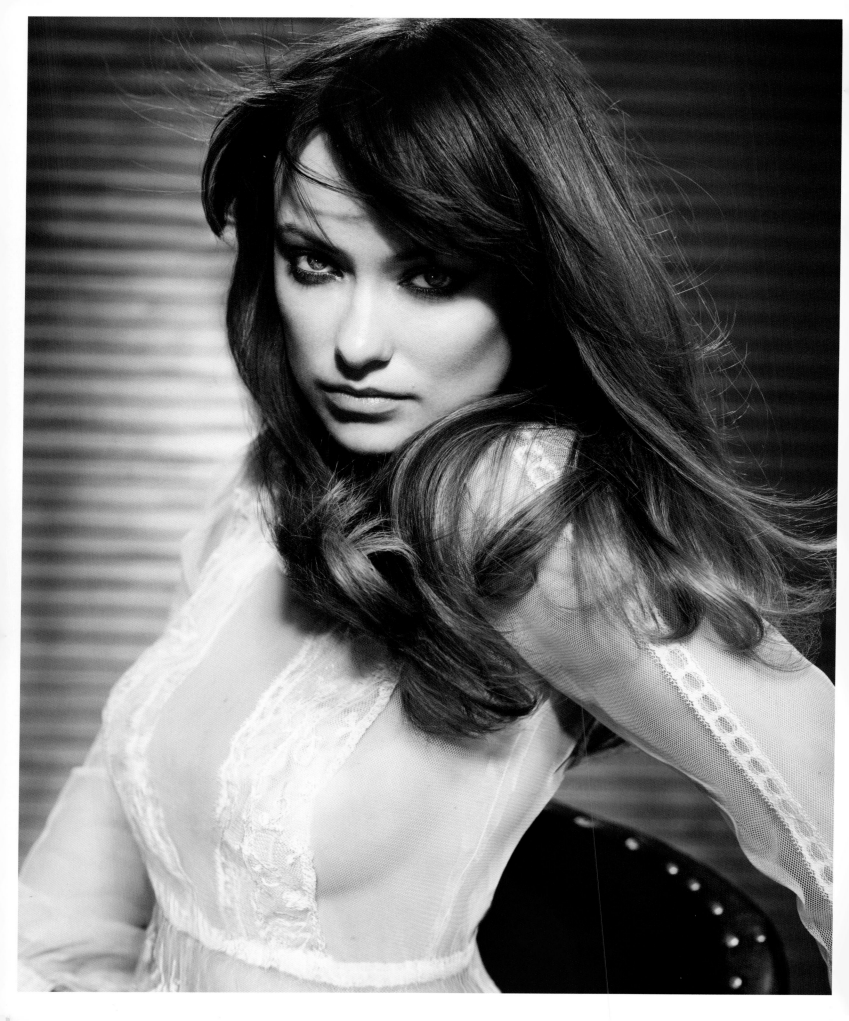

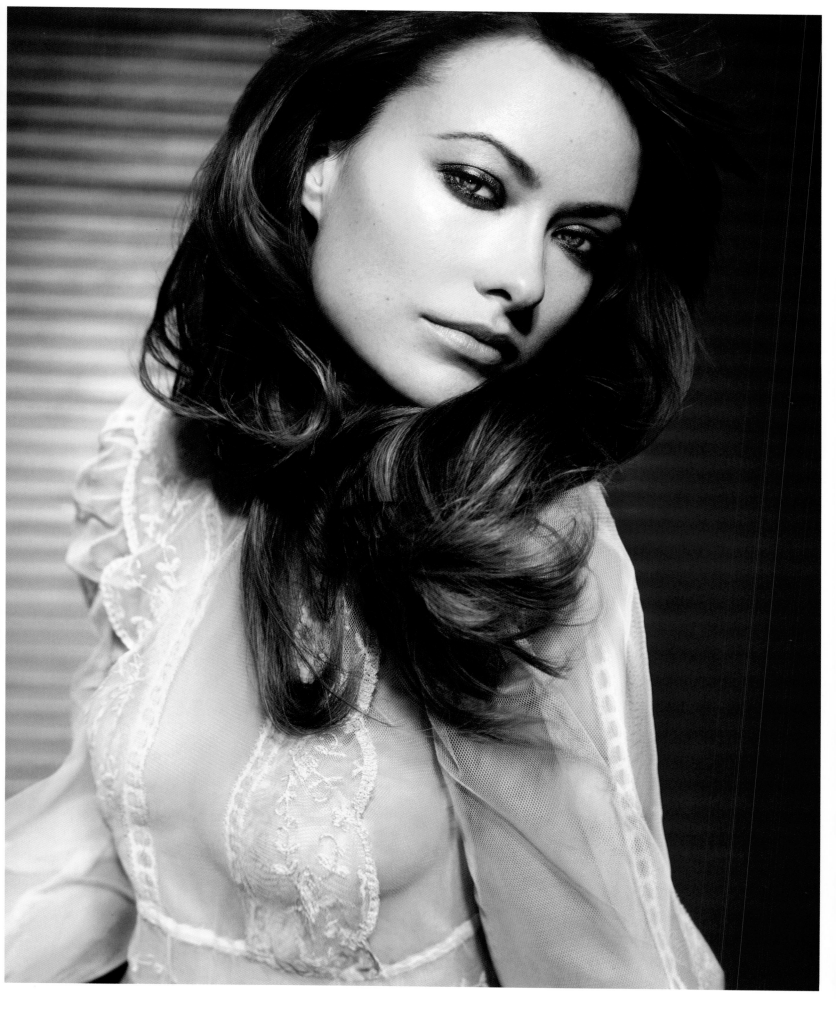

OUTKAST

The hip-hop duo OutKast weren't shy in their styling choices, reflecting their outrageous personalities in turbans and bright suits. "We were excited to capture their style in the color still, and bring a little more of our signature look into the black-and-white shot," says Markus.

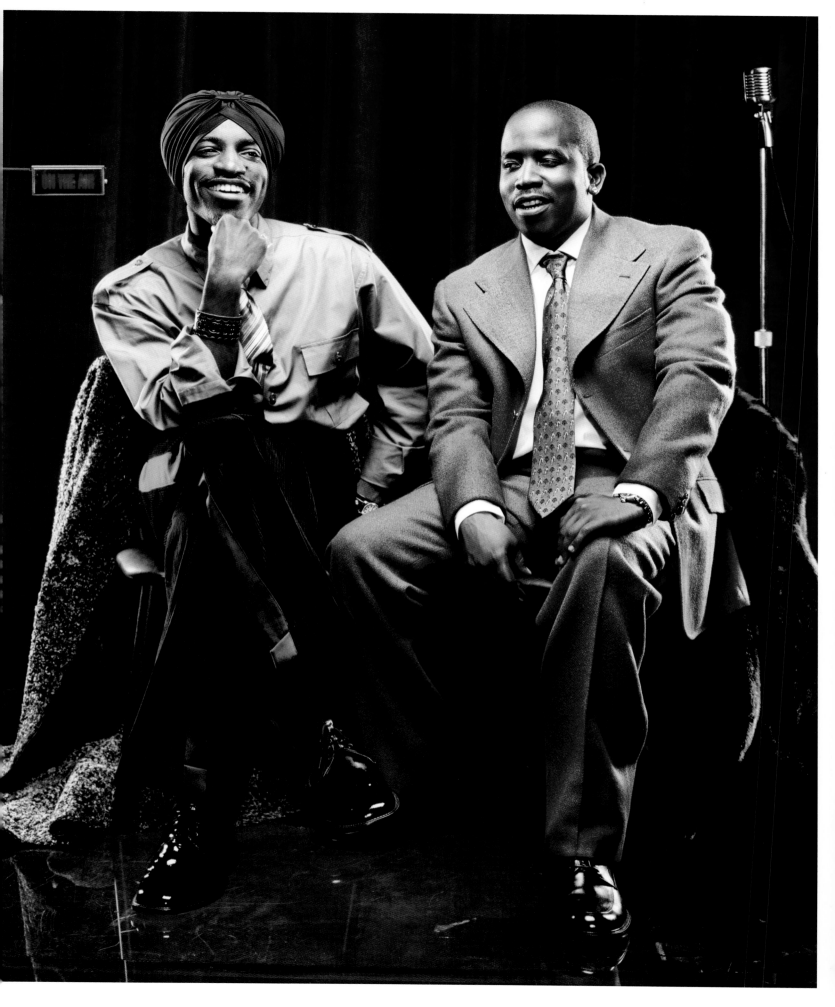

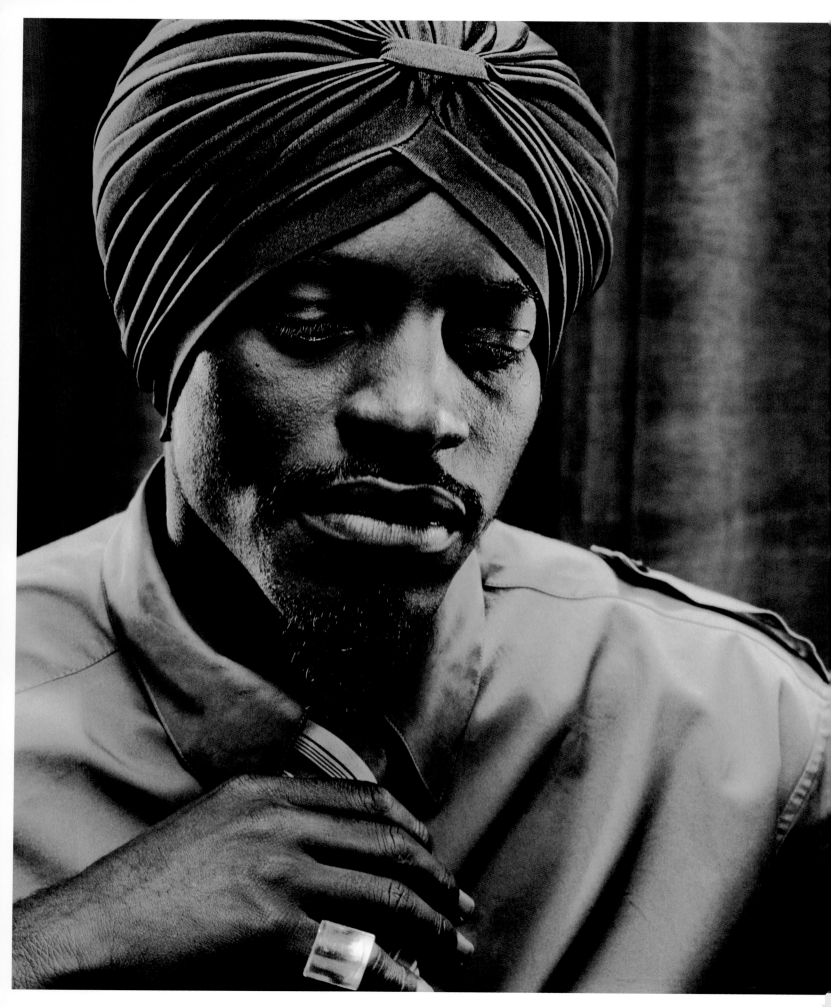

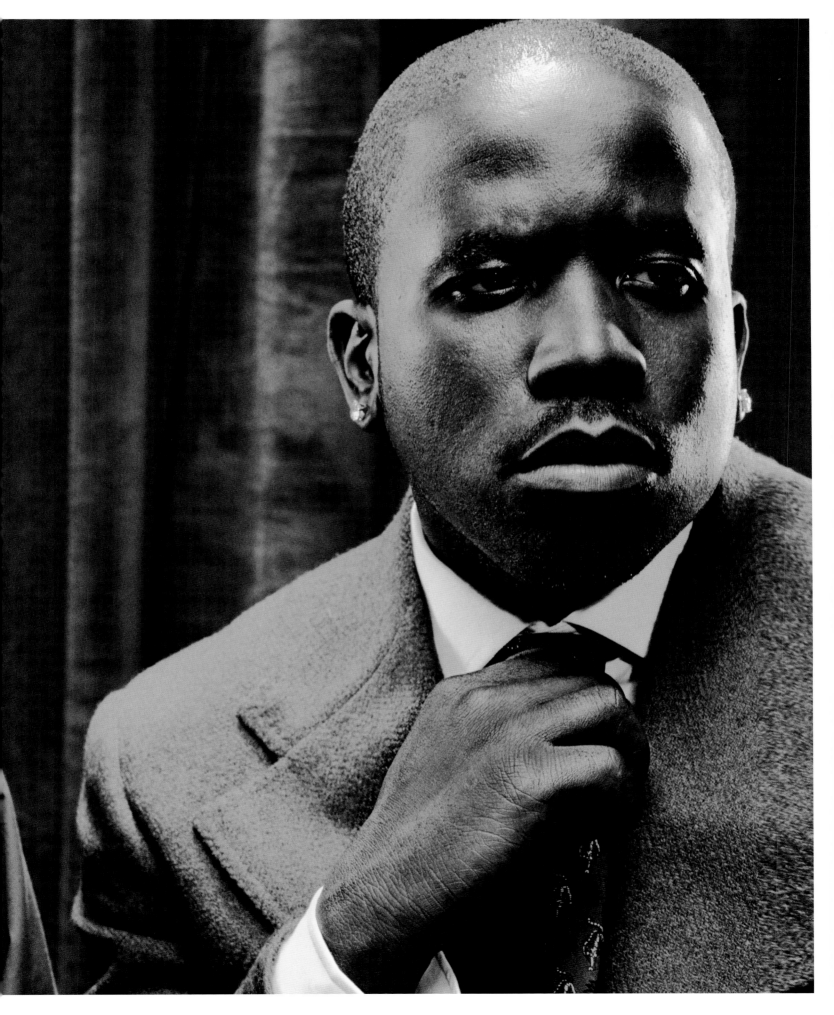

PAMELA
ANDERSON

Brigitte Bardot was the inspiration behind Markus and Indrani's shoot with Pamela Anderson. "She channeled the French star very well," says Markus. Indrani was fascinated by how professional and hardworking Pamela was. "She's very aware of her body and moves well. We shot her in sensual outfits, but didn't want it to be overtly sexual. I think that shows a truer side of her. She's a very down-to-earth and easy-going woman."

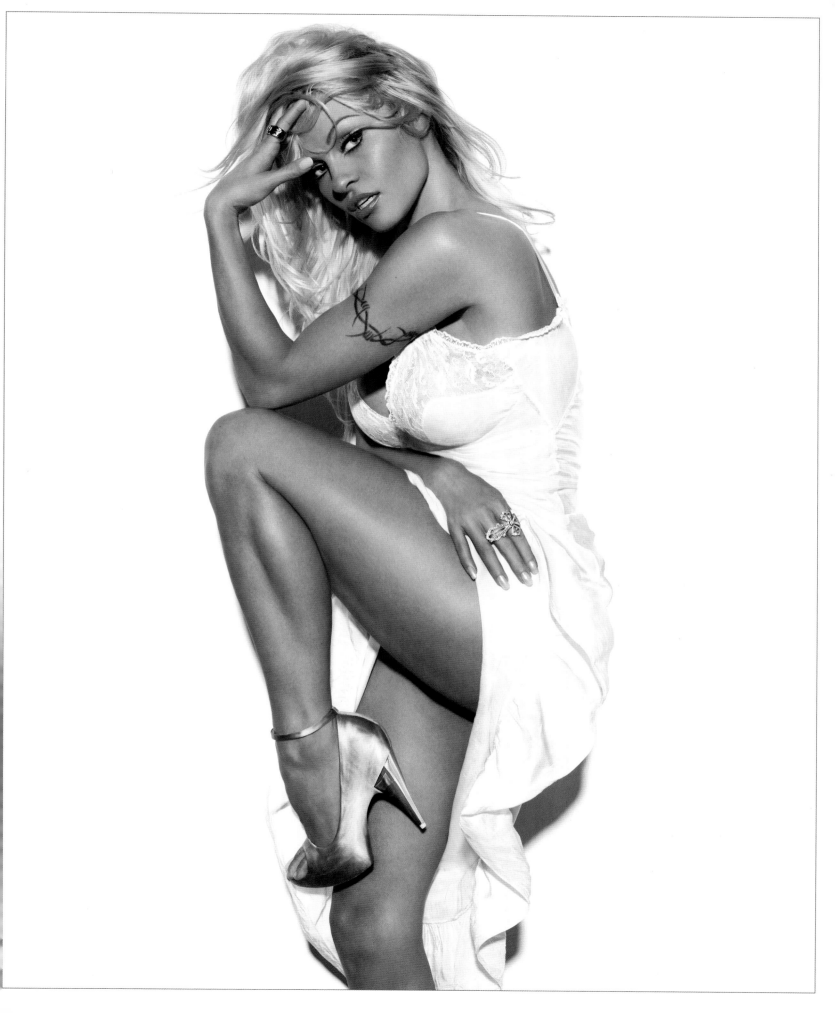

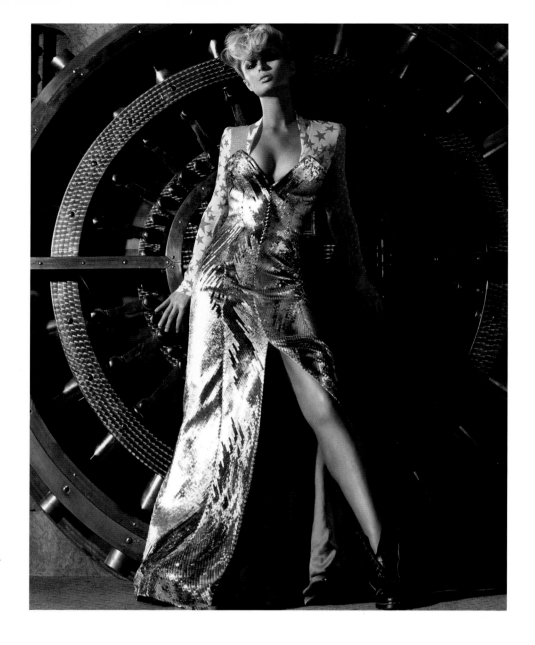

PARIS

HILTON

Markus and Indrani shot the Hilton heiress for British
GQ. "We really tried to give her a different look—more
of a fashion edge," says Indrani. "At the time she was
known for micro-mini skirts and long blonde hair. We
ended up with some really sexy, sophisticated shots."

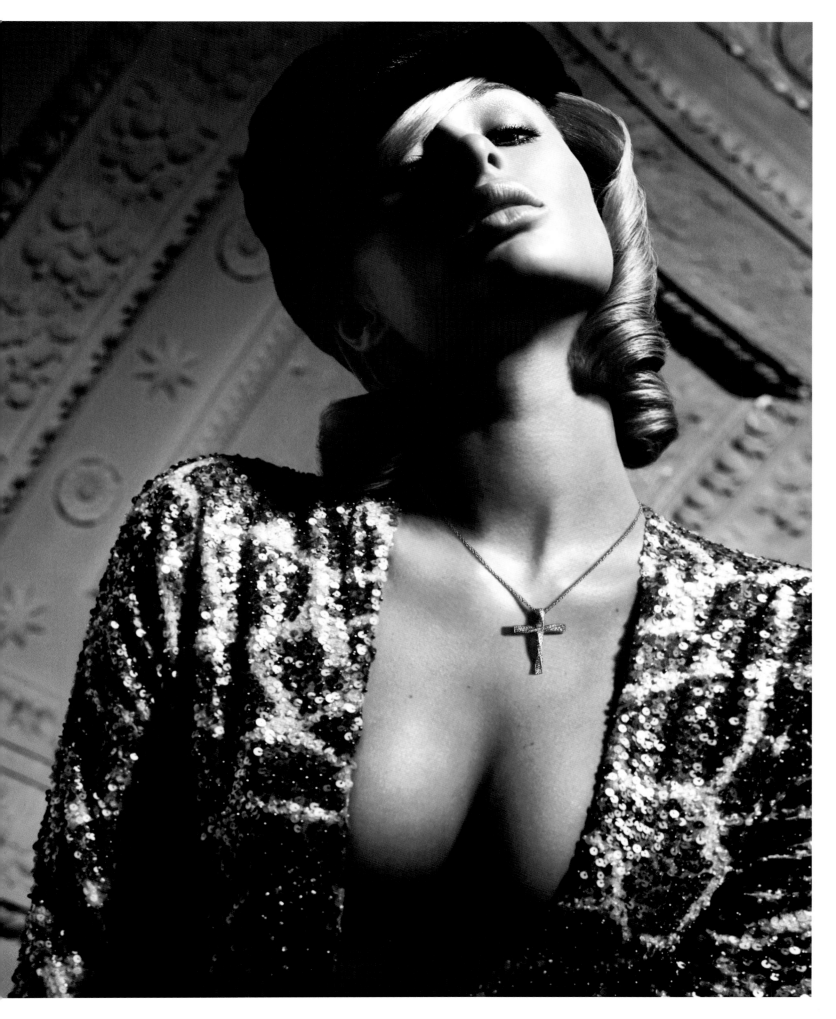

PEREZ
H I L T O N

"That was such a fun shoot," remembers Markus. "Since he reigns as king of the Internet with his blog we decided to shoot him as Louis XIV." The setting was the Box nightclub in New York, where a dozen nude models were brought in to be photographed with Perez for an exhibit at Art Basel in Miami. They dedicated the shot to Marriage Equality and the organization liked it so much they asked Markus and Indrani to be official members of their Advisory Board.

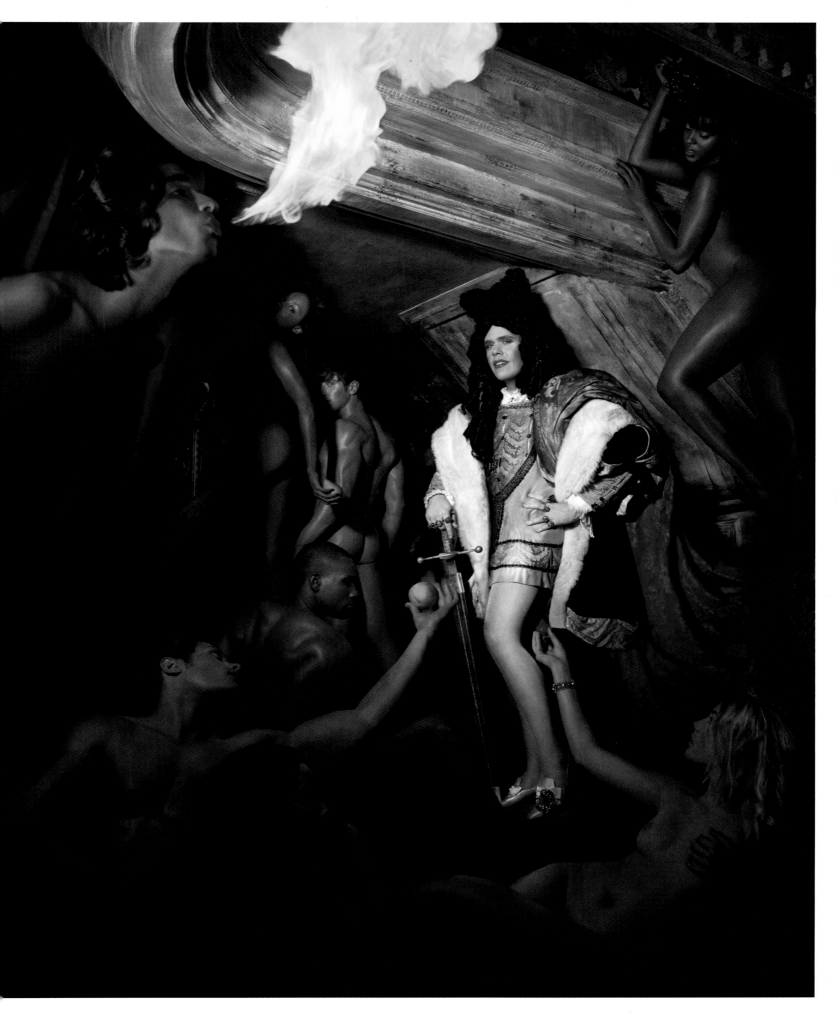

PHARRELL
WILLIAMS

Indrani: "Pharrell is so multi-talented, as a producer, musician, and fashion designer. He's also ridiculously good-looking, thoughtful, and has a terrific aura about him. The challenge was to bring out all of that in a single image."

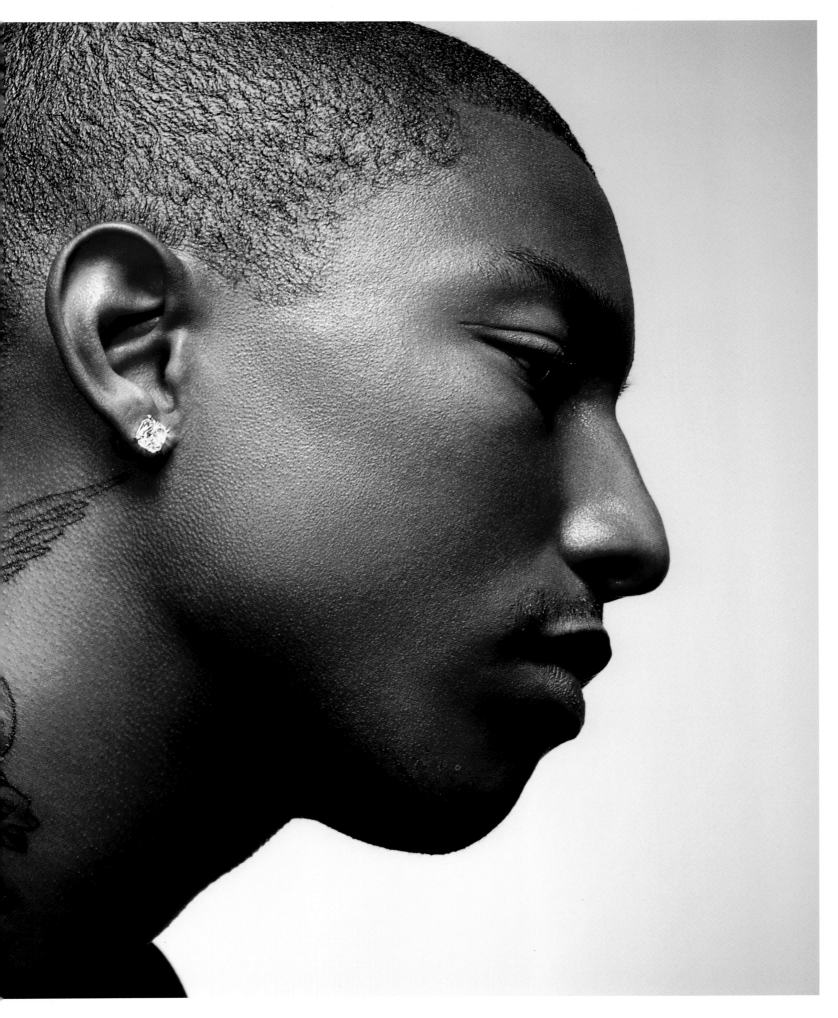

RONNIE

WOOD

Markus and Indrani's shoot with The Rolling Stones' Ronnie Wood was part of a feature for *GQ* celebrating iconic guitarists. "We drove up one foggy night to his phenomenal London villa," remembers Markus. "When we got there Ronnie was just out of bed, Guinness beer in hand, no entourage at all. He offered me a beer and we drank and got into a really good mood before starting the shoot in his personal recording studio. He started playing the most amazing riffs. I almost forgot that it was a photo shoot and just enjoyed the moment before getting the shot."

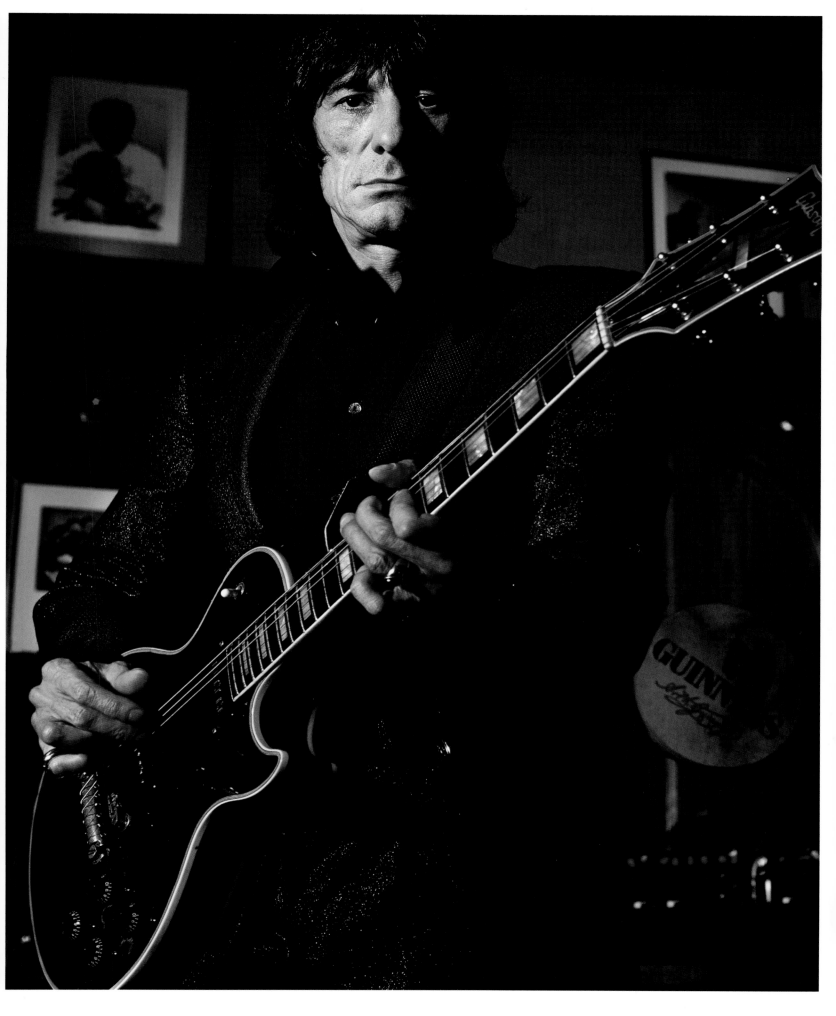

TOMMY
LEE

Markus and Indrani's session with rock star drummer Tommy Lee was inspired by his reality show at the time, *Tommy Lee Goes to College.* They shot him alongside young "school girl" models. "He was really engaging and full of energy while working with our storyline," recalls Indrani.

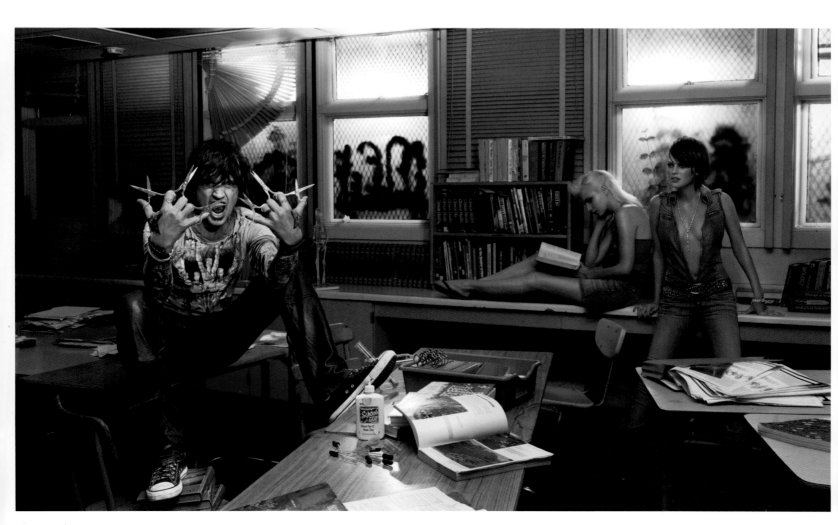

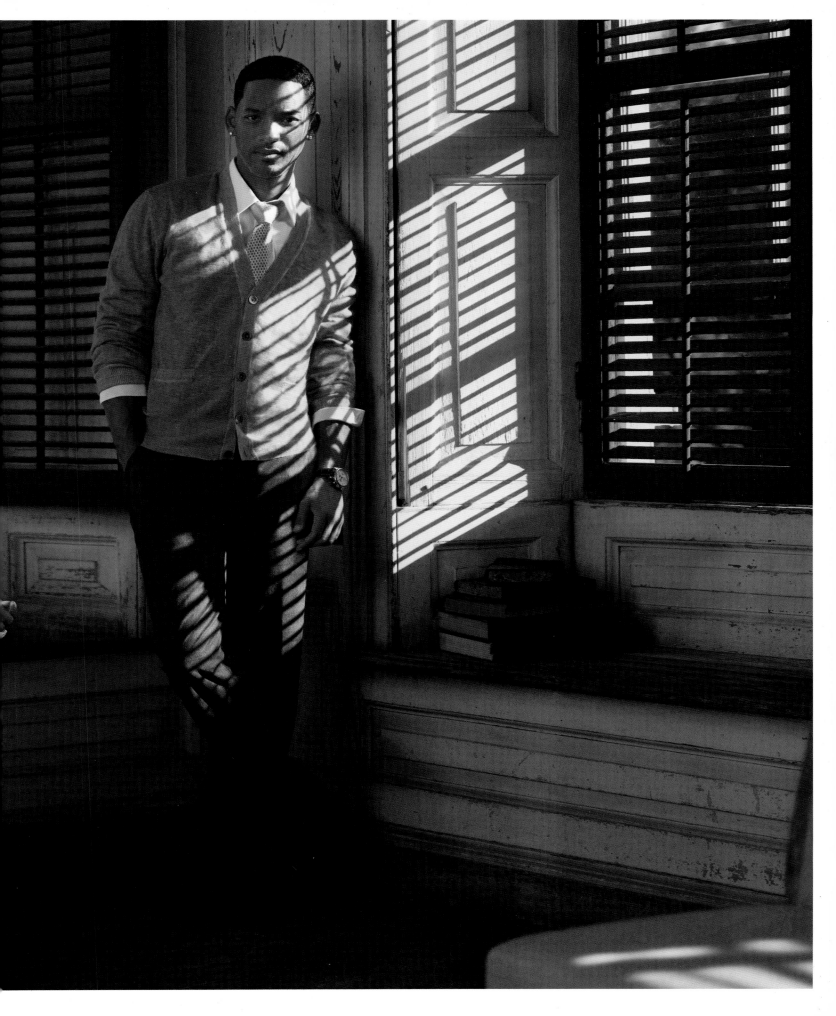

ACKNOWLEDGMENTS

As we celebrate our eighteenth anniversary of working together with the release of *Icons*, we look back with much gratitude and wish to give thanks to so many wonderful artists who inspired us, believed in us, and helped us to succeed in the creation of work that we love. We had so much fun during the last eighteen years, but must admit that working in the fashion and celebrity arena is as challenging today as it was when we first began, and we're thankful for that. So many wonderful people shaped, guided, and influenced our career, and we give our heartfelt gratitude:

Ingrid Sischy, then editor-in-chief of *Interview* magazine, the first major editor to give us opportunities in the U.S. with exciting assignments for her epic magazine.

Isabella Blow, the fashion icon who assigned cover stories for her *London Sunday Times* "Style" magazine, who gave us our first fashion story and magazine cover.

Iman, the first supermodel to commission us to shoot her, for the cover of her compendium of some of the greatest photography of the century, *I am Iman*.

David Bowie, the first musician to trust us with one of his biggest album covers as well as the cover for his British *GQ* "Men of the year" issue.

British *GQ*'s team, including **Dylan Jones** and **Jo Levin** also are thanked for many early celebrity opportunities.

Thank you to *Flaunt* magazine's **Luis Barajas**.

Many years after shooting for Isabella Blow's magazine, we were so fortunate to meet another equally gifted supporter and muse, **Daphne Guinness**. Our recent collaborations with her are among our most cherished.

Thank you to **Fern Mallis**, creator of New York Fashion Week, for all her support over the years. Thanks to **Anne Song** as well.

Among the countless celebrities and models that we were honored to photograph, some need to be given a particular thank you for allowing us and our work to reach new heights. **Lady Gaga**, **Beyoncé**, **Mary J. Blige**, **Jennifer Lopez**, **Mariah Carey**, and **Britney Spears** top this list.

Thank you to **Benny Medina** and **LA Reid** for believing in us and giving us some of our greatest opportunities.

Along the way we had many gifted and dedicated assistants who tirelessly and sometimes for many years worked with us and helped us achieve our goals. Among the long list, special thanks go out to **Mete Ozeren** and **Stacey Thiel**.

We also are grateful to our former and current agents, managers and reps. Special thanks to **Mutale Kanyante**, PMI's **Bill Coate**, Opus' **Jorge Perez** and **Bobby Heller**, our current agents, **Angela de Bona** and **Jason Eason**.

We also want to thank **Christina Papadopoulus** for the many years of working together. Many thanks to **Geoff Katz** of CPI. We are also grateful to **Tyron Barrinton** for all his help. Special thanks from Indrani to **Lance O'Connor** and **Sara Eolin** of **Aero Films**, who represent Indrani for film and commercials.

Special thanks go to our dear friend and attorney, **Gus Michael Farinella**, who is always there for us. We are also grateful to our friends **Dr. Ramin Tabib** and **Dr. Elisa Mello** for looking after us.

Special thanks as well to **Ziv Argov** of Leaf/Mamiya and **Claude Bron** of Broncolor.

Thanks and gratitude also go to L'Oréal Paris' **Sandrine Gadol**, our dear friend and inspiration.

A very special place on this list is reserved for our very closest friend, stylist, production designer, and couture designer **GK Reid**. We met many years ago, early in our career, and he has been constantly involved and part of our work.

Last but not least we are endlessly grateful to our beautiful and stylish editor, **Cindy De La Hoz**, who made this book happen.